Advance Praise for

Body Knowledge and Curriculum

"Deleuzian philosophy is revolutionary, inviting us to think of our lives in terms of a series of encounters that open us up to difference, to the possibility of becoming a new society, a new people. He was interested in how the arts might play a role in the processes he envisaged. Stephanie Springgay has taken up that challenge in this book, showing us how educational encounters with students in the art classroom open teachers and students to new ways of thinking and being that emerge through the creation of their own art works. As an a/r/tographer, that is, as artist, researcher, and teacher documenting her work with students and their art teacher, Springgay uses the concepts Deleuze invented for this revolutionary work to rethink education practice and philosophy in a way that is at once engaging, entertaining and inspiring."

Bronwyn Davies, Professor of Education, Narrative, Discourse, and Pedagogy,
College Research Group, University of Western Sydney, Bankstown Campus

"*Body Knowledge and Curriculum* is just the kind of theory and practice text the fields of art education, arts-based research, and curriculum theory need and deserve. In this work, Stephanie Springgay demonstrates why she is among the preeminent scholars in arts-based research and exemplifies the arts-based methodology—a/r/tography. *Body Knowledge and Curriculum* places at the center of consideration the engaged translations of theory within practice. Springgay weaves them together as mutually informative discourses and makes this difficult task accessible. Based on a six-month study in an alternative secondary school, Springgay renders explicit what can be done when students and educators work from mutual positions of respect and a desire for exploration."

B. Stephen Carpenter II, Associate Professor, Department of Teaching,
Learning & Culture, College of Education and Human Development,
Texas A&M University

Body Knowledge
and Curriculum

PETER LANG
New York • Washington, D.C./Baltimore • Bern
Frankfurt am Main • Berlin • Brussels • Vienna • Oxford

Stephanie Springgay

Body Knowledge and Curriculum

Pedagogies of Touch in Youth and Visual Culture

PETER LANG
New York • Washington, D.C./Baltimore • Bern
Frankfurt am Main • Berlin • Brussels • Vienna • Oxford

Library of Congress Cataloging-in-Publication Data

Springgay, Stephanie.
Body knowledge and curriculum: pedagogies of touch
in youth and visual culture / Stephanie Springgay.
p. cm.
Includes bibliographical references and index.
1. Body, Human—Social aspects. 2. Body image—Social aspects. 3. Body image in art.
4. Performance art. 5. Critical pedagogy. 6. Education—Curricula. I. Title.
HM636.S76 306.4'613—dc22 2008006442
ISBN 978-1-4331-0281-3

Bibliographic information published by **Die Deutsche Bibliothek**.
Die Deutsche Bibliothek lists this publication in the "Deutsche
Nationalbibliografie"; detailed bibliographic data is available
on the Internet at http://dnb.ddb.de/.

Cover design by Joni Holst

The paper in this book meets the guidelines for permanence and durability
of the Committee on Production Guidelines for Book Longevity
of the Council of Library Resources.

© 2008 Peter Lang Publishing, Inc., New York
29 Broadway, 18th floor, New York, NY 10006
www.peterlang.com

Printed in the United States of America

For my Mother

CONTENTS

Threaded throughout the book are the students' works of art and some of my own artistic creations. Many are reproduced through photographic still images, and the videos and additional images can be found at www.springgay.com under *Research* and *Inside the Visible*. The images are inserted into the text without traditional image captions. They are intended to be read as contiguous threads pulled and tangled alongside the written text and student conversations.

In addition, the images "capture" the ways that these artistic explorations were part of the students' living inquiry inside the classroom. Artworks were often photographed in the cluttered and busy art room rather than placed against a sterile backdrop as is common in practices of art reproduction.

Moreover, the images were taken using either a digital video camera or a low resolution digital camera and thus, their reproductive quality differs from what is traditionally included in print material.

ACKNOWLEDGMENTS

A debt of gratitude is owed to many people who provided support during the various stages of this project. I offer sincere thanks to the students and teachers at Bower secondary school. Your words, images, and bodily encounters continue to inspire me, evidence that thinking through the body is both necessary and inevitable.

I hold a very special place for my colleague and friend Rita Irwin, whose initial supervision of this study taught me the integrity and wisdom of a/r/tographical research. Your mentorship and passion for the arts enriches my life daily.

I could not have completed this research project nor the writing of this book without the encouragement of Syliva Kind, Alex de Cosson, Kit Grauer, Carl Leggo and Donal O'Donoghue whose own a/r/tographical journeys are felted into this text. To my friends, Nancy Nisbet, Cheryl Meszaros, Lara Tomaszewska, Marnina Gonick, Kim Powell, Natalie Jolly and the many others who constantly remind me I am never alone and who fill my writing life with humor and compassion, I am truly endebted. Deb Freedman deserves special mention for the ways she has helped to push my theorizing on inter-embodiment and touch. She also became my State College family—and her warmth and welcome made my transition from the west coast of Canada to a small rural college town full of kindness and laughter.

Paras, I am grateful for the love and support you have offered over the years. For my children's wonderful nannies Laura and Candace, who afforded me writing time and space, I can't thank you enough. Maurya and Liam—you make my heart expand.

I am also appreciative of the funding support I received from the Social Sciences and Humanities Research Council of Canada.

And for my mother, a gardener, and my first and always teacher, whose daily phone calls, child care, and motherly wonders provided me with energy and love. For you I write, felt, and stitch this text—you taught me to be passionate about education and to find knowledge in the un/familiar.

Rita Irwin

There can be no greater pleasure than for a mentor to introduce a book of someone they have mentored. It was a privilege for me to be Stephanie Springgay's research supervisor for her dissertation, and perhaps that is why I was asked to write this foreword. If not, I trust it is because I believe she is one of the most exciting young scholars to emerge in art education and curriculum studies for a long time. *Body Knowledge and Curriculum* began as Springgay's dissertation study and was further developed in the intervening years since she completed her Ph.D. at The University of British Columbia. Now an Assistant Professor at Penn State University with a joint appointment between Women's Studies and Art Education, Springgay asks us to rethink our bodied subjectivities as they are known, or not known, in education and the arts.

Body Knowledge and Curriculum is an a/r/tographic exemplar that examines the spaces between visual culture, and the production and negotiation of bodied subjectivities. Youth activism connected to visual culture is constituted through bodies and materialized through visual (and other sensory) encounters. Yet, as Springgay claims, body knowledge is invisible in visual culture and because of that we need to engage in living inquiry with students and teachers about the many ways bodied experiences are materialized and encountered as being(s)-in-relation. *Body Knowledge and Curriculum* brilliantly folds and unfolds questions about body knowledge, curriculum and pedagogy, and artistic forms of creating and enacting research. Through art and text, *Body Knowledge and Curriculum* examines the ways in which youth understand the complex territory of body knowledge, and in turn, intentionally creates pedagogical spaces that are uncertain. Using a/r/tography as a methodology, Springgay entangles image and text in rhizomatic spaces, creating performative understandings of bodies, visual culture and education. It is through this entanglement that relationality between bodies, art and education unfolds.

Springgay is not only an educator and researcher she is also an artist. In this text we learn about one site installation project that included the entanglement of red threads wrapped around rocks and branches along a

Vancouver beach. The red threads that felt their way through this book metaphorically perform the entanglement of the project. Yet there is more. We also learn about the "hair balls" Springgay created for an exhibition— and the evocative eating of hair that was shown on video. These and other provocative creations interrupt our accepted notions of what constitutes art and how bodies are viewed within art. Springgay creates a messy, complicated and often vulnerable space for body knowledge within curriculum and pedagogy. As mentioned earlier, these spaces are rhizomatic and represent the in-between of knowing and not knowing. To begin to understand these spaces one needs to become comfortable with uncertainty, interruptions, silence, and ruptures.

Body Knowledge and Curriculum describes and interprets a study undertaken in a high school setting. Working with students as co-researchers, Springgay challenged standard research traditions and stood in the middle of the complex space of pedagogical negotiation. As an a/r/tographer she embraced the post-structuralist view that no single view is intended but rather multiple meanings are possible, and throughout the text questions provoke further probing. To perform this complexity, Springgay entangles three bodies of text: the analysis of student artwork; text derived from student conversations; and Springgay's own artwork resulting from this research. Moreover, by exploring the three bodied curriculum themes of *body surfaces, body encounters*, and *body sites* during the teaching and learning inquiry, we begin to recognize the impact of Springgay's deep pedagogical understanding. It was through her pedagogical strategies that the students and their teacher came to understand *thinking through the body* and *art as interrogation*. Where this way of knowing was once invisible, it was now made known and interrogated through art.

A/r/tography seeks to engage individuals in living inquiry and through that inquiry, take action that creates meaningful change. For the students in this study, meaning was made manifest in numerous ways. Springgay richly describes the complexity of the study in ways that are truly powerful and engaging. Youth are capable of thinking deeply on profoundly demanding topics if educators are ready to be challenged themselves. Being a/r/tographers *can* be exemplified in a classroom community as Springgay so incredibly portrays. For me this is the most incredible contribution made by this book: youth thinking through their bodies by interrogating what they know and do not know through art. Springgay was able to create living inquiry, or a/r/tography, within the classroom and among the students.

The fields of art education and curriculum studies will be changed with the publication of *Body Knowledge and Curriculum*. I hope many scholars,

educators, and artists rethink their practices and encourage others to read this book. We have a long way to go to re/claim a relationship with our bodied subjectivities. This book offers tremendous insights into how we might move in that direction.

Red Threads of Entanglement

She wraps a red thread around rocks at the beach; twisting, pleating, binding. The video camera tilted slightly askew in the sand watches her performance as she moves inside and outside, tangling the thread and the spaces between. The long felted red tendril catches on the rocks, gets knotted together and in the process gathers up beach debris. Twigs, sand, and the odd piece of moss felt into the host. She struggles to un/do the knots, to perform the un/wrapping often creating further entanglements. Once the thread is completely un/raveled she begins again, this time in reverse, winding and wrapping the thread around her fingers, getting stuck in the process, new tangles and knots emerge. She realizes that this point of departure, this un/raveling is not in opposition. It is not a movement with a clearly defined beginning and an end, but a system of complex interactions, performances of possibility, tension and release. She's right in the middle of things, and every attempt to un/ravel only shifts the middle to somewhere else.

* * *

In a high school art class a student is engaged in the act of entanglement. Using torn out phone book pages, he randomly crosses out names and telephone numbers. Pencil lines begin to connect points that would not have been previously linked together. This act of crossing out is neither a process of annihilation nor a destruction of identifying markers but rather, it is a process of articulating another dimension, multiplicities undergoing metamorphosis. In the act of connecting names and numbers through lines, these very same lines divide and sever the alphabetized list, rupturing the linear pattern of point to point. The act of crossing out maps a movement, a displacement of events that is not reducible to units or determinate intervals. This crossing out, a simple gesture of entanglement, is a rupture that is open, full of excess, and uncertain.

Body Knowledge

Body Knowledge and Curriculum examines student understandings of body knowledge in the context of creating and interrogating visual art and culture. It illustrates a six-month research study conducted in an alternative secondary school in a large urban city in Canada. During the research project students created a number of visual artworks using a diversity of material explorations as a means to think through the body as a process of exchange and as a bodied encounter. The student's art, daily conversations, and interviews inform this research study, suggesting that knowledge with, in, and through the body is open, fluid, and formed in relation to other bodies. The arts-based study was guided by these questions: How do secondary school students experience encounters with visual art and culture in such a way that they are able to understand, materialize, and question body knowledge? And in doing so how might theories of touch, which enable sensory awareness and posit the body as living experience, inform an understanding of inter-embodiment? Or put differently, how do we make meaning creatively as being(s)-in-relation?

Research on the body is exhaustive and comprehensive, covering a multitude of possibilities and directions. Outside of educational scholarship the body has been addressed by countless disciplines reshaping how we organize and constitute, for example the gendered body, the social body, the material body, the phenomenological body, the political body, and the techno body (see Ahmed & Stacey, 2001; Grosz, 1994; Price and Shildrick, 1999; Turner, 1996; Weiss, 1999). Similar attentions have been paid to the body in educational research (see Bresler, 2004; Garoian, 1999; Oliver & Lalik, 2000; McWilliam & Taylor, 1996; Shapiro & Shapiro, 2002). While research on embodiment and bodied subjectivity continues to expand the discourses of schooling, many studies analyze the adolescent body as object, rather than investigate the ways students experience their bodies (Hunter, 2005). Much of this research approaches the adolescent body from the perspective of dis/ease insisting that educational imperatives need to repair, heal, and mend the body, or the research focuses on the discipline and control of the body in schooling. Not only does this position continue to leave absent the living body, it continues to think of the body in dualistic terms.

Body Knowledge and Curriculum is important because it explores the ways in which secondary students understand the complex, textured, and often contradictory discourses of body knowledge, and seeks to intentionally create pedagogical and curricular spaces as a means of dislocating boundaries. The purpose of the research study is to reveal body knowledge as

encounters, not as conditions to be expelled or disciplined. More specifically, it offers alternative curricular and pedagogical practices than ones that subscribe to a healthy body model. For instance, in many school districts in Canada, graduation requirements include a "healthy body portfolio" which documents eating habits, physical activity, and lifestyle habits. This portfolio is judged by teachers and parents in order to complete high school requirements. The students and teachers who participated in *Body Knowledge and Curriculum* recognized that this assumes a normal or universal body and further that it maintains an understanding of the body as an object that can be measured, coded, and recorded. In contrast, the students that participated in this research study inquired into the lived experiences of their body through visual and textual means. Without such interventions, I argue, and further research into body knowledge, the maintenance and control of the body will continue to dominate educational perspectives and practices. Non-dualistic models of curriculum and pedagogy should become aspects of teaching and learning where the body's uncertainty and fluidity are recognized as generative and fecund.

Body Knowledge and Curriculum addresses questions about the materiality of the body in knowledge production through a feminist conceptualization of touch and inter-embodiment, questioning the materiality and lived experiences of the body in knowledge production in order to provoke alternative ways of theorizing self/other relations in teaching and learning. Enacting educational research as living inquiry, *Body Knowledge and Curriculum* is an exemplar of the arts-based methodology— a/r/tography—examining the spaces between visual culture, and the production and negotiation of bodied subjectivities. Moreover, this study argues that youth activism and in particular, forms of activism linked with visual culture and collectivity, are precisely the kinds of spaces that educators either need to provide for students, or to consider when re-conceptualizing curriculum and pedagogy that is embodied.

Visual culture as a phenomenon and critical approach to teaching and learning has been instrumental in shifting traditional approaches to interpreting and creating images within art education (see Chalmers, 2002; Duncum, 2001; Freedman, 2003; Tavin, 2003). While there has been a plethora of divergent arguments as to the viability and significance of visual culture education, the urgency of these claims is primarily focused on visual culture as a new content for study and as a critical model for understanding the increasingly visual world that we live in. The implications of this educational paradigm have resulted in creating opportunities for students and teachers to make connections between a wide variety of images, texts, and

experiences. However, the pervasiveness of visual culture in education has continued to privilege the visual over other sensory experiences and has not included an inquiry into how visual culture impacts, mediates, and creates body knowledge. Moreover, it fails to account for bodied encounters in the production of meaning making. By contextualizing the body's role in the production and meaning making of visual art and culture, education can pose questions about how one comes to know in relation to or "being-with"— other beings and images. Similarly, a critical examination would follow regarding the trans-circulation, power, representation, history, and ways of seeing both bodies and images.

Scholars have addressed the invisibility of body knowledge in visual culture (see Duncum & Springgay, 2007) establishing a place for bodies who are outside the dominant model by asserting their role and contribution to the visual field (e.g., Pollock, 1988). Yet, this mode of analysis while important does not always ask questions about inter-embodied experiences, and neglects to inquire into the ways in which bodies are constituted and materialized through visual encounters. My intent is not to illustrate the history of invisibility in visual culture, nor to simply insist that the body as a subject become part of the everyday curriculum in schools, but rather *Body Knowledge and Curriculum* poses questions about the many ways students materialize through visual culture bodied experiences and encounters as being(s)-in-relation.

Red Threads of Entanglement: Performing, Writing, and Reading *Body Knowledge and Curriculum*

Body Knowledge and Curriculum poses questions about body knowledge, curriculum and pedagogy, and artistic forms of creating and enacting research. It explores the ways in which youth understand the complex, textured, and contradictory discourses of body knowledge, and seeks to intentionally create pedagogical and curricular spaces that are uncertain and folded. In addition, the research attends to the methodology of a/r/tography (see Irwin & de Cosson, 2004; Springgay, 2005a/b, 2004, 2003, 2002; Springgay, Irwin, & Kind, 2005; Springgay, Irwin, Leggo, & Gouzouasis, 2008), a form of arts-based research that entangles image and text performing what Giles Deleuze and Felix Guattari (1987) refer to as a rhizome. A Rhizome is an assemblage that moves and flows in dynamic momentum. It is an immanent force, creating multiplicities that do not rely

on hierarchical categories. A rhizome has no root-origin; it spreads out, becoming, an asignifying rupture. A rhizome:

> [H]as no beginning or end; it is always in the middle, between things, intervening. The middle is by no means an average; on the contrary, it is where things pick up speed. Between things does not designate a localizable relation going from one thing to the other and back again, but a perpendicular direction, a transversal movement that sweeps one and the other away, a stream without beginning or end that undermines its banks and picks up speed in the middle. (Deleuze & Guattari, 1987, p. 25).

Contrary to dichotomous relations, in a rhizome something passes between two terms such that they are both modified. It operates by variation, perverse mutation, and flows of intensities that penetrate systems of classification, putting them to strange new uses. It creates the unfamiliar. To be rhizomorphous is to become, a becoming that effaces stable identities. It is performative and gestural. The rhizome is a space of entanglement where bodies, visual art and culture, education and forms of research are interrogated and ruptured. The diversity and complexity of entangling subverts the expectations of a linear, progressive development that flattens or maps out in any simple way youth understandings of body knowledge. Entanglement becomes a rich metaphor precisely because it embodies a complex web of meaning making that shows the *relationality* between bodies, art, and education. Moreover, entanglement bears witness to difficult knowledge where in the act of crossing out or un/folding one writes oneself into existence through uncertainty, discomfort, and equivocal means.

The red thread that performs my entanglement is not a woven thread but a long piece of felted wool. Felt, according to Deleuze and Guattari (1987), is an anti-fabric, "impl[ying] no separation of threads, no intertwining, only an entanglement of fibers obtained by fulling…It is infinite, open, and unlimited in every direction; it has neither top nor bottom, nor centre; it does not assign fixed and mobile elements but rather distributes a continuous variation" (p. 475–476). The materiality of felt displaces binaries. Unlike a woven fabric or textile, which can be unraveled to reveal its constitutive parts (warp and weft), the un/doing of felt is not its opposite, but rather results in additional felting, further entangling the material.[1]

Comparably, in a fold, say in cloth, the outside is never fully absorbed. It is both at once exterior and interior. Unlike felt which has no sides, a fold produces both interior and exterior simultaneously, and in a fold these sides are doubled; what is exterior is also at once interior. While tension (fulling or friction) produces felt, it is the fold itself that occupies the space of tension and excitement. This doubling between folding and un/folding displaces the

possibility of reversal. The un/doing of a fold may result in additional folds, not through the elimination of folds, but rather the entanglement and doubling of interiority and exteriority. Un/folding resists unification; a fold is not absorbed, nor rendered neutral. Folds are doubled only to be disrupted and appear again as further folds.

Deleuze (1993) translates the fold as sensuous vibrations, a world made up of divergent series; an infinity of pleats and creases. Un/folding divides endlessly; folds within folds touching one another. Deleuze writes: "Matter thus offers an infinitely porous, spongy, or cavernous texture without emptiness, caverns endlessly contained in other caverns" (p. 5). A fold is not divisible into independent points, but rather any un/folding results in additional folds; it is the movement or operation of one fold to another: "A fold is always folded within a fold" (p. 6). Thus, un/folding performs in the very space between and of boundaries, where entanglement becomes an activity of inter-embodiment. In writing about this performance of un/folding I use the slash to accentuate the activity of movement and the in-between. Un/folding with the slash allows the term to reverberate, to flicker, and to be in a state of constant movement. I use this slash not only with the word un/folding, but also for terms like un/doing and in chapter four some of the students will entertain the slash in their performance of un/writing.

The performance of entanglement begins in the middle, emphasizing the multiplicities and the complex mappings of understandings that result from the play of the fold. Researching, writing, teaching, and creating art as acts of entanglement produce spaces where seemingly disconnected ideas come together in provocative and inventive ways without ever becoming resolved. Likewise, the performance of entanglement creates new openings and raises questions rather than seeking certainty or clarity.

This leads me to think about a conceptual narrative I described in my dissertation (Springgay, 2004). At one point in my committee meetings someone mentioned that my writing read like too many "dropped threads." It was a wonderful metaphor that interconnected with numerous conversations I had had with the classroom teacher.

In pondering this notion of "dropped threads" I discovered an image of Bronwyn, the art teacher, sitting in the class un/knitting. I also remember my grandmother having to unknit something because she had "dropped" a stitch, which meant that there was a mistake in her pattern, a place that she needed to return to so that she could reknit her project. This form of unknitting is linear, traveling a path backwards to a place of origin, to a dropped, missed stitch, in order to repair and correct the knitting. Bronwyn's un/knitting was altogether different. These were not dropped threads that she was trying to

mend, but rather she was involved in an active process of dropping threads—intentional acts of disruption. Using previously knitted objects, Bronwyn un/knits, and I use the slash in this instance to "image" the idea of unknitting and knitting simultaneously, in order to create something new. Her knitted art pieces are interwoven combinations of "dropped threads," entangled wools of different colours and textures. Bronwyn's un/knitting is living inquiry, it is a process of interrogation, and because she intentionally questions, examines, and reflects on it's meaning in relation to her art practices and pedagogy, it also becomes an a/r/tographical gesture. Jean Luc Nancy (2000) articulates this concept of un/knitting when he argues that meaning is created when it "comes apart" (p. 2). This philosophical shift is important because common sense posits meaning as a linear assemblage, as something that is added to and built upon. Instead un/knitting insists that meaning is an exposure; a rupture that emphasizes an opening up.

Dropping threads is a difficult metaphor to contend with given that education has often rewarded students and teachers for finding the correct answers or mending knowledge as opposed to searching for painful questions. The act of dropping threads in the performance, writing, and reading of *Body Knowledge and Curriculum* is purposeful. Following a logical and linear argument beginning with my research questions, research site, methodology, theoretical framework, and then moving onto the data analysis, would create isolated boundaries and impose a false sense of order. Instead, I encourage you, the reader, to embody and perform the gesture of dropping threads as a process of interrogation that un/knits new directions and new meanings together.

The performance, writing, and reading of *Body Knowledge and Curriculum* embrace the entanglement of red threads, like the ones I wrapped around rocks at the beach. Interrupting accepted notions of a "textbook," *Body Knowledge and Curriculum* celebrates the messy, complicated, and vulnerable spaces of curriculum, pedagogy, and body knowledge. It invites readers to step into the rhizome—the in-between—in order to imagine the possibilities of inter-embodiment. To be engaged in an act of entanglement means to launch into the middle of knowing and not knowing, which as Alexandra Fidyk and Jason Wallin (2005) suggest "requires a certain hospitality toward interruptions, repetition, and silence" (p. 215). Attending to performing, writing, and reading research also means we need to attend to ourselves and to our collective lives with others. This attention calls for a meditation which "makes possible a new kind of stillness in which can be heard or recognized, maybe for the first time, all of those voices, intuitions, dreams and aspirations which have been suppressed under the dispensations

of the dominant order" (Smith, 1999, p. 86). Through inter-embodiment "we are enabled to "return" to ourselves, to be true to ourselves, to the belonging-together of things that go on without us, without our doing. Thus, we know ourselves in terms of our relations rather than substance so that personal identity appears as emergent and contingent, defining and defined by interactions with the surrounding space" (Fidyk, 2003, np). The red threads that felt their way through this book attempt to engage the reader, as writer, in the performance of entanglement.

As the six-month semester in the school un/folded, my research methodology, the visual explorations with the students, student and researcher understandings, and ongoing analysis of student work emerged simultaneously. There were many days when I would arrive home from school and as I prepared myself for the following day, uploading video, reading over the day's notes in my visual journal, or designing a lesson on a contemporary artist, I would find myself frustrated, panicked, and scared. I had nothing. I would convince myself that I had collected "no data." The research was going nowhere. And yet, something propelled me forward; a nagging voice echoing in my ear, "What did it all mean?" As the video tapes piled up on my apartment floor and the student's art explorations propelled class discussions, I realized that I was right in the middle of things, in a space marked by meditation and complexity.

Complexity thinking, according to Brent Davis and Dennis Sumara (2006), maintains that systems are composed of necessarily different parts which are diverse, self-organizing, self-regulating, and constantly shifting in unpredictable ways. For example, bodies are composed of interconnected sets of complex systems such as cells, tissues, and organs. Each of these complex systems exist individually and in relation to each other, to form and transform embodied responses and experiences. However "because complex systems defy preconceived hypotheses mapping these responses, they remain inherently and productively elusive of predictions" (Stevens, 2005, p. 278). A/r/tography, like complexity thinking, allows meaning to emerge more from what is absent, tacit, literalized, and forgotten than from what is present, explicit, figurative, and conscious. Therefore, *Body Knowledge and Curriculum* is consistent with research understood in terms of the production of emergent possibilities and potentialities. Moreover, a/r/tography is poststructuralist in nature, insisting that no single meaning is intended. Rather each time the work is viewed/read, new and individual meanings, purposes, and experiences are created, materializing multifaceted interpretations while simultaneously de-centering the authorial voice.

A/r/tography, like poststructuralist ethnography "can offer education a more complicated version of how life is lived" (Britzman, 2003, p. 246).

Red threads of entanglement emphasize that the processes of research are unfinished, multiple, and conflicting ones. Disrupting "any desire for a seamless narrative, a cohesive identity, or a mimetic representation" (Britzman, 2003, p. 247) the red threads that weave their way rhizomatically through this research study underscore the fact that "every telling is constrained, partial, and determined by the discourses and histories that prefigure, even as they might promise, representation" (p. 247). The students' stories of body knowledge—told through image and text—compete, contradict, and slip alongside one another, reminding us of the partiality of language, "of what cannot be said precisely because of what is said, and of the impossible difference within what is said, what is intended, what is signified, what is repressed, what is taken, and what remains" (p. 244). This partiality recognizes that the artworks and theories I have presented in this book, are not intended to fix or point towards a coherent narrative of bodied experience, but rather shows their rearrangements and indeterminateness. To that extent, threaded between the youth's artworks/ voices are my own artist, researcher, teacher understandings and questions in the form of art installations and aesthetic inquiries.

During the semester that I worked with the students in the school I was a doctoral candidate at the University of British Columbia, in Vancouver, Canada. At UBC I taught in the pre-service teacher education program and supervised student teachers during their practicum placements. My graduate student life included participation in a study group (see Springgay, Irwin, & de Cosson, in press). It was through the collective efforts of this group that a/r/tography began to be theorized extensively by doctoral candidates and their research supervisors. While a few other students had used a/r/tography to frame their dissertation research (self-studies), my study in a secondary school was among the first a/r/tographical studies to include research with participants. It was an anxious space, often having to explain to faculty and students that my methodology was not "complete." A/r/tography itself was being materialized in the very process of the research study.

In addition, I was actively committed to life as a contemporary visual artist. I had a studio space on the east side of town and I participated in a number of group exhibitions throughout the lower mainland of British Columbia. My life since that semester has changed dramatically. I am now an assistant professor at a large research institution in the United States and a mother of two young children—one 3 and another 10 months in age. My current sense of displacement living in a small American college town,

thousands of miles away from the west coast of Canada—the smell of salt air, the snow capped peaks, and my studio—is not altogether that different from the dislocation and disarticulation I felt during the time I worked on this research project. It was a challenging semester—engorged with theory and graduate school conversations—my time spent in the secondary school left me feeling anxious and unsettled. It wasn't that I didn't fit into the school, for the students and faculty opened themselves fully to my wanderings, it was more to do with the element of unknowability in research and teaching that left me feeling out of place and exposed. Researching in the school inevitably meant researching myself, which as Marnina Gonick (2003) writes, "becomes a relational form of understanding in which both researcher and researched are engaged and there is no pretence that these encounters and the knowledge they convey are either transparent or innocent" (p. 59). Challenging the taken-for-granted assumptions about conducting research with secondary school students, I aimed to provide a space through research and teaching where the voice, images, bodies, and lived experiences of youth could reside. Being mindful of the dilemmas of doing research *with* youth as opposed to *on* or *about* youth (Vadeboncoeur, 2005) acknowledges that how research "is organized, constituted, and accomplished will, to a large degree, determine the form and substance of claims it is able to make, resulting in an anxious fixing, unfixing and refixing" (Gonick, 2003, p. 55). I was also cautious of the implications of using terms such as secondary school student, adolescent, and youth to describe the population I worked alongside. Often characterized as unfinished and undeveloped the adolescent (Vadeboncoeur, 2005) is viewed as needing adults to impose order and control. In an effort to destabilize languages' ability to restrict and code bodies I use the three terms interchangeably and as processes rather than as fixed positions. As Stevens (2005) writes: "The political potential of viewing the subject as process rather than as fixed serves to include and acknowledge the multiple, competing, and contradictory positions that are both concurrently and disparately invoked within the subject and across subjects" (p. 276).

A/r/tographical research poses questions about what kinds of possibilities exist for imaging experience as inter-embodiment. Like Gonick (2003), I reject a research model which sees theory as something to be tested and proven through research. Therefore, the theories I engage with, the artworks, student voices, analysis, and curricular and pedagogical implications are constantly in motion—entangled together, unable to be systematically pulled apart. While, I will provide a more detailed analysis of a/r/tography in chapter one, what is important for the performance, writing, and reading of this book, is an understanding that the students works of art *and* their

conversations make up the research "data" and as such the artworks need to be recognized on their own (not simply as described through student "words") exemplifying the complexities of student understandings of body knowledge and inter-embodiment. Writing about autobiography as research, Carl Leggo (2008) considers the ways that personal narratives shape our lives. He writes, "We make sense of ourselves through stories" (p. 9). I concur, but the students' stories exist at the intersections between narrative, visual, and tactile experiences.

Likewise, in *Places of Learning*, Elizabeth Ellsworth (2005) examines visual culture from the perspective of "in the making." She positions these art forms as anomalies, places that are irregular, peculiar, or difficult to classify only when viewed from the "centre" of dominant educational discourses. The students' artworks and their bodily-relational encounters that are the context of this research study need to be considered from this perspective—not as "things" already made into concrete facts, projects to be taught, nor metaphors for teaching and learning, but in the making— "harboring and expressing forces and processes of pedagogies as yet unmade, that provoke us to think or imagine new pedagogies in new ways" (Ellsworth, 2005, p. 6).

How does one write about such visual and bodily-relational encounters? How does one acknowledge and express the ambiguous potential of the body in and as visual culture without predictably and immediately containing that potential within the limits of academic writing? How in other words, can one use writing to describe that which surpasses the boundaries of language, and in turn, how can one describe such a situation without falling into an uncritical embrace of the uncertain, the embodied and the experiential? I attempt to address these questions through performative writing (Pollock, 1998) that takes into account the complicated spaces of bodily encounters and visual culture. I play with "linearity" entangling together three "texts" in an attempt to recognize the multiple performances at play in the research study. As the centre of my paper, the "text" contains my analysis of the students' artwork and follows the formatting of a word-processed document. Threaded throughout the "body of the text" are the students' works of art themselves. Many are reproduced through photographic still images, and the videos and additional images can be found at www.springgay.com under *Research* and *Inside the Visible*. Reflecting the structure of an online document, the hypertext of images is not intended to "represent" in visual form what is analyzed in the "body of the text" rather, the art itself needs to stand alone as something else yet unnamed (see Bagley & Cancienne, 2001; Mullen, 2003). Similarly, two art installations of my own work resulted from

this research study, and the images and brief descriptions of these projects are threaded throughout the text. This is not to say that the installations are illustrative of the research site, methodologies, or data; they are my own artistic inquiry into inter-embodiment, body knowledge, and touch.

The third "text" that intersects this paper, is constructed from student conversations, field notes, and my own personal reflections that were either video recorded or annotated in my visual journal at the time of the research study. Student conversations comprised secondary data, which assisted me months later in recalling memories and sensory experiences of the bodily encounters and events. Intersected with student "images" these conversations allow for intertextual voices to resonate within the text. I have tried to weave the three texts together, to unsettle the split between scholarly analysis, the experiencing body, the visual, and that which cannot be contained within language. All of this is an attempt to think/write/image relationally—to locate the body in the threshold of meaning making and to understand that to be a body is to be continuously in relation with other bodies and the world. In what follows, I will describe in more detail the research site and the bodied curriculum I implemented in the school. In favor of entanglements and the rhizome I will return to theoretical considerations of touch, inter-embodiment, and a/r/tography in chapter one.

The Research Site

The research setting is an alternative secondary school in Vancouver, Canada. Positioned in the school as an artist, researcher, teacher, I designed and implemented a body curriculum for the senior art class (grades 11 and 12 combined). As an artist, researcher, and teacher I participated in all school activities five days a week for six months. Students were introduced to contemporary artists and their practices, they participated in group discussions and written exercises, kept visual journals, and they investigated and created artworks on the themes *body surfaces, body encounters*, and *body sites*. Emphasis was placed on performance, installation, and new media art. The 13 students who participated in the research study were self-selected from the senior art class. I had visited the school on a number of occasions the previous semester and introduced the research study at that time. The classroom teacher was also involved in all aspects of the research. Data were collected through a diverse range of methods including: observation collected through digital video and still images; written observations and reflections annotated in a visual journal; recorded

interviews and group discussions; written assignments and student visual journals; and student-created and researcher-created artworks. A/r/tography, action research (Carson & Sumara, 1997), and visual methodologies (Pink, 2001; Rogoff, 2000; Rose, 2001) shaped continuous analysis where daily reflections and material collected from the students informed the genesis of the project and navigated ongoing dialogue amongst all of the participants. The school, although part of the local public school board system, operates within a different philosophical paradigm. Key to this philosophical shift in curriculum and pedagogy is the absence of punctuation points, such as bells that mark the beginning and end of classes or the school day. The school, which I named *Bower* is characterized as an alternative school because of its size (115 students from grades 8 through 12); self-directed student learning; and students addressing their teachers by their first names. The principal and other school administrators are also absent from the school building. Their offices are located in the larger, more traditional high school located "up the hill" from *Bower*. The student body is comprised of different racial, cultural, and economic backgrounds. Students participate in a weekly school meeting, which is facilitated by students in the senior grades. These various characteristics contribute to student and teacher understandings of the school as a community (see chapter two).

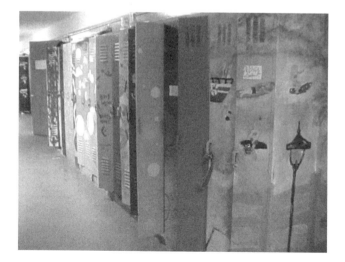

The lockers at *Bower* are considerably different from the austere gray of most other secondary schools. Lockers are painted with colourful murals and often a series of lockers contribute to a collaborative group theme. In addition, there are no locks on the lockers, contents spill out onto the floors

and accumulate in piles on tops of lockers. The students tell me that the no-lock policy is one of openness and comfort. It fosters an awareness of each other and a responsibility towards collective space. Ming,[2] a student at the school shares that the small student ratio enables this distinction. "If someone were to steal something they would not go unnoticed." On another level the openness of these lockers attested to student understandings of boundaries that were not about property and containment, but boundaries that in themselves constitute change and difference.

I chose the name *Bower* for the school because it reflected the idea of a boundary as open rather than contained. Unlike many other schools in the city whose names are associated with geographical locations or names of individuals, the school's original name was quite literally a description of the type of community that parents, teachers, and school administrators believed it fostered. In choosing a pseudonym I wanted to express the students' understanding of their school community.

In addition, the art teacher, Bronwyn, spent months photographing nests around the school (I encouraged her to also make art as part of the research study) and ones she discovered on one of the small islands that dot the coast where she lives during the weekends. She also began to stitch a nest out of discarded fabric and other odds and ends. Watching her tactile experiences I began telling her about my encounters with the bower bird in Northwest Australia. The male bower builds mating nests out of sticks or reeds, constructing the walls upwards, rather than as a bowl shape more commonly associated with protection. The nests are not built in trees or on rocky ledges but on the earth often in very exposed places. The floors of the nests are lined with shiny objects, perhaps shells, stones, or even human debris like aluminum pop can tops, pieces of glass, or any other bit of coloured material. Sometimes the Bower uses berries to stain the walls of the nest. These nests are not places of protection, rather they *invite encounters*.

I recall how fascinated I was with the construction of the bower nest, the flashy shells and glass, the unusual wall structures. A person who collects things, most notably small objects, is often thought to be a bower. Similarly, bowery has been used to describe a leafy green arbor. The brightly painted lockers with things spilling out of them, the art room stuffed to the rafters with miscellaneous objects from junk heaps, fabric shops, and dollar stores all reminded me of a bower(y) and processes of encounters between being(s)-in-relation.

A Bodied Curriculum

I want art to be part of their lives, and their experiences, not a class with a beginning and an end. I want students to think about art as inquiry. —Bronwyn (Art Teacher)

I developed and implemented a bodied curriculum that formed the basis for the research study. Although designed for the senior art class (grades 11 and 12 combined), students in other grades joined the project out of interest at different times throughout the semester. As an open and alternative model school, students moved freely throughout the school, often dropping in on classes they were not enrolled in. When word got out that I was going to show a video on hip-hop and graffiti artists, more than half the school turned up in the art room. Likewise, the art room was at the heart of the school community. During breaks, lunch, and student spare classes, students (even those who had opted not to take art) hung out in the art room and in the process of hanging out became involved in creating something.

There were a series of rationales for my presence in the school as more than a researcher. First, it was important for the students, art teacher, and the school to benefit from my participation and presence in the school. I wanted to offer something in return to the school for allowing me to work with the students and the art teacher. In addition, by volunteering to teach for six-months, students who were unable to participate in the research study due to parental permission or who were not interested could still choose to be actively engaged in class, thereby reducing the sense of exclusion amongst students. In fact many students in grades 8 through 10 joined my class (or worked with me after school) at different times throughout the six months I was at the school. The art teacher encouraged all students to participate regardless of their involvement in the research study.

The second rationale is tied up with my presence in the school as an artist. I was invited by Bronwyn to work with her class as an artist-in-residence with two goals in mind. She wanted contemporary art introduced to the school/students and she wanted some aspects of technology to be a part of what I did with the students. Bronwyn wanted to introduce her students to contemporary artist practices, but she did not want to do this through a series of lessons built on traditional models of viewing art through slides, in which students were expected to critique and respond to static images having little connection to their own lives and understandings. Rather she was interested in the intersections between contemporary art and the student's own meaning making through the *doing* of art; art as living inquiry.

Similarly, Bronwyn wanted students to explore installation, performance, and new media work, and she was delighted that I was willing to introduce students to video art. However, the body curriculum was not driven by the acquisition of technical skills, nor did it focus on one medium of art versus another.

My pedagogical philosophy embraced the possibilities of *thinking through the body* and *art as interrogation*. Lessons and class explorations were not intended to instruct students about bodies, or about particular techniques, rather art became a means through which students could think through and negotiate the lived experiences of their bodies. If a student needed to know how to "make something," I, the art teacher, or even other students initiated demonstrations. Occasionally I introduced a mini lesson, showing students a particular art skill (e.g., how to use imovie) that I thought they might be interested in learning. Bronwyn's own teaching philosophy embraces art as living inquiry, a curriculum model that does not begin and end within the time frame of art class.

Bronwyn, like myself, desires to foster an art curriculum that encourages students to interrogate visual experiences and to make meaning with, in, and through the body. As a textile artist herself, she is interested in an approach to teaching that includes the practices of being and becoming an artist.

> I see that art should be part of their lives. I don't want it to be something that they go to and sit there for an hour then leave again and do something else. I want it to be part of everything, more organic. I don't want it to be so structured that when they leave they say well now we're done with art for the day and we should do something else, rather it should feed into all those other things. So I try to make that kind of atmosphere where it almost seeps in. (Bronwyn)

Bronwyn and I expected students to experiment and explore a variety of material possibilities. Students were encouraged to conceptualize an idea or to generate an area of inquiry. When and if they needed assistance in actualizing this idea, then I would offer material suggestions or technical support. It was not that one project was to focus on video and another on sculpture, rather students were encouraged to choose materials that were appropriate to the types of explorations they wanted to initiate.

Bronwyn's involvement in the project was invaluable. She allowed me to assume the role of teacher, to develop and implement the curriculum project I had designed. Nonetheless, I would argue that we co-taught many aspects of the project and I appreciate all of the support and enthusiasm that she provided. She was also an extra hand in the class, assisting students when they needed help, monitoring deadlines and reminding students when I'd be in the school for interviews, and she even acted as participant observer, using

the camera on occasion to document the students working on the art projects, when my own hands were tied up with another group of students.

The curriculum project took place five days a week during class time for approximately six months, between January and the end of school in mid June. Official class time was approximately two and a half hours a week, split between three class periods.[3] In spite of the block allocations, I tended to spend full days at the school often arriving early in the morning and staying late after school. Students worked in the art room during their spare periods, before and after school, and at lunch hour. It was one of a few social spaces in the school where students simply hung out. Infusing myself into the school environment, attending the student-run meetings, and assisting students in all grades on art-related matters, I believed I was embracing Bronwyn's belief that art is a living inquiry, that it did not start and end when I came and left the school. In addition, spending time with the students was important in my role as researcher. I wanted students to be open to take risks with me and for that they needed to know I was dedicated to their ideas and their work; I could not simply run in and out of the school in two and a half hours. On a practical level the research study, which included conversational interviews, took a considerable amount of time and I was grateful to the students and all of the teachers for allowing me to be at the school on a full-time basis.

Focusing on the body, I selected three themes to explore: *body surfaces*, *body encounters*, and *body sites*. Each theme included class discussions, small group activities to get students thinking about a conceptual problem or an issue, and the viewing of contemporary artists' works in addition to the making of art. For instance, the first theme, body surfaces, analyzed the concept of a surface and investigated works by Stelarc, Orlan, Jana Sterback, and Aganetha Dyck amongst many others. The second theme focused on globalization, communication, and consumption, while the third theme, looked at the body's relationship to space. The students were expected to create a minimum of one art piece (they could work in groups) for each of the first two themes, although many students created multiple works. The third theme, undertaken at the end of the school year while students were pre-occupied with studying for final exams, was completed as a class project where we erected our own temporary site-specific sculpture.

In addition to working with the students I brought my own art-making practices into the classroom. So often in art education classrooms the teacher's aesthetic inquiry is absent (Porter, 2004). In the art room at *Bower*, littered with an expanse of clutter and art supplies, I would often talk with the students while sewing rose petals or felting long tendrils of red wool.

Initially my intention was to do more artwork in the school but I found I was overwhelmed with the responsibilities of teaching and researching, so that my larger artistic explorations took place on the weekends in my studio. In place of red felt I could be seen throughout the school, video camera in hand (when it wasn't being used by the students) or alternatively a tape recorder followed me around as I worked with individuals or small groups of students on their art projects. At times it seemed as if the entire school body was in the art room, already crowded with computers, cameras, weaving looms, dyed fabric drying along one wall and a toy train that slowly took over a corner. The students moved in and out of the classroom, all of them eager to learn, to question, and to making meaning through art.

The Body of the Book: Chapter Descriptions

Respecting the tangled nature of a/r/tographical research, the chapters that compose *Body Knowledge and Curriculum* are interconnected. The organization of the book, while appearing in a linear fashion on the page, in fact attests to the felted and messy spaces of writing and imaging research that begins in the middle. Chapter one develops the theoretical frameworks of touch and inter-embodiment through an examination of interventions by contemporary visual artist Diane Borsato. Arguing for an ethics of embodiment, the chapter repositions power as collectivity, activity, and potential. The chapter entangles theories of touch with an analysis of the methodology of a/r/tography and proposes an understanding of excess, not as something to be expelled, but as force, desire, and relationality. Chapter two reconceptualizes body image from the perspective of the fantastical body contextualized through student artwork and conversations around the theme "comfort." I first outline theories that posit body image as a stabilizing momentum. Then, I explore an installation highlighting the ways that students configure body image as movement and change. From here, two sculptural pieces provide a means to examine skin as a threshold of experience and meaning that is unknowable and uncertain. In chapter three I examine short segments of student-created videos drawing on contemporary mapping theories that conceptualize space as enfleshed. My analysis discloses the ways that students engage with nomadic subjectivities re-constructing teaching and learning as variable, heterogeneous, and discontinuous. From the perspective of relational aesthetics, chapter four examines an email art project, a mail art piece, and a public intervention with attention to bodily encounters such as emotions and corporeal generosity. In

Chapter five I discuss the outcomes of the research study for the students at *Bower* and contextualize their living inquiries in relation to global knitting activist projects and artists.

Sleeping with Cake and Other Touchable Encounters: Feminist Theories of Touch and Inter-embodiment

Western thought has always privileged vision as the dominant sense, equating it with light, consciousness, and rationalization (Vasseleu, 1998). The other senses, marked by the body's effluence, were understood as interior sensibilities and thus of lesser value (Classen, 1993). In fact the non-visible senses such as touch, taste, and smell were characterized as emotive senses and therefore gendered female and/or culturally dark, vulgar, and deviant. For instance the differences between the following two turns of phrase signify the ways in which Western thought has constructed knowledge as separate from and in opposition to the body. "I see" has commonly meant I know or understand, while "I feel" is often associated with intuitive knowing, which has historically been condemned as ridiculous and dismissed as trivial.

While vision is premised on the separation of the subject and object, creating a rational autonomous subject, as a contact sense touch offers contiguous access to an object. Touch alters the ways in which we perceive objects, providing access to depth and surface, inside and outside. Touch as a way of knowing can be understood through two modalities. First, touch is the physical contact of skin on matter. The second modality is a sense of being in a proximinal relation with something. In visual culture this has often been addressed as synaesthesia. Synaesthesia refers to the blurring of boundaries between the senses so that in certain circumstances one might be able to say I can taste a painted image. A further understanding of proximity has been taken up by corporeal phenomenologists (e.g., Merleau-Ponty, 1968) and feminist scholars (e.g., Ahmed & Stacey, 2001; Grosz, 1994) who argue that knowledge is produced through bodied encounters, which can be

interchangeable with the terms: inter-embodiment or intercorporeality (Weiss, 1999).

Inter-embodiment, an approach explored by feminist scholar Gail Weiss (1999) emphasizes "that the experience of being embodied is never a private affair, but is always already mediated by our continual interactions with other human and non-human bodies" (p. 5). Inter-embodiment poses that the construction of the body and the production of body knowledge is not created within a single, autonomous subject (body), but rather that body knowledge and bodies are created in the intermingling and encounters between bodies. Elizabeth Ellsworth (2005) maintains that a relational learning experience "acknowledges that to be alive and to inhabit a body is to be continuously and radically in relation with the world, with others, and with what we make of them" (p. 4). How we come to know ourselves and the world around us, our subjectivity, is performed, constructed, and mediated in relation with other beings. It is this relationality that is crucial. Rather than knowledge formed through the rational autonomous I, knowledge is the body's immersion, its intertwining and interaction in the world and between others (Merleau-Ponty, 1968).

In an effort to make present this relational knowing, this chapter examines theories of touch and inter-embodiment by first turning to the work of contemporary visual artist Diane Borsato. Borsato's work explores everyday activities and materials through the body—of paying attention to the absurdities, ambivalence, and unthought encounters that exist between bodies. To begin I analyze the conceptual and theoretical underpinnings of touch and inter-embodiment through careful attention to relationality, space as difference, and the in-between. I then shape arguments for a bodied curriculum opening up the possibility of an ethical form of exchange between self and other, which allows us to understand subjectivities as becoming, non-unitary, and in constant motion. My exploration of an ethics of embodiment repositions power as collectivity, activity, and potential. Keeping in mind the red threads of entanglement I conclude the chapter by attending to the methodology of a/r/tography, which I argue constitutes an ethical approach to creative activity, research, and teaching and learning as being(s)-in-relation.

Touching 1000 People and Sleeping with Cake:
Theories of Touch and Inter-embodiment[4]

Imagine walking down the street of a large urban city. How do you encounter and face the stranger? How do you hold your body? How do you materialize and mark your space? For most of us, we are inclined to embark on the dance of avoidance—the refusal of contact, touch, or conscious encounter. We sidestep and we walk around—marking our territory an uncomplicated space. But imagine walking down a busy street and suddenly a hand reaches out to caress your shoulder. Or envision yourself reaching for a plump juicy red apple and finding your fingers slightly intertwined with those of another. Picture yourself accepting change at the checkout counter and being gently fondled by a thumb and forefinger; or sitting on a crowded public bus and feeling your shins being softly nuzzled by the sole of an athletic shoe. Having come across research that suggested that touching people in a seemingly unconscious manner could possibly affect their well-being, artist Diane Borsato subtly came in contact with 1000 perfect strangers. Whether it was simply grazing someone's hand or lightly caressing an arm, Borsato sought to change the well-being of the city, improving its mood (and her own) through touch (Borsato, 2001).

As an exercise in "diligently counting—463, 464, 465"—Borsato's performative piece became an exercise in "paying attention" (Borsato, 2001, p. 65). Moreover, her absurd task renders meaningful the non-visible sense—touch—as a way of knowing and encountering self and other.

Destabilizing pervasive binary categories that distinguish western philosophy, Maurice Merleau-Ponty's (1968) theories of perception and bodied experience are framed by an analysis of touch. Refuting the separation of mind and body Merleau-Ponty's theories of inter-subjectivity posit the body as the threshold of experience. This thinking was in direct contrast to normative views of the body.

According to Elizabeth Grosz (1994) the body has inherited from Cartesian thought three concepts: the body as nature, the body as a passive vessel, and the body as container for personal and private feelings. These views posit the interior and the external worlds as separate and distinct. The separation between the body (inside) and the world (outside) is characteristic of dualistic thought. Dualisms such as human or animal, culture or nature, mental or physical, analysis or intuition, rational or irrational, vision or touch and so on, implicate the mind or body split within them. The splitting objectifies, classifies and orders existence, privileging one term over the other. Dualisms also inscribe a separation between self and other. Individual

consciousness is viewed as private, self-contained, and invisible. An individual's identity formation is removed from contact with other minds (or bodies) and is perceived as "outside" of space and time.

Yet, Merleau-Ponty (1968) challenged dualistic thinking arguing that "to comprehend is not to constitute in intellectual immanence, that to comprehend is to apprehend by coexistence" (p. 188) and "the bodies of others are not objects; they are phenomena that are coextensive with one's own body" (1964, p. 118). Thus, a reconceptualization of body knowledge must consider the possibilities of interactions *between* bodies—knowledge as inter-embodiment. In doing so, the body shifts from being something that experience happens to (i.e., experience is external to the body) towards an understanding of experience *as* bodied; experience and knowledge as entangled and interconnected.

The concept of *Flesh* emerges as Merleau-Ponty's designation for an ontology grounded in the body. Flesh belongs to neither the material body nor the world exclusively. It is both subject and lived materiality in mutual relation. It cannot then be conceived of as mind or as material substance. Rather, Flesh is a fold "coiling over of the visible upon the visible" (Merleau-Ponty, 1968, p. 138). Flesh is a chiasmic space in-between the body and the world, where it folds back on itself in an intertwined and enmeshed relation. Flesh as Being gives rise to the perceiver (seer) and the perceived (seen) as interdependent aspects of subjectivity. Understanding self and other as a tangled chiasm, Merleau-Ponty insists perception must be understood as a reversal, a mode of being touched and touching. "Flesh is being as reversibility, being's capacity to fold in on itself, being's dual orientation inward and outward, being's openness, its reflexivity, the fundamental gap or dehiscence of being" (Grosz, 1999, p. 154). To illustrate this double sensation, Merleau-Ponty implements the metaphor of one hand touching and grasping the other hand, which in turn touches back. Cathryn Vasseleu (1998) annotates this concept: "A hand that touches is, in contact with the other, simultaneously an object touched. The two hands represent the body's capacity to occupy the position of both perceiving subject and object of perception" (p. 26). In this reaching out and crossing over, the hand touched (object) reverses or folds back on itself and becomes the touching subject, thus in the chiasm or the space of the fold, the body inserts itself between subject and object, interior and exterior. Perception is formed in proximity, reversible in and through the body. "Tactile perception involves perception of our own bodily state as we take in that which is outside of that state… The pressure involved in touch is a pressure on ourselves as well as

upon objects" (Stewart, 1999, p. 31). The act of touching inverts the subject-object relationship disrupting the boundaries between self and other.

However, as feminist scholars have noted, embodiment (from a Merleau-Pontian perspective) ignores the specificity of gender, sexuality, etc., universalizing the body on the basis of the standard male norm (Stawarska, 2006). Therefore, Merleau-Ponty's theories of inter-subjectivity, while important for including the body in knowledge production, erases the particularities of difference lived and encountered with, in, and through different bodies. To that extent, my interest in touch and relationality resides in the notion that we are always "with" others, not to consume or assimilate one another's experience and subjectivity, but that in the event of the "with," difference and thus, thought is produced. I find Merleau-Ponty's theories of embodiment useful in helping to develop arguments for inter-embodiment, but I infuse them with theories of relationality and in particular a feminist reading of Jean Luc Nancy's (2000) "being-with." To be a body is to be "with" other bodies, to touch, to encounter, and to be exposed. Bodied encounters in and through touch, produce intercorporeal understandings and in doing so imagine an intimate curriculum premised on difference.

For Borsato, the intimacy of "Touching 1000 People" altered the way she moved through the city. She writes,

> I started to feel much closer to familiar cashiers, and I think I felt compelled to smile more at strangers around me, and at service people in general. I found myself feeling responsible to "touch," in even a small emotional way, grumpy taxi drivers, indifferent waiters, and anyone else who seemed to need such touches….As I moved through the city throughout the month—counting, negotiating the streets with my palms as eyes—I even started noticing all the dogs that needed comforting as they waited anxiously outside of shops. (2001, p. 65)

As a result of touching, Borsato and the strangers she encountered began to unravel an unthought experience. Through the act of touching (both literally and in terms of proximinal relationships) the subject is able to make sense of something and simultaneously make sense of themselves. To make sense of something, to know it, to create it, is to come into contact with it, to touch it, and thereby produce a body (Perpich, 2005). In other words, in the moment of encounter—touch—self and other emerge, not as already pre-determined subjects/objects but as subjects in the making.

While Borsato, and the research she drew upon, suggested that physical touching would alter people's moods in a positive way, Borsato also observed that different individuals reacted differently to acts of being touched. She writes

I also began to recognize the differences in people's feelings of entitlements to space and how it related to what I perceived to be their age, cultural background, gender, and class. For example, it seemed much harder to touch teens than older adults, much harder to touch finely dressed women than men, much easier to touch very old people, etc. Site also mattered. For example, it was much easier to touch people in the supermarket than in a fancy department store or a museum. (p. 65)

Feminist scholar Sara Ahmed (2000) makes sense of these individualized reactions by suggesting that the concept of who is a stranger needs to be challenged. It is commonly believed that a stranger is "any-body" we do not know. Rather, Ahmed (2000) contends, a "stranger is *some-body* whom we have *already recognized* in the very moment in which they are 'seen' or 'faced' as a stranger…we recognize somebody *as a stranger*, rather than simply failing to recognize them" (p. 21). A stranger is some-body we recognize as "strange," or as Ahmed (2000) implies, "it is a figure that is painfully familiar in that very strange(r)ness" (p.21). Strangers are recognized as not belonging, as being out of place. In order to recognize some-body as strange(r) there needs to be closeness, proximity—a touching encounter. Likewise, in order to recognize some-body (or for that matter some-thing) as out of place there needs to be a demarcation and enforcement of boundaries and of space. It is the "coming too close"—the bodied encounters which produce a body (the stranger) in the moment of exchange and thereby brings into being knowledge of self and other, and the other's otherness. The subject, writes Ahmed (2000), "is not, then, simply differentiated from (its) other, but comes into being by learning how to differentiate between others" (p. 24). Put another way, the Westernized autonomous individual is no longer the central axis upon which all else is judged, rather selves and others simultaneously become differentiated. Thus, bodied encounters *as* difference dislocate fixed boundaries and involve *spatial* negotiations between bodies.

Spac(e)ing: Bodied Encounters as Difference

Like vision and touch, our dominant understanding of space is Cartesian. Space is an empty place marker into which things are placed and encountered. For instance, most individuals would think of the body (which is an object) as being in space (a void), rather than constituting space itself. Post-Cartesian views about the ontological status of space include substantivalism and relationalism. Substantivalism claims that the world consists of material objects and a further entity called space. Space is no longer empty but a separate object in and of itself. Thus, space can be observed as a discrete unit in the same way that one might be able to observe

objects. Relationalism denies this objective existence of space and argues that objects are related to each other by spatial relations. Accordingly, space does not exist as such, but rather in terms of spatial relations and patterns (James, 2006). Nancy's "being-with" emerges both as an affirmation of relationalism but also as a radical critique in terms of the relation between the experience of space and of embodiment. In a similar way, Gilles Deleuze's thinking on space exists as a passage, a network of movements (to), and force. While Nancy develops the concept of the body (or what he calls *sense*) as an element of spacing, Deleuze theorizes the interval or the in-between. Both, for the sake of my arguments, assist in thinking of bodied encounters *as* difference, a position that enables us to examine a re-conceptualization of curriculum and pedagogy as bodied. In what follows I develop a relational understanding of space in order to establish a conceptual framework for thinking of inter-embodiment outside of universalizing structures.

In binary thought we think of opposing terms; for instance mind and body, self and other, or light and dark. Likewise, as Irigaray (1993) claims, the use of one term as the neutral or universal term to define both is the basis of western language and culture. For instance there is not simply the term "mind" and another independent term "body," but rather there is only one term, "the other being defined as what it is not, its other or opposite (Grosz, 2001, p. 94). Irigaray's claim is that the one term, and in this example—the body—is erased and that the body emerges only as supplement or complement to the privileged other term—the mind. The supplementary term is the one that must be overcome, transcended, or refused. Similarly, the Other does not exist separate from or independent of the self, but is always defined in relation to the sovereign subject.

However, when we speak of the in-between, in a Deleuzian sense, it is not a physical place bounded by fixed entities (i.e., mind and body) rather, it is a space of movement, of development, and of becoming. The in-between, according to Grosz (2001), "is that which is not a space, a space without boundaries of its own" (p. 91). The in-between does not negate either term (i.e., mind and body) but resists the privileging of one to the other. In our example of mind and body then, the body comes into being not as a supplement to, or reliant on the mind, but under its own terms, its own force, movement, and assemblage. The in-between, claims Grosz (2001), "is what fosters and enables the other's transition from being the other of the one to its own becoming, to reconstituting another relation, in different terms" (p. 94).

The in-between pervades the writings of many contemporary philosophers under various terms including: différence, repetition, iteration, liminality, the interval etc. The in-between is a "space in which things are undone, the space to the side and around, which is the space of subversion and fraying, the edges of any identity's limits. In short, it is the space of the bounding and undoing of the identities which constitute it" (Grosz, 2001, p. 93). It is a space of juxtaposition and realignment that opens bodies and thought to new arrangements and possibilities. Valerie Triggs (2007) believes that the in-between "tears at the edges of us so that there's an unravelling that provides openings for relation instead of smooth surfaces that deflect one from the other" (np).

This may be why the middle, according to Deleuze, is the best point from which to begin, where thought unravels itself.

> The middle is by no means an average; on the contrary, it is where things pick up speed. Between things does not designate a localizable relation going from one thing to the other and back again, but a perpendicular direction, a transversal movement that sweeps one and the other away, a stream without beginning or end that undermines its banks and picks up speed in the middle. (Deleuze & Guattari, 1987, p. 25).

Contrary to dichotomous relations, in the middle something passes between two terms such that they are both modified putting them to strange new uses. To be in-between is to become; and "becoming is bodily thought" (Grosz, 2001, p. 70). The in-between is where "thought, force, or change, invests and invents new series, metamorphosizing new bodies from the old through their encounter" (Grosz, 2001, p. 70). The in-between becomes an unhinging of expectation and sequence, not to replace them with their opposites but with reordering of something new altogether. Thus, the in-between is entirely spatial and temporal. Grosz (2001) suggests that space be reconfigured as indeterminate, un/folding, serial, multiplying, complex, heterogeneous, and as an opening up to other spaces. This, she argues requires a thinking of the materiality of space—shifting our understanding of it in terms of proximity and entwinement.

While Deleuzian theories position space as the in-between, Nancy's use of the term "being-with" seeks to think of embodiment in terms of the concepts of touch and spacing. The term space, for Nancy, should be understood as being constituted in meaning. Being (for instance the self) does not exist prior to knowledge and meaning, but being comes into existence through the act of creating meaning and knowledge. Nancy's reconceptualization of space leads him to formulate a materialist, or a bodily ontology (James, 2006). In this sense, space cannot be thought of as a

separate entity rather, the experience of space un/folds as a spatial-temporal event between bodies, which is understood as open and ecstatic. Bodies/things, Nancy argues, exist through a spacing—a spacing of space. In doing so, Nancy contends that space be thought of as "an opening or exteriority which never closes or folds onto itself" (James, 2006, p. 104). This spacing or the in-between is intangible and ungraspable in the sense that it is not an "object" or something that we can "see" with our eyes and thus point to and say "hey, I found the in-between sitting over here." Spacing exists in the relationships between bodies/things.

Spacing is crucial to thinking about embodiment in terms of touching. For instance, we often think of touch as a physical contact of skin on matter, but spacing allows us to conceive of touch as intangible, as something in a proximinal relationship with something else. Spacing does not imply a measure of distance (i.e., 1 meter or 500 miles) rather spacing constitutes the very place where things happen between bodies/things. Thus, touching as a way of knowing implies that I can know the other without fixing her or reducing her to an object.

> It captures the tension between the need to intangibly touch the other, while maintaining a respectful distance from her. The intangible touch is not one that does violence to the other by violating her corporeal boundaries; rather, it is a reciprocal touch that gives me access to the other's limit, the borders of her body. To touch the other is to interrupt a logic that attempts to know the other by subsuming her into categories of the same, a logic that attempts to fix the other, confer an identity on her, an identity that renders her body either meaningful or worthless. To touch the other, in both a tangible and intangible sense, is to gain access to her specificity, to be exposed to it, to be affected by it and to respond to it, but not to subsume it or annihilate it. (Sorial, 2004, pp. 220–221)

And yet, feminist theories of touch also caution the privileging of certain forms of touch over other more violent forms of bodily encounters. So while Sorial contends that the intangible touch is not violent, we can't assume that *any* kind of touch, tangible or otherwise is devoid of violent possibilities. My intention is not to ignore the possibilities of violence as a result of a touching encounter, or feminist scholarship that attends to issues of bodily harm. Through touch I address the potential for forms of bodily encounters that do not continue to reify binaries and otherness.

Emmanuel Levinas (1969), whose work has influenced feminist theories of touch, describes bodily encounters through bodily processes such as a caress or breathing. These forms of touching, Levinas argues, do not grasp the other or turn the other into an object, but are ways of encountering the other as a form of "opening up" (p. 181). Such forms of touch open the self

to the other through proximity and as indeterminate events. "Breathing does not establish territory or fix the relation between self and other, and yet breathing is that which allows one and the other to live in a co-inhabitance that is not premised on the commonality of a bond, but on the intangibility of air" (Ahmed, 2000, p. 140). However, Ahmed contends that by preferring some bodily processes over others "some processes are more able to protect or preserve the otherness of the other" (p. 140), thereby defining those who belongs *as the other*. Instead she proposes an ethical mode of encountering others that fails to be contained in the body, that "fails to grasp" the others' otherness. What Ahmed means by this failure is that we need to rethink the terms of particularity. Rather than particularity as a description of an other, particularity becomes a "mode of encounter."

> Particularity does not belong to an-other, but names the meetings and encounters that produce or flesh out others, and hence differentiates others from other others. In this sense, introducing particularity at the level of encounters (the sociality of the "with") helps us to move beyond the dialectic of self-other and towards a recognition of the differentiation between others, and their different function in constituting identity, and the permeability of bodily space. (Ahmed, 2000, p. 144).

In this way, touching encounters create a space where difference emerges not as "something different from" but as difference itself. Moreover, regardless of what kind of touching encounter occurs (a caress, a look, or sexual violence), bodied encounters produce bodies, and as such "inter-corporeality is subject to forms of social differentiation, although such differences cannot simply be found on the bodies of those who are marked" (Ahmed & Stacey, 2001, p. 6). Examining inter-embodiment poses the question of how we are "with" others differently. This understanding of difference, I argue, is enacted in Borsato's visceral experiment titled "Sleeping with Cake."

In this private performance she filled up her bed with "about 10 cakes—a few chocolate cakes, cherry cakes, vanilla cakes, lemon cakes and a flan—and slept surrounded by them for an entire night" (Borsato, 2001, p. 63). Seeking comfort from presence and touch it was not the taste of each different cake that made itself present, but the materiality of the cake—how it felt next to her in bed.

> Even while I was sleeping I was tremendously aware of the cakes all around me. I was shocked to appreciate how dense a cake really is (especially my homemade cakes, it seems). All these points of pressure on the bed around me made it feel like I was sleeping with 10 cats. I could smell the intense sugar of them all night long, and being surrounded by such lusciousness was even somewhat erotic, something I

had predicted I wouldn't experience on account of the sticky crumbs and frosting. (2001, p. 63).

It wasn't that Borsato came to know the objects in her bed as "chocolate cake" or "strawberry frosting" but as events that presented themselves in-between, or in the spacing between her body and the bodies of the sweet cakes. For Borsato, what became known was the intimacy of the encounter, and with/in this intimacy she was propelled to recognize the relationality between bodies/things. This relationality is where knowledge is created, mediated, and ruptured, presenting itself for future relational events. In-between or through spac(e)ing a bodied curriculum emerges (Springgay & Freedman, 2007).

A Bodied Curriculum

The body has always been of importance to the theories and practices of curriculum. Understanding curriculum as *bodied* offers an exploration of the production of subjectivities not premised on self/other dichotomies. Bringing the viewer into the work through bodied processes that are basic to all our lives, Borsato's art performs a bodied curriculum. Enacted on busy urban streets, in the privacy of her own bedroom, or in the homes and restaurants inhabited by others, Borsato engages with others in unusual and purposeful ways. However the work is received and interpreted, Borsato's performative gestures shift the "the terms of embodiment and its representation away from the primacy of vision as a model for comprehending the body to other sensual registers—volume, tactility, taste, and smell—productively mining different ways to speak the corporeal (Smith, 2002, p. 156).

Assigning herself the task to cook alongside each of her aunts, Borsato's performance "Cooking with Zias" shifts the attention from "learning to cook," a prescriptive curriculum based on recipes, organized procedures, and particular ingredients, towards a bodied curriculum situated in the everyday, where bodied encounters become the performance. Although a passion for food brought the women together, it was the relationality of bonding, of conversation, and of the incompleteness of the event that constitutes it as a bodied curriculum. Borsato explains this: "I spent seven different afternoons talking about food, culture, the generation gap, women's roles, sex, love, art, and family gossip" (Borsato, 2001, p. 62). Sometimes, Borsato notes, the encounters with her aunts, many of whom she had never spent time with before, were awkward, and filled with the weighty presence of uncertainty and partiality.

This calls to mind the work of Maxine Greene (1973) who encourages educators to conceptualize curriculum through a "stranger's vantage point on everyday reality" (p. 267), to search for the unknown and the unfamiliar not to reveal or expose such details but rather to see what "other possibilities" being in unfamiliar spaces evoke. Maxine Greene, Madeleine Grumet, and Janet Miller are among the many curriculum scholars who work to understand how encounters with the arts could open curriculum spaces. While my efforts to reconceptualize a bodied curriculum are indebted to their work, and to those scholars who have theorized curriculum as an "aesthetic text," my aim is not to (only) think about how works of art destabilize our assumptions, providing us with transformative, creative, and unfamiliar possibilities of teaching and learning, rather, my interest lies in examining the encounters that exist between bodies and thereby produces particular body-subjects. Thus, it isn't so much that Borsato's work is an unusual form of art, or that witnessing her work, which we might add is almost an impossibility because of their intimate and private nature, might provoke unfamiliar or taken-for-granted responses, rather the moment of unfamiliarity that is generated through her work, is the impossibility of ever completely knowing self and other.

Discussing the role of autobiography in curriculum work, Janet Miller (2005) calls attention to the ways that language shapes and reshapes one's "self" and to the ways that language is constituted in power. She notes that many teacher education programs invite teachers to construct autobiographical tracings of themselves as teachers. But these stories, she argues, are insufficient evidence of teaching because they are crafted in such a way as to appear seamless or "spun of whole cloth" (p. 51).

Such "teacher stories" often offer unproblematized recountings of what is taken to be the transparent, linear, and authoritative "reality" of those teachers' "experiences." And their "teacher identities" in these stories often are crafted as unitary, fully conscious, universal, complete and non-contradictory. (p. 51)

Miller observes, these stories reify the autonomous "I" of Cartesian dualism, separate from not only the teachers' material body, but the body-subjects of others embedded within such stories, or the bodied encounters—the relationality—such tellings produce. A bodied curriculum approaches the notion of "experience" as socially and discursively produced and recognizes that interpretation and representation are always incomplete. In this way, it is not the performative gestures of cooking and sharing interpersonal stories with her aunts that exists as meaningful, rather it is the realtionality—the touching encounters—that "takes us somewhere we couldn't otherwise get

to" (Miller, 2005, p. 54) that generates the site of meaning making and thus, curriculum in action. Cris Mayo (2007), in discussing the place of "coming out" stories in the transformative classroom, insists that we need "to get ourselves out of the business of telling stories and move more strongly into a pedagogy of accusation" (p. 171). Accusation is a relational strategy that demands a response, showing that "relations of difference are already there, even if they are not recognized" (p. 173). Extending such arguments that educators ought to recognize that the telling of stories should be understood as "site(s) of permanent openness and resignifiability" (p. 54), I insist that such tellings exist as intercorporeal encounters, where self and other emerge "with" one another, where the "with" constitutes inter-embodiment as difference.

In another of Borsato's touching experiments, she assembled sentimental objects such as her steel-toed boots and a worn copy of her favourite book *A Natural History of the Senses* and boiled each of them for many hours to see if she could distill their sentimental essence. However, after hours of boiling the objects, much like one would make broth, Borsato discovered that she was unable to "boil out sentiment like a flavour for a soup" (Borsato, 2001, p. 63). Each object's meaning was not something that could be abstracted or removed; rather, its meaning was lived and embodied within its materiality. Meaning "was in the presence of the objects themselves, in their existence as whole, unique, touchable, heavy things" (Borsato, 2001, p. 63). Boiling and making broth of her objects Borsato was unable to know her objects more— she may have discovered their particular odors or how long each object took to distill, but she was unable to know the other fully or completely. However, while Borsato was unable to extract the sentiment from each object, her performative gestures propelled her to experience a mode of being together with her objects that exceeded the boundaries of the experiment. By staging these bodied encounters, unthought of possibilities will break through the conventions of daily interactions and involve self and other in transformative experiences. This interaction, suggests Zygmunt Bauman (1993), is a mode of relationality not governed by rules and expectations but an encounter that demands an attentiveness to alterity, to the uniqueness of the Other. Building on Bauman's work, educational philosopher Sharon Todd (2003) writes that such encounters are "a togetherness born out of the immediacy of interaction, a communicative gesture that does not have as its end anything except its own communicativeness, its own response" (p. 48). As such, Borsato's intimate and touching gestures "offer insight into how the surprising and unpredictable forms of relationality that arise in the immediacy of an encounter with difference carry profound relevance for ethical interaction"

(Todd, 2003, p. 4). Left with smelly broth, much like the sticky remainders of "Sleeping with Cake," we are confronted an "ethics of embodiment" (Springgay, 2008; La Jevic & Springgay, in press; Watt, 2007). An ethics of embodiment, I contend shifts how "we as teachers, students, and teacher-educators perceive our "selves" and others' "selves" so that we do not simply incorporate or appropriate "others" and their stories into the ones we already and always have been telling about ourselves or "them" (Miller, 2005, p. 229). "Being-with" compels us to examine and take responsibility for the meanings we make, "understanding all the while that the meanings and categories by which we typically comprehend and live our daily existence can be altered" (Miller, 2005, p. 229). Inter-embodiment as difference underscores the importance of learning to live "with" others, touching not to consume or inhale, but opening up to particularities and possibilities of what each may become.

An Ethics of Embodiment as "being-with"

In understanding the term "ethics" I draw on feminist cultural theorist Sara Ahmed (2000) who argues that ethics is distinct from morality, where morality is a set of codes and behaviors. "Ethics," she offers, "is instead a question of how one encounters others *as* other (than being) and, in this specific sense, how one can live with what cannot be measured by the regulative force of morality" (2000, p. 138). Similarly, Rosi Braidotti (2006) suggests that ethics from a feminist poststructuralist standpoint "is not confined to the realm of rights, distributive justice, or the law, but it rather bears close links with the notion of political agency and the management of power and of power-relations" (p. 12). In feminist poststructuralist ethics, responsibility is understood through issues of alterity, otherness, and difference as opposed to intentionality, action, behaviour, or the logic of rights. When education takes up the project of ethics as morality, it is interested in particular principles that govern bodies such as regulations, laws or guidelines (Todd, 2003). In this instance ethics as a moral curriculum is designed to assist students in learning how to live and act through concrete practices, duties, and systems of oppression. Ethics becomes a particular acquisition of knowledge that is rationalist in its features.

In contrast, Sharon Todd (2003) suggests that ethics understood through interaction, and where knowledge is not seen as absolute, gives importance to the complexities of the ethical and bodied encounter. This, Todd and Ahmed both claim, insists on transitioning from understanding ethics as

epistemological (what do I need to know about the other) and rather problematizes ethics through a relational understanding of being. Ethics "is therefore the discourse about forces, desires and values that act as empowering modes of being" (Braidotti, 2006, p. 14). A feminist poststructuralist approach to ethics asks questions about power—that is, about domination and subordination—instead of questions about good and evil. Such an approach to ethics is centered on action aimed at subverting rather than reinforcing hegemonic relationships (Jagger, 1994). An ethics of embodiment is focused on the non-unitary subject and intersecting webs of accountability, which Braidotti (2006) calls an ethics of sustainability:

> A sustainable ethics for a non-unitary subject proposes an enlarged sense of interconnection between self and others, including the non-human or "earth" others, but removing the obstacle of self-centred individualism. This is not the same as absolute loss of values, it rather implies a new way of combining self-interests with the well-being of an enlarged sense of community, which includes one's territorial or environmental interconnections. (p. 35)

This is an ethics of relationality composed of nomadic becomings and belongings.

Butler (2006) in her revisitation of Irigaray's work contends that the ethical relation is premised on the "*never yet known*, the open future, the one that cannot be assimilated to a knowledge that is always and already presupposed" (p. 115). Ethics does not claim to know in advance, "but seeks to know who that addressee is for the first time in the articulation of the question itself" (p. 115). This argument, Butler (2006) suggests, poses a more difficult question: "How to treat the Other well when the Other is never fully other, when one's own separateness is a function of one's dependency on the Other, when the difference between the Other and myself is, from the start equivocal" (p. 116). It is the *never yet known* that Todd (2003) argues is at the heart of educational relationships, stating that "our commitment to our students involves our capacity to be altered, to become someone different than we were before; and, likewise, our students' commitment to social causes through their interactions with actual people equally consists in their capacity to be receptive to the Other to the point of transformation" (p. 89).

Thus, ethics shifts from "getting to know the other" to an understanding grounded in bodied encounters—being-with—that are themselves ethical in nature. This, Todd (2003) contends, moves education from being "focused on acquiring knowledge about ethics, or about the Other, but would instead have to consider its practices themselves as relation to otherness and thus as always already potentially ethical—that is, participating in a network of relations that lend themselves to moments of nonviolence" (p. 9). The

intimacy of touching places us in relation to openness and risk, and to what we cannot know beforehand, enabling us "to be vulnerable to the consequences and effects that our response has on the Other" (p. 88).

Embracing the unknown, an ethics of embodiment transforms art, research, and teaching and requires us to consider "tangles of implication." Bodies imbricated in ethical and intimate touching encounters challenge us to examine "our desires for and enactments of, as well as our fears and revulsions toward, those identities and practices that exceed the 'norm'" (Miller, 2005, p. 223). An ethics of embodiment points to possibilities for agency and transformation by examining the ways

> in which students and teachers might negotiate the official discursive terrains of schooling that bound the "design and development" of curriculum as well as "identities." By investigating our "tangles of implication" in what we might come to see as contradictory and conflicting discursive constructions, we also might glimpse spaces through which to maneuver, spaces through which to resist, spaces for change. (p. 223)

These "tangles of implication" are what Borsato engages with through her performance works. Touching strangers, sleeping with cake, cooking with her aunts, and even licking and distilling objects, Borsato's intimate explorations through touch invite "one another to risk living at the edge of our skin, where we find the greatest hope of revisioning ourselves" (Boler, 1999, p. 200). An ethics of embodiment is concerned with the processes of encounters, the meaning that is made with, in, and through the body not discernable facts about a body.

Feminist philosopher Moira Gatens (1996) argues that:

> Reason, politics and ethics are always embodied; that is, the ethics or the reason which any particular collective body produces will bear the marks of that body's genesis, its (adequate or inadequate) understanding of itself, and will express the power or capacity of that body's endeavour to sustain its own integrity. (p. 100)

In other words, ethics is not dictated by a rational and universal mind but rather embraces notions of bodied particularity.

In turn, any understanding of ethics always assumes a complex body. Therefore an ethics of embodiment is complex and dynamic; open to challenge and revision. An ethics of embodiment "opens the possibility of engagement with others as genuine others, rather than as inferior, or otherwise subordinated, versions of the same" (Gatens, 1996, p. 105). Ethics, argues Gatens (1996), is not just different forms of knowing but different forms of being, and it is this complicated and responsive understanding of lived experience that is at the heart of a/r/tographical research.

A/r/tography

A/r/tography[5] is a research methodology of entanglement and becoming. Rhizomatic in nature (see Irwin, Beer, Springgay, Grauer, Gu & Bickel, 2006) a/r/tography penetrates meaning, opening it to what Jacques Derrida (1978) calls the "as yet unnamable which begins to proclaim itself" (p. 293). It is an interstitial space, hesitant and vulnerable, where meanings and understandings are interrogated and ruptured.

A/r/tography invites educators to contiguously bring together the various elements that constitute our creative and educative selves. For example, rather than thinking of teaching, learning, art making, and researching as disparate and fragmented entities, a/r/tography is engaged in the process of actively un/folding such multiplicities together. As such, a/r/tography attends to the spaces between artist, researcher, and teacher allowing for these dynamic practices and subjectivities to interface and collide with one another so that meanings, understandings, and theories generated become multiple, entangled, and complicated.

Although in name, a/r/tography isolates artist, researcher, teacher, in theory and practice these subjectivities collide releasing something from each. Likewise, a/r/tography sees the slash as the place of negotiation; a place to move and a position from which to create a rupture. In a/r/tography, binaries are not abandoned, but played off of each other, rendered molecular, so that their realignments in different systems are established.

While many forms of arts-based educational research focus on the creation of artistic products as representations of research, a/r/tographical inquiry is constituted through visual and textual understandings and experiences rather than visual and textual representations (Irwin, 2004). A/r/tographical research may culminate in an artistic form (e.g., art installation, poem, or dramatic monologue), however it doesn't need to. While many arts-based methodologies focus on the end result, a/r/tography is concerned with inquiry—the mode of searching, questing, and probing— insisting that these elements be informed by and through the arts. A/r/tography interfaces art and scholarly writing not as descriptions of each other, but as an exposure of meaning, pointing towards possibilities that are yet unnamed. Neither is subordinate to the other; rather they operate simultaneously, as inter-textual elements and often in tension with each other. In a/r/tography the representation of research cannot be seen as the translation of experience. Instead a/r/tographical research as living inquiry constructs the very materiality it attempts to represent. In other words,

engaging in a/r/tographical research constructs the very "thing" one is attempting to make sense of.

The features of a/r/tography include six renderings through which research can be imag(e)ined, enacted, and understood: *living inquiry, contiguity, openings, metaphor/metonymy, reverberations,* and *excess.* Renderings enable artists, researchers, and teachers to interrogate the interstitial spaces between things, and to convey meaning rather than facts. To be engaged in a/r/tographical research means being open to a continual process of questioning. The intent of the term rendering is not to offer a criterion-based model, nor to suggest that these six are descriptions of a/r/tography. Each rendering is formed in relation with each other through aesthetic inquiry. Elsewhere the renderings have been described in detail (see Springgay, Irwin & Kind, 2005; Irwin & Springgay, 2008). For my purposes here, I have entangled these renderings, demonstrating their relationality while further conceptualizing the performance of red threads.

Contiguity and Living Inquiry

Contiguity is a rendering that helps us understand those ideas within a/r/tography that lie adjacent to one another, touch one another, or exist in the presence of one another (Irwin & Springgay, 2008). Contiguity is found within artist, researcher, and teacher subjectivities which exist simultaneously and alongside one another. In addition, contiguity attends to the relationship between art and graphy, or the creative activity of living inquiry coupled with the act of scholarly writing. Contiguity is rhizomatic in nature and thus, shares an understanding of being-with as difference.

Living inquiry enables a fecund and evolving sense of art, research, and teaching. Like Borsato's touching experiments, living inquiry is embodied in experience where our self-perceptions and world-perceptions are sensuously and creatively intertwined with how we examine educational phenomena. Moreover, living inquiry transforms the idea of theory as an abstract system distinct and separate from practice, towards an understanding of theory as a critical exchange that is reflective, responsive and relational. Theory *as* practice becomes an embodied, living space of inquiry. Theory is not pre-determined nor a stable interpretive scaffold, but part of a relational encounter, itself capable of creative change and development (Meskimmon, 2003). Thus, meaning finds its place in the in-between where language hesitates and falters, where uncertainty cannot be represented, and where knowledge remains unspoken.

It is precisely this in-between of thinking and materiality that invites researchers to explore the interstitial spaces of art making, researching, and teaching. According to Elizabeth Grosz (2001) the in-between is not merely a physical location or object but a process, a movement and displacement of meaning. It is a process of invention rather than interpretation, where concepts are marked by social engagements and encounters. Concepts, argue Deleuze and Guattari (1994), "are centres of vibrations, each in itself and every one in relation to all the others. This is why they all resonate rather than cohere or correspond with each other" (p. 23). Meaning and understanding are no longer revealed or thought to emanate from a point of origin; rather they are complex, singular, and relational. As such, a/r/tographical texts are not places of representations where thought is stored "but [are] a process of scattering thought; scrambling terms, concepts, and practice; forging linkages; becoming a form of action" (Grosz, 2001, p. 58). As living inquiry, a/r/tography expresses meaning as an exposure—*a never yet known*.

A/r/tography materializes the in-between and thus effectively invites researchers and teachers to move beyond static dualisms which pit theory against practice, self against other, and mind against body towards a living, breathing, becoming—inquiry. Rooted in corporeal theory (Meskimmon, 2003) where the body's immersion and intertwining in the world creates meaning, a/r/tography is a way of living in the world as being-with, of touching the other, not to know or consume the other, but as an encounter that mediates, constructs, and transforms subjectivity.

A/r/tography is an attitude of endless questioning; a "thinking [that] involves a wrenching of concepts away from their usual configurations, outside the systems in which they have a home, and outside the structures of recognition that constrain thought to the already known" (Grosz, 2001, p. 61). Such a thinking is situated in the in-between.

However, one must be careful of over romanticizing the power of the in-between. As Sara Ahmed (2000) argues, there may be ways in which relations of power are paradoxically secured through the very process of destabilization. Examples from popular visual culture include the iPod advertisements and Pepsi commercials (Durham & Baez, 2007) where fragmentation, fluidity and marketing through the exploitation and exoticization of difference are central elements. Therefore rather than assuming the in-between as inherently subversive, there is a need to pay attention to the different ways in which specific forms of liminality are positioned and to the possibility of their different effects (Gonick, 2003). What I mean by this is that it is not sufficient to make claims that

understanding the body as unstable, fluid, productive and in-between enables its resistance; rather we need to examine the in-between as a space where bodied encounters and the relationality between beings produces different knowledges and produces knowledge differently.

Issues of race, class, gender, sexual orientation, and multiculturalism (bodied identities) are now being discussed as essential to postmodern education and in many cases have advocated particular understandings of liminality, uncertainty, and the in-between. I believe that such pronouncements are necessary and important but what a/r/tography adds to this already redolent space are pedagogical practices, art making processes, and a research methodology that is located at the in-between, where the *never yet known* is interrogated and ruptured.

As educational researchers many of the questions we grapple with take into account how we conduct research with others; how do we negotiate diverse voices; and how do we re-present their stories? A/r/tography maintains that the representation of research (which we all do by imaging and writing about research) does not reproduce violence towards the other, but rather looks to a network of relations that are continuously being produced in and through the inquiry itself. A/r/tography refuses to locate ethics within a rational, autonomous body/subject but rather in the "very forms of relationality that structure our encounters with other people, ones that are frequently infused with powerful feelings and emotions" (Todd, 2003, p. 141). As educators and educational theorists we need to recognize that the very things we seek to understand are produced in the moment of inquiry and hence slip from our ever knowing them fully. From an ethical point of view, a living inquiry that is contiguous cannot be a matter of policy or procedure, rather it demands a relational intercorporeal understanding of self and other.

As my time in the school un/folded I continuously revisited the recorded interviews, the hours of video documentation from class discussions and work sessions, and meticulously poured over the student's written words and their artworks. I returned to the school with my analysis, hesitant and stuttering, laying it bare for the students to rework over and over again. There was a transparency to these methods, the students and teacher performing, writing, and reading alongside me. The following year while lost in seclusion formally writing the research, I would return to the school from time-to-time to have the students read passages or to engage in further discussions with them. They were all present at my doctoral defense and each student was provided a copy of the dissertation on a DVD, which included the videos and images of their works. I'm not saying that any of

these actions on their own constitute ethical research, rather what I hope to show is that my journey as an a/r/tographer had no previously trod path to follow. As I worked with the students and their teacher I was constantly in the midst of knowing and not knowing, and I recognized that the research would always be unstable, ambiguous, and contingent.

Openings, Metaphor and Metonymy, and Reverberations

A/r/tography is a mode of thinking about or theorizing multiplicities. It is not about framing rules or understanding principles, but about the possibilities of intercorporeal encounters. Instead of requiring logical certainty and the guarantee of universal validity a/r/tography is embedded in imagination, experimentation, uniqueness, and conjecture—openings that seek to provoke and generate meaning often using metaphors and metonymic relationships. For instance, a/r/tographers envision openings as cuts, tears, or cracks that resist predictability, comfort, and safety (see Springgay, Irwin, & Kind, 2005). Openings allow contradictions and resistances embodied in living inquiry to exist in contiguity.

Reverberations refer to the dynamic movement of meaning making that shifts and slips in uncertainty. Della Pollock (1998) talks about nervous performative writing, suggesting it "anxiously crosses various stories, theories, texts, intertexts, and spheres of practice, unable to settle into a clear, linear course, neither willing nor able to stop moving, restless, transient and transitive" (pp. 99–91). Through creative links and zigzagging inter-connections, reverberations create meaning as an in-between space indicating variations, discontinuity, and complexities.

Excess

A/r/tography allows for meaning to reside in excess. This excess is not simply surplus to be disregarded, nor is it an unlimited meaning making process. Rather, excess is meaning as evocation, as provocation, calling us to the unnamed; to something else altogether. Excess is that which is created when control and regulation disappear and we grapple with what lies outside the acceptable (Bataille, 1985). Excess may deal with the monstrous, the wasteful, the leftover, and the unseen, as well as the magnificent and the sublime. It is also the "as yet unnameable" and "the never yet known"—those aspects of our lives and experiences that are potentials and filled with possibility. Janet Miller (2005) writing with Mimi Orner and Elizabeth Ellsworth observes that traditionally research, writing, and pedagogy are practices that contain and regulate excess. However, as Peggy Phelan (1993)

points out, representation "always conveys more than it intends" (p. 2). This excess creates a supplement "that makes multiple and resistant readings possible, and prevents the reproduction of the same meaning or sense from one reading of a text or event to the next" (Miller, 2005, p. 128). Excess becomes that which exceeds the norms, that which is unexpected, creating "ruptures and gaps, making a full, complete, or adequate understanding of the world impossible" (p. 128).

Nancy (2000) contends that excess is not a numerical equivalent (10, 400 or 2 million) but discourse in its totality. Excess is not a degree of magnitude. It is being-with; an unheard of measure. In other words, being-with is not qualifying something against something else—the setting of criteria or an established norm. Rather the conditions for being-with are contingent upon and exist within the structure itself—an absolute measure. In this sense an a/r/tographical act is its own possible measure. Instead of thinking of our actions, encounters, and thoughts—our living inquiry as substance that can be arranged in discrete moments, counted, and subjected to normative evaluations, we need to understand living inquiry in education as *never yet known*. What I am suggesting is a complex understanding of the ways we participate in attending to difference within institutional contexts, and also to the ways that education and research as practices already contribute to the conditions that create difference. Therefore, inter-embodiment—played out in art making, researching, and teaching—is committed to ambiguity, uncertainty and to the never yet known.

My initial research questions, now simply notes in the margins of my visual journal have long since been abandoned. Immersed in bodily discourses that controlled and coded the body in schooling, I set out on my research journey looking for an absent or repressed body in teaching and learning. But the students voices and images slipped through a gap in my understanding and offered to me a body in excess, a body that is fleshy and fully present in and of the world. The students' art, my own aesthetic inquiry, and the theories that I was engaging with led me to new investigations and to consider the body as excess. But I struggled with a means to articulate this through words.

One day when the struggle seemed especially painful I took a walk along the streets of Belltown, Seattle, where I was in retreat, writing my dissertation. On the walk I passed by a small commercial gallery. Through the window I could see a series of vessel-like sculptural forms hanging from the ceiling. Their woven surfaces that enclosed small cast-glass objects—shells, a bird's beak, a tiny hand—conjured up notions of memory, loss, and the absent body as vessel and container. Viewed in this way the sculptures

were only partially interesting, as I felt this trope had long been examined in feminist art practices.

On entering the gallery space, however, I discovered something unnamed; a becoming something else through shadows. Hanging close to a white wall with projected light from the gallery floor the vessel-like forms become more than themselves through the addition of shadows. The shadows were not separate from the sculptural forms nor did they simply mimic the woven vessels. Their exaggerated limbs penetrated, tangled, and intersected the lines of the sculptures. Depending on where I stood the shadows changed form and intensity, at times even touched my body; passing through and moving between. Instead of a body absent, the installation was a body in excess. This excess was not a gigantic or monumental body, more suggestive of scale, the grotesque and other power relations. Instead it was an abundant body that was provocatively ephemeral, in transition, and hesitant.

I'd been struggling for months to articulate this never yet known; to find a way to conceptualize, to describe in words what I saw and experienced in the school with the students—a fully present body, a body in excess, as opposed to an absent or abject body. Shadows embody the fullest potential of the present moment while allowing alternative assemblages to become, to un/fold, and to mutate. What might we discover if we begin to envision and embody art, research, and teaching through shadows? Of course this would mean looking at shadows not as separate from, or as negative abstractions, but as the never yet known—as excess.

An installation that I created and exhibited in Vancouver during the time I was also actively involved in the school research project exemplifies the never yet unknown in a visual form. The installation titled "mouth speaking flesh" brings together sentient knowledge, provoking a visceral response that

is uncertain and in excess. The following excerpt is pulled from the exhibition text and artist's statement.

* * *

mouth speaking flesh. she touches it

to make it tell her present

in this other language so difficult to translate.

the difference.

she is writing her desire to be,

in the present tense,

retrieved from silence.[6]

I chew and swallow in endless repetition. First rose petals. Then long dark tendrils of hair, which I shove into my mouth in handfuls. The hand held camera wavers and frames images of skin, wrinkles, and scabs—the flaking detritus of the body. In contrast and equally disturbing, folds of white cloth spill onto the video screen. This epistemology of disorientation and revelation, movement and space, creates a moment of dis/comfort coupled with the un/familiar. But there is a dialectic of proximity at work here. A poetics of un/covering, like the peeling back of flesh to display interior matter. The body is exaggerated, distorting the boundaries of the body. There is an uncertainty and a vulnerability to these dislocations. The body is never fully represented, displacing the viewer's conventional desire to contain and to consume. The claustrophobic and engrossing sound further implicates the viewer in the processes of dis/orientation. There is a haptic quality to the work, fabric and skin caress the viewer as the differences between the senses translate one another.

The installation—a TV monitor perched precariously in the corner of a black room emerges from piles and tufts of shorn hair. As the weeks pass, dark tendrils begin to creep up the walls and small curls cling to the face of the monitor. The work pulsates and breathes.

* * *

In "mouth speaking flesh" the repellent sound and unsettling images are grounded in a visceral and synaesthetic experience. There is also a letting go of form, a detachment emphasizing an opening; an exposure. It is ephemeral and ambiguous, an enchanted instant in an uninterrupted flow of repetitions. Destabilizing the gaze by provoking other sensations, the video emits a series of oscillations; seeing becomes hearing and tasting through texture. The body is in and of the fold.

In pointing out that Merleau-Ponty's theoretical paradigm is indebted to femininity and maternity, the feminist philosopher Luce Irigaray (1993) suggests the use of the concept "mucus" as the threshold where bodies, experiences, and knowledge collide. Mucus, "which always marks the passage from inside to outside, which accompanies, and "lubricates" the mutual touching of the body's parts and regions" returns experience to the primacy of touch (Grosz, 1999, p. 160). Mucus is neither subject nor object but the inter-determinancy between them, unmediated by external sensibilities (Grosz, 1999). Mucus is a more visceral, pulsating and active body knowing. Mucus escapes control; it cannot be grasped in its fluidity, or

contained. Mucus can also be understood on the level of maternal-fetal bond where blood courses through and is shared by both bodies. For Irigaray, feminine morphology is never complete: "The birth that is never accomplished, the body never created one and for all, the form never definitively completed" (Irigaray, 1985, p. 217). Thus, touch for Irigaray, is not only the first sense but remains the primary mode of knowing.

Bodily fluids, including mucus, have often been addressed as aspects of the body that threaten closure and containment. Similarly, the grotesque and mutant body disturbs classic, ideal "norms" (Shildrick, 2001, 2002). The grotesque body, the mutant body, and mucus all have in common what Julia Kristeva (1982) refers to as abjection. Abjection is the body's effluence, which are always present but which are contained, repressed, or envisioned as lack as the body emerges towards a clean and proper state. The abject cannot be completely expelled from the body, but is always already present, disturbing and endangering the limits of the body. Bodily fluids entertain the permeability of the body, and attest to the disgust of the unknown. They mark the body as unstable and uncertain, formed through proximinal relations of touch.

Theories of abjection suggest that the fundamentally unstable corpus is always already present, threatening to reveal the corporeal vulnerability of the self. For instance Margrit Shildrick's (2001, 2002) research on conjoined twins attests to the threat of a body without any clear borders, "an unnerving doubling of the one in the other" (Shildrick, 2001, p. 390). As opposed to the normative body, which posits the separation and proper constitution of bodily form, the figure of excess entwines self and other through proxminal relations. To redefine excess through touch we need to recognize difference not as lack but as "lack of containment" (Grosz, 1994, p. 104). If this lack of containment—this seepage—is not a condition of the monster and contamination, but a way of being that resists the structures of domination, systems of codification, and control, how might we reconsider body knowledge, researching, writing, and teaching as excess?

At first glance the student artwork "External Openings" seems to embody a somewhat literal rendition of the hard outer shell of the body contrasted by a fragile, earthy interior. On closer attention one realizes that the rose petals aren't so much on the inside as they are woven between and intersecting with the wrapped wire structure, altering the overall surface of the form. The wire and flowers are swathed in an irregular pattern, crisscrossing threads of metal and dried flesh. A few petals puncture the boundary of the skin. The fingers, glass test tubes, protruding from the wire base are filled with pages torn from a medical book, each finger an

illustration of the body's codification and structure. On display the hand is unsettled, appearing gigantic in a world of the miniature. Although physically not much bigger than an average adult hand, its materiality and distorted stretching renders it gigantic and somewhat disoriented. This distortion reveals what is concealed or held in suspension, uncovering and differentiating between the body's boundaries, un/folding interior and exterior.

The body is our mode of perceiving scale (Stewart, 1993). It is a measurement for what is interior to us, and what lies outside; external demarcations, and prohibitions between self and other. Exaggeration becomes a slippage, un/folding in time and space of the everyday. This time, writes Susan Stewart (1993) "is textual, lending itself to the formation of boundaries and to a process of interpretation delimited by our experience with those boundaries" (p. 13). In Heather's careful exploration, boundaries and scale are ruptured open; there are no stoppers on the test tubes, the paper strips wind their way out of the glass containers, wire and flower fail to cohere, confusing, undoing the functional logic of the body. Splayed open,

the hand reaches out— touching, grasping, caressing. "External Openings" is emblematic of inter-embodiment; a doubling between proportion and disproportion, inside and outside, control and excess. It is excess, Miller (2005) reminds us that creates "slippages between text and world, knowledge and the real, and the intended and unintended audiences" (p. 129). Such slippages make it possible for subjects "to deviate the citational chain toward a more possible future to expand the very meaning of what counts as a valued and valuable body in the world" (Butler, 1993, p. 22). Ultimately it is the body in excess as a/r/tographical research that materializes knowing and being.

The Fantastical Body and the Vulnerability of Comfort: Alternative Models for Understanding "Body Image"

T he study of "body image" has been an important aspect of research on adolescent development. Researchers have argued that during adolescence, body image begins to play a central role in how youth negotiate the contested terrain of their bodies (Driscoll, 2002; Oliver & Lalik, 2000). Such research contends that body image is a "concern" or a "problem" that needs to be reconciled within education, and as such, body image is addressed through curricular topics as media awareness, health, and physical education. Moreover, this research tends to represent body image as a discrete phenomenon that can be examined apart from the lived experiences of bodies and in doing so neglects to understand how body image is interconnected to embodied encounters.

In contrast Gail Weiss (1999) argues that individuals do not have one body image but rather a multiplicity of body images that are created through a series of corporeal encounters and exchanges. She writes,

> To describe embodiment as intercorporeality is to emphasize that the experience of being embodied is never a private affair, but is always already mediated by our continual interactions with other human and nonhuman bodies. Acknowledging and addressing the multiple corporeal exchanges that continually take place in our everyday lives, demands a corresponding recognition of the ongoing construction and reconstruction of our bodies and body images. These processes of construction and reconstruction in turn alter the very nature of these intercorporeal exchanges, and, in so doing, offer the possibility of expanding our social, political, and ethical horizons. (pp. 5–6)

Body image as intercorporeality is an awareness of our body in relation to its gestures, movements, and positions in space. It is a responsiveness that is

determined in relation with other bodies, objects, and the environment, in addition to the coordination and sensations of our own functioning body. This awareness in turn shapes our encounters with other bodies, thus rendering body image as integral to knowledge production and our relationship with the world.

Thus, I argue, new models of inquiry need to be posed that interrogate body image as immanent and dynamic, a folding that is informed through interactions and processes rather than maintained by substances and boundaries. In this chapter, I reconceptualize body image from the perspective of the fantastical body.[7] To begin, I provide a brief summary of body image as equilibrium, which suggests that any movement or change to body image is in fact a stabilizing momentum. From here, I offer a theoretical understanding of the fantastical body contextualized through student artwork and conversations around the theme "comfort." The ability to fantasize about changing clothes and thereby changing image, and the embodied inter-relations of touching fabric pose alternative questions about the ways students might understand discourses of body image. The third section of the chapter extends theoretical understandings of inter-embodiment through a discussion of two sculptural pieces that examine skin as "a becoming body" that is permeable, open, and unknowable. As a way of conclusion, I maintain that an analysis of the fantastical and becoming body poses certain possibilities for thinking further about how *pedagogies of excess* might work with and against the contradictions of body image. However, before I begin the section on body image theories, I'd like to briefly look at one of the student's videos, in order to think about the rationales for a reconceptualization of body image as inter-embodiment.

Never Stop Thinking

There are a number of popular misconceptions and limitations of body image and how it functions as an aspect of body knowledge. During the first few weeks of the research study, I noticed a woman at my gym wearing a t-shirt with the words "fat is not an emotion" printed across the front. I pondered such a blatant statement and laughed at the irony of a message intended to empower the individual body but that simply continued to imprison it devoid of touch, sentient knowledge, and emotion. At school that week I asked a number of the students what they thought about the saying. The students talked about how the importance of the intended message was displaced given that it disallowed, what to them was a fundamental understanding of

body image—feeling. The message, they argued, was meant to suggest that fat, in the strictest sense, should be understood from a body mass index perspective, and prohibited an awareness of one's body in relation to other bodies, experiences, encounters, and the environment. It was poignantly summed up by one of the students: "It reduces the body to a piece of meat and forgets about how we live our bodies." Students showed me covers of popular teen magazines, both of which had similar mottos emblazoned on their covers. Body image—at least as an emotion—it seemed was being obliterated. If we could get rid of body image, then perhaps youth might adopt a "healthier" attitude towards their bodies. This I felt was absurdly wrong.

While educators agree that body image is a complex phenomenon they have often created overly simplistic curricular practices entrenched in the conviction that if we can teach students to be critical of the media and to understand the unreal possibilities of fantasizing and trying to achieve an ideal body, only then will we be able to repair adolescent body image. This educational praxis embraces the idea that adolescent bodies are diseased or unhealthy and in desperate need of control and restoration (see Oliver & Lalik, 2000). This belief is problematic because it reduces body image to "representation" and does not account for tactile and emotional epistemologies (Boler, 1999; 2004). It also maintains an understanding of body image as static, fixed, and certain. Instead, as Oliver and Lalik (2000) advocate, body knowledge education needs to provide students with alternative ways of living in the world—alternatives, I argue, that include fantasy.

Heather's video "Never Stop Thinking" is an interesting visual example of pedagogical models of body image that fail to address the lived experiences of students bodies in the construction of body image. In her video, Heather demonstrates the ability to critique the media as she manipulates images from fashion magazines, interviewing fellow classmates about their opinions of the media and its affects on body image. She and her friends are all too familiar with fashion magazines' air-brushing techniques and the very limited possibilities of obtaining particular body types.

The opening segment to her video shows images torn from fashion magazines and placed in cardboard boxes. These women seem imprisoned by fashion and standardized notions of body image. As the video sequences move through a series of similar images mostly depicting fashion models and film stars, the voice-over of Heather and her two friends, talking candidly, alludes to the haunting reality of how youth negotiate the representation of a body image ideal within visual culture. The students are very aware of the

media's manipulation of body image and offer a somewhat humorous and sarcastic account of the absurdity of many of the models poses, clothing, and body types.

In one film clip Heather captures an advertisement for *jlo* perfume. She found an ad in a female teen magazine and the same ad in a magazine for popular music. In the female teen magazine the model's gauze-like covering was less transparent, while in the music magazine, which she and her friends believed was targeting male youth, the model was more visibly naked. Heather and her classmates could easily talk about the effects of such exploitation, the body as object, and the unreal representations of body types. In fact their responses were almost too candid. I couldn't help but interpret their words as "schooled" in the sense that the students seemed adept at critiquing the media and the praxis of trying to achieve an ideal body type. Further to this there was a strong understanding of how the circulation of images globally oppressed particular body types, whether it was through gender, age, or race. I recognize that these girls at age fifteen to seventeen may have already benefited from educational practices on body image, however their responses also revealed a disturbing tension between the sterile understandings of body knowledge posed through media critique, and their own lived experiences of body knowledge that they defined through comfort, feeling, and sensory experiences. Thus, while in no way am I calling for an abandonment of body image education that includes media awareness through critical forms of pedagogy, I want to enable an alternative discussion of body image through *pedagogies of excess* that examine student understandings of fantasy and becoming. I believe that these considerations will further enrich educational practices that include body knowledge. But first, let me return to a brief summary of body image theories that foster a stable yet pliable body.

Body Image Theories

According to feminist scholars Gail Weiss (1999) and Elizabeth Grosz (1994) the most salient characteristics of body image are: 1) The body's plasticity and its ability to constantly change its body image in response to changes in the physical body and/or the situation; and 2) The dynamic organization of the body image offers an equilibrium, which enables it to serve as a standard. Changes are then measured against this centre or origin. These characteristics call attention to both the adaptability and the stability of body image, emphasizing that instability is in effect in constant renewal of a

unified body image that is measured against standardized norms. For example, in Oliver and Lalik's (2000) study with preteen girls, images of women provided a set of standards that they associated with being "normal." Adopting different clothes, hair styles, or body shapes "represented one of the cultural codes or rule structures that linked them to others and provided them with a logic and set of criteria for a life well lived" (p. 56). Changes to the girls' body image (i.e., through the manipulation of "fashion") created a normalizing process. This normalizing process is always oriented towards a stable and unified body. In Heather's video example, the girls' conversations about the use of airbrushing techniques and photoshop style manipulation of models' bodies illustrate an understanding of this normalizing process. No matter what style of garments are worn by a model or what features of a model's body are highlighted, sculpted, or exaggerated, the overall effect is to comply to a standardized norm of beauty.

Another way of thinking about body image is from the perspective of "body habits" (Merleau-Ponty, 1962). These habits are the postures that we fall into such as sitting at a computer, driving a car, and walking. However, it is these habits that structure and bind our body. Some of the ways that we resist this boundedness is through "playing," such as clothes, decoration, and other body modifications. In the research study, the students' play with fashion, whether they dressed sporty or goth, allowed them to challenge and manipulate their body habits. However, as Elizabeth Grosz (1994) notes, because body image is fluid, dynamic, and plastic it has the ability to incorporate external objects into its postural model. For example, clothing, jewelry, and other accessories become part of the body's awareness and experience in the world. These objects are no longer objects but understood as incorporations into the unified body image. Similarly, intermediate objects, such as those defined as the abject (spit, semen, blood, urine etc.) are bound up with body image resulting in the various investments accorded the body depending on psychical, interpersonal, and socio-historical meanings. Thus, over time even resistance is adopted into the habit body, marking and inscribing a set of norms that function to maintain the body's equilibrium. In the case of Emma and her friends, wearing clothing that was comfortable initially marked them as different from the pop icons like Britney Spears who sport, in the girls' minds, uncomfortable low-rise jeans and belly-baring shirts. However, the students' own comfortable style soon became adopted as the "norm."

Socio-cultural models of body image, while locating the source of change as external to the body, also establish the adaptability of the body image towards unity and stability. Susan Bordo (1997) locates two aspects of

body image that are central in establishing the practice of change and stability. The *intelligible body*, which includes the academic, scientific, philosophic and aesthetic representations of the body, establishes the "rules" and relationships of the cultural conceptions of the body. The intelligible body is perceived of as a fixed, static, and certain body, often translated as the "ideal" body or a "normal" body. Each society, community, group or individual has its own definition of what constitutes the ideal. So while it is virtually impossible to describe an ideal body as a particular size and shape, what we do know, according to Bordo, is that the perfect body has tight, monitored boundaries. The ability to control and modify the corporeal schema to maintain equilibrium is a symbol of emotional, moral, intellectual and physical power. "The ideal here is of a body that is absolutely tight, contained, "bolted down," firm: in other words, a body that is protected against eruption from within, whose internal processes are under control" (Bordo, 1998, p. 294). The soft, loose, excess flesh threatens the borders of the body, the stability of the individual, and the premise that one is "normal" and in control of their life. The ideal body is excess-free, maintaining the borders between inside and outside.

To achieve this ideal body a particular praxis is required, which is the *useful body*; body sculpting, dieting, fashion, cosmetics and body grooming. In extreme cases of self-management, for example anorexia, the body's desires have been rigidly contained. Weiss (1999) describes the body's maintenance of stability as the ability to accommodate slight changes in the corporeal schema over time. When the body schema becomes inflexible the body dissolves into disequilibrium. While the useful body appears as an active body that is engaged in the process of change, it is a transformation marked by efforts to defend a static and stable corpus. It is an activity aimed at regulating and working the body to fit into a normative discourse of wholeness and unity.

What is clear from this cursory glance at body image theories is that body image is defined by movement but that this activity is oriented towards the maintenance and control of a stable body, and is marked by borders and boundaries of containment. Moreover excess is either something to be expelled or adopted into normalizing practices that aim to preserve stability. Alternatively, what I want to focus on is the fantastical body rendering body image as continuous processes that are always becoming, always immanent, and which operate in resistance to determinate organization.

The Fantastical Body

The fantastical body is a body that conceptualizes corporeal difference through processes of creation. It is a body that is dynamic, creative, and full of plentitude, potential, and multiplicities. Deleuze and Guattari's (1987) conceptualization of the body as a series of processes, flows, energies, speeds, durations and lines of flight is altogether a radically different way of understanding the body and its connections with other bodies and objects. The body, they argue neither harbors consciousness nor is it biologically pre-determined, rather it is understood through *what it can do*—its processes, performances, assemblages and the transformations of becoming. Not only do they propose very different models of materiality and encounters between bodies, they also develop a different understanding of desire. Desire, they contend, is a process, something that can be produced when new kinds of assemblages are created. It is not a desire *for* something, a desire determined and organized through a norm, but a *desiring production* that makes its own connections. Grosz (1994) argues that this desire is one of articulation, contiguity, and immanent production. For Grosz, and other feminist scholars any model of desire that dispenses with the primacy of lack is worthy of examination (see Braidotti, 2002, 2006; Kennedy, 2004).

Reconceptualizing desire as production (versus lack), Deleuze and Guattari (1987, 1983) posit the *Body without Organs* (BwO). The BwO is a body without discrete organizing principles. This is not to say that it is an empty body, but that it does not organize itself according to hierarchical orders such as those associated with the functions of organs.[8] The concept of an egg helps to describe the processes of a BwO. An egg (embryonic) is a system of flows and intensities. It has no boundaries and represents potentiality before individualization. It's becoming is organized through various forms that could always have been otherwise—change is constant and inevitable. The BwO involves a letting go of determinate properties; a deterritorialization that allows for new assemblages. This mutable, amorphous, body knowledge resists predisposed patterns in exchange for assemblages that constantly mutate and transform. Tasmin Lorraine (1999) suggests that the BwO opens up awareness to creative processes by challenging "one's sense of corporeal boundedness and one's social identity as well as one's perceptions and conceptions of everyday life" (p. 171). It is a concept which challenges the traditional mind or body dualism of Western thought. Focusing on processes rather than substances, the body's becoming subverts conventional boundaries while suggesting new forms of living in the world.

The fantastical body borrows from the concept of the BwO, most notably its organizing principles: processes rather than substances, and its refusal to be contained or determined by fixed boundaries. Likewise, the fantastical body is material, sensuous, and tactile. Fluid, uncertain, and ambiguous, it attests to body knowledge as intercorporeality—in and through touch. Changes to the fantastical body are not a result of maintaining equilibrium, but are modifications, new assemblages that challenge determinate organizing principles, interrogating bodied encounters, and offering possibilities and potentials to actively engage with the world. In the following section, I turn to student artwork and conversations that uncover the tensions at work in the fantastical body.

"Un/attainable Comfort":
Student Understandings of Body Image

A soft fuzzy blanket lies folded on the floor. Nearby a large pillow from the same fabric invites you to nestle yourself comfortably within its flesh. A pair of slippers appears discarded, the body left to lounge on the soft folds of blanket and pillow. The slippers look warm and comforting until you notice that they are studded with thumbtacks, the fierce sharpness threatens your feet. The blanket and pillow also allude to this false sense of comfort. The blanket is stitched together so that it cannot be un/folded and the pillow, full of hard cardboard and paper makes it a less than luxurious place for your head. There is a tension at work between the sensuousness and extravagance of the fabric, the generous size of blanket and pillow that invite the body into its folds, and the exposure to harm from the thumbtacks. The space is fraught with conflict, frustration, and pain, while simultaneously conjuring up notions of warmth, delight, comfort and frivolity. Hot red and plush. Danger; a warning.

* * *

"Un/attainable Comfort" is an installation created by Jamie, Emma, and Maura. It operates on a number of different levels attesting to the uncertain and fragmented terrain of body knowing. Group discussions reveal divergent understandings of body knowledge moving between the body as passive vessel that the mind controls, to a more fantastical understanding of body image. Arguing that works of art are interlocutors—conversations and theories that attest to the complexity of the body, I resist any notion that the

student's words simply illustrate or describe their visual investigations. Rather, what I hope to expose is the ways in which these students navigate through art the complexities of bodies and knowledges. As a conversational device I have tried at times to keep the students' words in dialogue form to illustrate the ways in which their thoughts about art and the body reverberated between each other, allowing for their incompleteness and hesitations. In addition, there is an aesthetic to their words, both spoken and written. An aesthetic that is tangled, felted, and partial. In allowing for the conversational form and the excerpts of their writing, I want to "image" their words so that they do not appear as explanations of the art, rather in conversation with and through the artworks and each other.

Jamie, Emma, and Maura are joined by some of the other female students in the class. We hover in the back of the room to talk as Trinity, with help from Emma, glues dried flowers to the skirt of her art piece.

Alexandria: When people first see it they think... Oh... I like it. It looks warm and cuddly and comforting, and then when you are

actually closer you see you can't un/fold it, it's actually stuck together.

Emma: Because in fashion magazines all those dresses, the tight jeans… and its not comforting. But it looks really nice.

Alexandria: It's taking something that is comfortable and making it uncomfortable.

Emma: Jeans could be comfortable but not the ones that barely cover anything.

Trinity: Comfort is important especially in the world today, especially with Fashion. Things are advertised more as looking beautiful…not so much about feeling comfortable. I think it's important that you feel comfortable in it; that's much more important than actually looking or being a part of the trend.

Emma says that particular clothes are less comfortable than others. The girls cite the fashions worn by pop stars like Britney Spears, fashion models, and even some of the more everyday clothing that adolescent girls wear—very low cut jeans that expose the pelvic bone—as uncomfortable. Emma personally doesn't find these types of clothes appealing. As the girls sit in a circle discussing the latest uncomfortable fads I notice that two of them have their sweat pants dropped well below the waist with the tops of their underwear, brightly coloured thongs, peeking out at the waistband. Another one is wearing pelvic revealing jeans. As the conversation continues and in subsequent weeks when we revisit the theme of comfort, the girls all agree that *comfort* is an important aspect of body image. However, comfort I discover, is itself not a stable and static signifier. Comfort, they tell me is the ability to choose what you want to wear based on: 1) how you feel (emotions); and 2) what image you want to project.

Emma: You can dress sporty or chic then you start wearing sweat pants and it's not that you are trying to express that you are a slob but its comfortable. You just change the way you dress all of a sudden.

Jamie: There are two different ways people can dress—in whatever

they feel like wearing. Or people trying to be something they are not.

Dressing differently, Alexandria explains is dependent on moods or emotions. If you feel a particular way in the morning you will choose clothes that reflect that mood. She continues to describe moments when sweats would be more preferable to dressing up, for instance when you are stressed and have a test.

Alexandria: One day you'll wear heels and a skirt to school and the next day you're in sweatpants next day jeans....one day you feel like dressing up and the next you don't care and I'm not going to shower today because I don't give a crap and then you just go to school....

Emma: Dressing goes with what you feel like and your mood for the day. If you're really grumpy or tired...clothes are a statement of how you express yourself.

Alexandria: On Valentines Day, not my favourite day of the year, I dressed all in black.

Maura: Also, if you get older. Different clothes mean different things. Some of my clothes express myself when I was younger.

One might assume that the girls understood emotions as stable internal markers that exist prior to the signification of clothing. Yet, Emma shared an example of wearing sweats, which seemed to be the clothing of choice when feeling stressed due to the pressures of school. Emma stated that the opportunity to come to school in comfortable clothing shifted her mood from anxious to being relaxed. "Sometimes I just put on sweats because I'm tired but then during the day the comfort of the clothes makes me feel less tired. I sort of feel happier."

Iris Young (1990) reminds us that body experiences are often imagined through the tactile sensation and the pleasure of cloth. The material-semiotic nature of fabric allows for both tactile sensations of skin touching cloth and sensuous bodied knowing characterized through memories associated with the pleasure of wearing clothes. Describing women's fascination with

clothes, Young (1990) suggests that women's imaginative desire stems from three pleasures associated with the body: touch, bonding, and fantasy.

> Touch immerses the subject in fluid continuity with the object, and for the touching subject the object touched reciprocates the touching, blurring the border between self and other. By touch I do mean that specific sense of skin on matter, fingers on texture. But I also mean an orientation to sensuality as such that includes all senses. Thus we might conceive a mode of vision, for example, that is less a gaze, distance from and mastering its object, but an immersion in light and colour. Sensing as touching is within, experiencing what touches it as ambiguous, continuous, but nevertheless differentiated. (pp. 182–183)

Touch as a primary mode of perception displaces the measured and distant gaze with a desire that immerses the subject in fluid continuity and a folded relation with the world. Touch ruptures the containment of the body as unified and discrete, rendering the body as permeable and porous.

Young contends that touch is a form of relating to another, a relation that is contiguous and folded, not premised on possession or objectification. Alexandria remembers a particular sweater with fondness, telling us that when she wears it, it alters her mood, making her happy. Maura concurs, describing a few articles of clothing that she still has from elementary school, reminding her of past experiences and encounters. Alexandria and Maura often share clothes, a bond that Young (1990) describes as intimate and relational, "As the clothes flow among us, so do our identities; we do not keep hold of ourselves, but share" (p. 184). The encounters between beings, the relations formed through clothes allow us to touch and enter into each other's lives. Knowing is formed with, in, and through the folds of cloth, the lived emotional experiences of wearing, touching, and being caressed. The emotional, tactile, and embodied experience of clothing is often glossed over in schools. Instead too often teachers criticize students for wearing particular types of clothing or for spending so much time focused on something that is interpreted as frivolous and meaningless. Yet, clothing offers sensuous pleasure, tactile experiences of knowing self and other, and the comfort of being able to embody outwardly emotional sentient knowledge. Instead of structuring educational practices that limit students' self-obsession with fashion, understanding it as unhealthy and inappropriate, curricular practices would benefit from acknowledging the emotional and interpersonal meaning of fashion (see Springgay & Peterat, 2002–2003). While this may seem to be a rather simple tautology, educators often neglect to inquire into the conditions that produce particular appeals to clothing and the emotional, tactile, and comforting experiences of clothes. Writing about "dress stories," Sandra Weber and Claudia Mitchell (2004) suggest that dress be understood

as a "method of inquiry into other phenomena and issues" (p. 253), stressing the performative nature of wearing clothes. Dress as a mode of inquiry allows individuals to interrogate their own embodiment and bodied encounters.

As a mode of inquiry, clothing allows these students to change what they wear and thereby fantasize about who they want to be. For instance, the students tell me that if they dress sporty it does not mean that they are sporty people, just their *image* is sporty. Image they define as what you project on the outside, usually determined "through clothes and fashion." Fashion is more than the objects that makeup its constitutive parts (clothes, make-up, hairstyle, jewelry, body art) but also the *way* you chose to wear particular clothes, an example being the underwear craze that swept through the school (underwear showing above the waistline of pants). This outside image the students believe can be different from who they are on the inside.

Ming: If you change outfits you can be something else. So that's also to do with image and not your body. 'Cause your body is the same day-to-day but you change clothes and you are a completely different image.

I ask her to clarify image.

Ming: Your outfit is your image. If I was to wear fishnet stockings, high heels and black eye make up I would be a completely different image I'd still be the same person the same body just a different image.

Ming: You can completely change your clothes and still be your own personality. But if I was looking at you, then I would think your personality would be Goth.

Ming's articulations reflect on one hand "split subjectivity," where the seeing subject is limited, restricted, and objectified through the others gaze (Young, 1990). Young asserts that women's split subjectivity—akin to the Lacanian alienation—undermines the integrity and agency of the self. Split subjectivity occurs when women become aware of their bodies as others see them. Young advocates that women need to overcome this split by accepting the limitations of their bodies.

I am hesitant to assign such a reading to Ming's words. She and many of the other students spoke at length about the opportunities that the fluidity of

body image provided. This suggests, contrary to Young, that change can be an interrogation, a masquerading possibility, a becoming of an alternative and imaginary body schema that was created through inter-embodiment. In this way the splitting becomes a folding, an opening that intertwines experience in and through the body.

Inter-embodiment is an important aspect of student understandings of the fluidity of the body. Ming believes that who she is on the inside does not have to be reflected externally. This is not to suggest that internal and external body images are in opposition to each other, nor is one striving to maintain and stabilize the other. Instead, the splitting of inside and outside should be understood as a fold, where experimentation and assemblage become determining factors. Change is fragmented, vague, and not assembled by any predetermined organization. It was a change of becoming, a creative flow of potentiality. Changes to body image were not efforts to achieve an ideal norm, nor to maintain a practice of a true inner self, rather body image alterations were conditions of subjectivity in themselves. Therefore, educational models premised on acceptance of the body's limitations fail to address the unlimited potentialities of the fantastical body. Corporeal agency is found in the multiplicity of body images, which destabilize the normalizing practices of a specific body image. The fantastical body allows us to create a sense of corporeal fluidity.

The students believed that changes to one's body image were about *imaginary possibilities* that you could "be" if even for just a moment, what that image projected. For example, wearing sporty clothes even if you never played sports allowed you to try out the "image" of being sporty. Similarly, if you dressed Goth you weren't necessarily Goth, but you were trying it out for that moment. These articulations had less to do with others perceptions of you but more with fantastical options that change provided for oneself. And yet, this change was not solely a personal change. While change was not *for* another, it was created in and of an encounter, and therefore in relation to another. Others' perceptions of you were part of shaping the fantasy of becoming. The perception provided through encounters did not split the subject, but rather opened up fantastical opportunities. Therefore body image needs to move away from a position of splitting to one that embraces the idea of un/folding—an open, ruptured, fantastical body. Instead of change towards equilibrium, change is a process that is dynamic and multiple.

The ability to change body image underscores the importance of thinking through the fantastical body as a body that is not defined by boundaries. This shifts body image from a self-image defined by limited borders towards an understanding of corporeality as a process of becoming with multiple points

of convergence in an infinite world, out of which body images are not only formed but continuously reworked and assembled as well. The fluidity of body image thus poses alternative possibilities for living in the world. Alternative corporeal schemas, according to Weiss (1999) provide "subversive tactics available for undermining social constraints on what bodies can and can't do" (p. 74). Thus, instead of perceiving of the body as a set of discrete characteristics, the body needs to be re-theorized from the point of view of processes. Bronwyn, the art teacher reflects on this: "We always think that when you put something on you become it. But students don't see it this way. There is an idea of things not fitting; a mutability—a trying things out." Change is welcome not because one image is more important or desirable over another, but as an interrogation of what it means to live as a body in and of the world. The fantastical body provides students with unlimited possibilities, the potential of which they understand as comfort. However, comfort is not a static condition, but a process marked by its own vulnerability. Comfort played an important role in how students described their school community and bodied interactions.

The "being-with" of Community

Given the small student population at the school and its alternative model to education, teachers and parent advisory groups often labeled the school as a community. However, their perception of community is consistent with what Etienne Wenger (1998) defines as a community of practice, where participants are mutually engaged in achieving a goal. In other words ,practice "exists because people are engaged in actions whose meanings they negotiate with one another" (p.73). A community of practice is not defined by structures, but by the daily interactions between students and teachers. Adopting Wenger's model, students make decisions about their school (extra curricular events, fundraising, educational and youth programs in the community they would like to participate in, and the maintenance of the school to name just a few) at a weekly school meeting, which is facilitated by students in the senior grades. All students attend this lunch hour meeting and actively participate in creating the school environment. They even run a small canteen/cafeteria, which generates revenue for projects such as the maintenance of the student lounge and telephone line.[9]

Wenger insists that *mutual* engagement includes diversity and difference. For example, he notes that individuals may join a community of practice for a variety of different reasons and that they *bring to* the community diverse

perspectives, histories, and experiences. Regardless of such differences the individuals involved in a community of practice are united in their objectives and shared common goals. This type of community is traditionally described as a number of individuals having or building something in common. This "commonality" could be property or a sense of belonging (Agamben, 1993; Irigaray, 2001; Lingis, 1994). Community, under this model is autonomous, rational, and universal. In its idealized and abstract form it excludes and marks particular bodies as unbelonging, imposing boundaries in the process.

What Wenger fails to articulate is the implicit power structures that make mutual engagement not only unattainable but also problematic, and furthermore how encounters actually differentiate and produce difference. Communities of practice invite encounters between bodies, and these encounters are not neutral. They are formed through relations that mark some bodies as strangers and allow for the demarcation of spaces of unbelonging (Ahmed, 2000). In other words, encounters complicate the social experience of interacting with other bodies and the lived experiences of inter-embodiment. Community cannot be reified as a unified practice where bodies interact together irreducible of difference and power. As Ahmed (2000) defends, the stranger is not someone whom we fail to recognize at a distance, but the body that is recognized in proximity as unfamiliar. Thus, it is unfamiliarity and excess that produces knowledges, thereby differentiating difference. Alphonso Lingis (1994) offers a similar insight when he writes that one enters into community not through belonging or property but by exposing oneself. It is an exposure to the other with whom one has nothing in common.

If we begin to reclaim community from the common, we take the emphasis away from boundaries as borders that mark who or what belongs and does not belong, a practice that maintains its equilibrium through exclusion. Instead what is in question is not the limit but the very threshold itself. Boundaries demarcate inside and outside. If we turn our attention to the threshold, the passage between inside and outside, re-determining outside as this boundary that gives access to the world, we might begin to envision community beyond a conception of "essence" but a "being-together of existence." In Agamben's (1993) words, "The threshold is not, in this sense, another thing with respect to the limit; it is, so to speak, the experience of the limit itself, the experience of being-*within* an *outside*" (p. 68). It is a disruptive move that shifts the fluidity of individual identity towards an examination of the vulnerability of knowing and being. In this space of proximity being(s) come together without being tied to common property or identity, which the students identified as comfort.

Student understandings of the importance and instability of comfort played an important role in defining their body image awareness in school. Bronwyn recounts early on in the project that "Safety is important to them. It's what they like about this school; they get upset when safety is violated." In more traditional schools safety has been imposed through measures that structure and control the student body: locks on lockers, rules about loitering in hallways and public spaces and other such body maintenance measures.

According to Bronwyn, the parents and school administrators believed that they had created an ideal community where their children were safe from the perils associated with larger schools, such as violence, drugs, and alienation associated with not-belonging. The students also articulated similar ideals, stating that the small size of the school meant that students were less likely to judge each other harshly, to steal from each other's lockers (remember there are no locks on the lockers), and students aimed to work together to sort out differences and problems. However, they were also quick to comment that even at *Bower* students faced the pressures of unbelonging, judgment, and a sense of disease. Yet, rather than understand community through imposed and closed boundaries defined by what is common, the students articulated an understanding of community and body image through comfort that is vulnerable and fantastical. Body image moved from representation—static images that contain the body as passive victim, towards lived experiences of comfort; a comfort that was un/attainable, in constant change, and often contradictory.

Instead of the term safety (which the art teacher used frequently) students described their body awareness in terms of comfort. "Here everyone thinks we are safe. We don't use that word. They do. Its not safety that we want. More like comfort, but it's just understood different. Kinda more unsure" (Heather). Another student offers: "Comfort is different than all of us being the same. Comfort is different for each person and it changes all the time" (Alexandria). Comfort is not a space that has no boundaries; rather it is a threshold. This threshold, like the in-between, is a space that allows new and alternative assemblages to be created without any predetermined model of organization. The threshold differs from a boundary in that it is not a limit that holds things in place, but is the experience of a limit—an experience of being exposed, open, and folded.

Body image understood through comfort becomes a means to interrogate limits. Boundaries that are constructed based on protection are not only closed, they mark limits as knowable. Comfort challenges us to think through touch such that limits are recognizable precisely because they are unfamiliar

and unknowable, and it is in the uncertain terrain of unfamiliarity that body knowledges become unraveled.

So often we tell our students to take risks and that risk taking is about crossing borders, thinking outside "the box." But this notion of risk taking is impossible if we consider border crossing as privileged and inaccessible to everyone. Furthermore border crossing insists that a boundary is about containment, and that risk taking is contingent on being on the other side. If we want to begin to think about risks in education and body knowledges that do not take sides, we need to think about being in the threshold, a being-with, and that this within is a space of movement and dislocation, where meaning hesitates, slips, and un/folds. We need to image(ine) education as undecid-able and undeterminable, where curriculum and pedagogy become performative acts suspended in the undeciable time of learning to learn as being(s)-in-relation. Learning, writes Chandra Mohanty (1986) "involves a necessary implication in the radical alterity of the unknown, in the desire(s) not to know, in the process of this unresolvable dialectic" (p. 155).

"Un/attainable Comfort" challenges the protective mechanisms surrounding the body. There is an illusion between the softness and the hardness of the pillow and the threat posed by the tacks. It creates a discordant perceptual system between what looks soft and easy to penetrate and something that can't be opened, used, or made accessible. It is this vulnerability that is open for discussion.

Despite the openness of the student's investigations, there remains a sense of literalness to this piece, especially through the incorporation of materials that lend themselves immediately to issues of representation. In fact it is the title that is most telling. It is not the notion of something being uncomfortable that the girls are exploring in this piece. Although each would describe in different ways what is or is not comfortable, their piece speaks to the idea of "comfort" as something that is un/attainable. Having used the slash often in my writing (in the class), the students picked up on this doubleness and used it in their title to attest to the vulnerability and uncertainty of comfort. Is comfort a source of strength or power that is conditional on the basis of whether it has been voluntarily embraced, or whether it has been imposed on one's subjective experience of the world?

The pieces all positioned on the floor invite viewers into a compromised proximity to the work without any physical awareness that they have crossed a spatial threshold. There is an ambiguity between being drawn to the work, our desire to touch and experience the flesh of the soft fabric, between our visual understanding of something from a distance and the reality we face

when up close. There is a relational awareness of one's own body in position to this art piece.

Given that the blanket and the slippers are on a human-scale, the pillow seems over sized, looming larger than our bodies, accentuating the threat of violence, insecurity, and the vagueness of belief in the comfort that these articles offer. In conversations with the three students we agreed that scale could have been manipulated even further in both the blanket and the pillow, allowing the slippers to function as a marker for our own bodies in relation to the piece. The viewer's vantage point becomes precarious. The viewer has to get very close to the piece to see the tacks and to pick out the stitching in the blanket and the sharp contours of the pillow. The visceral experience of invitation is pushed to a limit without even employing the human touch. There is a threat to resolution, which is displaced by the realization that new knowledge and experience does not after all provide one with reconciliation. Instead of seeing new structures that simply replace existing ones, it is in the perilous penetration of instability that knowledges past and present come together and are reworked.

"Un/attainable Comfort" became a focal point in class discussions around notions of comfort and in particular student understandings of bodies and knowledges. Comfort, they argue, is not a bounded space but a threshold. This threshold allows new and alternative assemblages to be created without any predetermined model of organization. The threshold differs from a boundary in that it is not a limit that holds things in place, but is the experience of being exposed, open, and folded. In what follows, I analyze two sculptural pieces that explore the idea of skin as a threshold—a becoming body.

Skin and a Becoming Body

To differentiate between the familiar and the strange is to mark out the inside and the outside of bodily space; to establish the skin as a boundary line. (Ahmed, 2000, p. 42)

Skin is often employed as a metaphor for the fragility and temporality of existence. Depicted as decaying, marked, and ephemeral, artists have used a number of materials to evoke this body boundary, suggesting its determination to make meaning, memory, and to signify change. As Jay Prosser (2001) suggests, "We become aware of skin as a visible surface through memory... the look of our skin—both to others and to ourselves—

brings to its surface a remembered past" (p. 52). Transparent paper, delicate flowers, and even butterfly wings signify the body's life cycle, the fecundity and richness of bodied experiences, while simultaneously alluding to the exposure and transparency of skin as a protective layer, a shell, or armor. Skin is a rich symbolic space of fluidity and metamorphosis, while also imprisoning the body and subjectivity within a container.

As a contact sense, touch emphasizes skin as a location of different kinds of touching, thereby creating different bodies. Skin is a border that feels; it is open to other bodies, interacting and taking on different shapes. It is in this opening to others through inter-embodiment that touch differentiates bodies requiring us to examine the boundary not as a division but as the very location, a threshold that produces bodies and knowledges. Ahmed (2000) states

> So while the skin appears to be the matter which separates the body, it rather allows us to think of how the materialization of bodies involves, not containment, but an affective opening out of bodies to other bodies, in the sense that the skin registers how bodies are touched by others. (p. 45)

Skin is the site at which memories surface and interactions with other people and thoughts take place. Thus, inter-embodiment becomes a site of differentiation rather than inclusion. In this way, a thinking through bodies requires that we not just think of skin as an exposure to another or as something that conceals and protects, but a site of bodily differentiation that is tactile and visual.

"Vacancy" and "Worn Out" are two dress-type sculptural pieces that hint at clothing as a second skin, a membrane that separates and joins. Dresses have been used in feminist art practices to examine gender, femininity, and the material experience of the body. For instance, Renee Baert (1998, 2001) has written extensively on "the body through dress," an artistic practice that explores the textuality and corporeality of the body without actually representing the physical body. The empty dress, she contends, takes on particular significance in feminist art practices, transmitting a host of cultural messages, the most salient being the absent or missing body. However, the students' visual explorations through dress focused on the concept of skin as a threshold—a becoming body that is always present; of touching and being touched.

"Worn out" is fashioned from a discarded rusted muffler and a skirt made of rows and rows of dried flower petals and leaves. The hard metal of the muffler immediately contrasts the delicate flowers, and yet both offer an image of decay and deterioration. There is something discordant about their proximity to each other. The excess of flowers glued and pressed so tightly

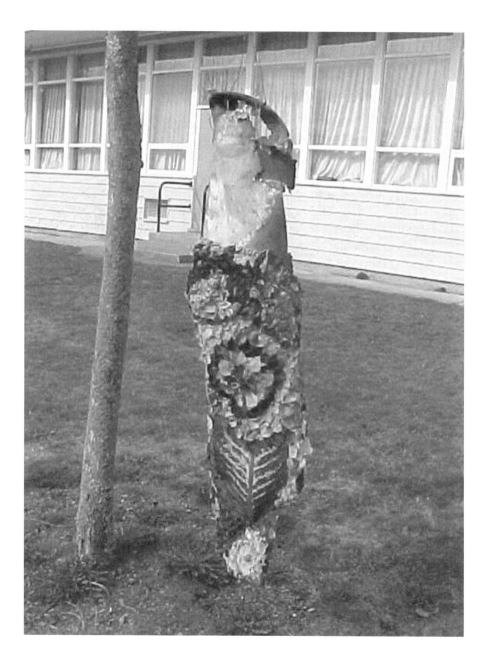

together creates a surface that vibrates and hums, almost like a murmur. It seems to overpower the rusty metal, which is cracked, torn, and falling apart, and almost unrecognizable. The dress as skin appears as if it is inside out, imperiling the very notion of boundaries and containment. The acrid odors of the dying petals further augment the fleshiness of the figure. It is heavy, thick, and engorged, the weight of the skirt pulling on the metal bodice, a threatening impression.

In contrast, "Vacancy" almost seems to float and hover in the air; neither grounded nor soaring off into the expansiveness of space. Made from white tulle, the feminine dress pattern encases a large, scarlet red, organic form— perhaps a heart, a kidney, or a lung. Its ambiguity only distinguished by reference to location on the inside of the dress. Unlike "Worn Out," which appears turned inside out, looking at "Vacancy" our sight passes through the dress, distorting objects on the other side. The dress is machine sewn giving it a uniform or generic appearance, while the pattern used is reminiscent of a classic trope of gender, femininity, and sexual desire; virginal white, pristine edges and seams. Inside the organ pulses—fleshiness—its edges fraying and basted together with loose, uneven stitches, which unravel and hang loose from the body's form. Both pieces draw attention to skin as a boundary, as a threshold, an uncontained within.

> Skin. The first thing I think about when one says skin is of course the coat that covers our body. Our skin is a very important matter because it protects our body— an internal body from harmful things. Aside from clothing skin is our cover, our shield, our mask. It is another layer. The difference between skin and clothes is that it cannot be removed. You can't wear another person's skin. Therefore skin doesn't always protect us. Sometimes it can tear. It can even get stained.—Trinity

Trinity wrote this passage in her journal as part of a written exploration of her piece "Worn Out." Trinity was initially attracted to the muffler and the petals because of the tactile and synaesthetic qualities that they evoked. Many of her journal entries reference this aspect of art making and a knowing that is bodied and sensual. "When I first saw the muffler in the alley near the school I just knew that I wanted to make something with it. I could almost feel its roughness in my hands. It looked so delicate lying in the mud. I left it there, this was months ago and then when you talked about our first art project I went back to see if I could find it again." As the weeks passed and Trinity and I met to discuss her piece we thought about other signifying traces in her work.

Trinity says of her dress: "It could be a shelter, a cover, a mask—I guess a camouflage. So it almost acted like a bubble and created a world of its own. It gave me a sense of release and my own little space." I asked her if she could have conveyed her ideas another way. "Hmm, maybe a cage. But that would give a different message because it is a cage." I wondered what she meant between her own space and a cage and so pressed her further. "A cage is associated with things like animals and stuff. Thinking of it as a shelter makes it think that you were put there for a reason. That it wasn't your own choice. Your hopeless kind of thing and you don't have that power. And you're not released. You're in isolation almost, so it's kinda opposite to this sense of space. And it doesn't have that sense of comfort."

As our conversations come undone we begin to see how "Worn Out" signifies the possibilities of touch and skin as a threshold of existence. In a short paragraph about boundaries, Trinity writes that boundaries are limits that impose borders on what one can or can't do. However, she continues writing that these limits are not imposed from outside as external markers, but individually determined. "Boundaries are the extent of our imagination

and creativity." "Boundaries are things that happen through experience," she tells me. "Boundaries are created when we come in contact with other things. They are open to change because they are associated with comfort." Asking her to clarify, she reminds me comfort is similar to the materials she has chosen, decaying, temporal, and in constant and inevitable change.

The skin of her piece, its decaying and fragile materials are in conflict with its largeness, the weight of the petals, and the sense that we are looking at both inside and outside simultaneously. Trinity informs the class that originally she had this idea of making a dress, but that as she worked on the piece it wasn't a dress any more. Andrew asked her to explain how it wasn't a dress. She responds:

> Well remember the dress pieces Stephanie showed in class, and we thought that the body was absent or hidden. I don't think my piece is about a hidden body. The body is very much here. I mean you can quite literally touch and feel it. It's kinda of beautiful and gross at the same time. Bronwyn is worried that it's going to get damaged in class, because of the flowers. But really no one wants to touch it. It's too much like flesh. It even smells rotting.

This prompts another student to respond: "Yeah, I see it as scars. The patterns of the petals. Or it could be not scars in a bad way but just marks on the body, maybe tattoos." And another with: "So instead of a dress as a metaphor for skin, it is just skin. But not skin like a covering, more like if we peeled back skin, the inside and outside together." What became apparent to me what that the students saw the body not as something absent or repressed in teaching and learning, but very much there—in abundance and in excess. At the outset of the research study I had expected to find a docile and coded body in the classroom (see Foucault, 1977). Instead I was confronted with a redolent, fleshy, and becoming body.

Alexandria's dress "Vacancy" is another complex example of student understandings of the excessive body. In class discussions some of the students raised comments regarding the somewhat ideal or perfect external shell of her piece, reflected in the white tulle fabric and classic dress design. They wondered if she had intentionally wanted to describe the outside of the body as clean and tidy, and the inside, represented by an organic and more roughly designed form, as messy. This Alexandria thought was an interesting interpretation, but reminded the class that a viewer never saw either the outside or the inside without the other. When looking at her piece the transparency of the tulle allows the viewer to see both the tulle form and the red organic shape simultaneously. Also, as James noted in a class discussion, other objects in the classroom could be seen through the dress, somewhat distorted and altered by the fabric. Alexandria explained that her piece was

not about a specific kind of skin. "Instead of perceiving the body as separate parts," she writes in her journal, "I wanted to think of how the inside and the outside of the body is really inter-connected. I guess I'm not sure what I mean by the inside and the outside. Maybe that is what I'm trying to say that the definitions of what is inside and outside are different. It was really important that I find fabric that you could see through but that also distorted what you saw. Sort of the traces of the fabric where part of what you were looking at. Like the body is part of everything we experience." Instead of describing experience as distinctive parts, "Vacancy" points towards the dynamic conditions that generate perceptual knowledge by challenging boundaries, opening knowledge onto multiple connections with the world.

Understanding the body in terms of relations and not of component parts provides an important development in rethinking body image. In exploring the concept of relations it is necessary to try to understand Deleuze's work regarding "becoming." Becoming, according to Deleuze, refutes notions of a fixed identity or teleological order, replacing them with multiple assemblages and intensities. Duration, movement, and process are intrinsic to the sense of multiplicity. Subjectivity then, exists in flux, as affect, and through rhizomatic assemblages—in a state of becoming (see Kennedy, 2004). Deleuzian thinking about the body opens up new definitions of the term itself, providing a much more complex, situational, and contingent form. The body materialized in Alexandria's sculptural piece "Vacancy" engages with Deleuzian processes of assemblage (BwO) where multiplicities are signified amidst other multiplicities. The fantastical body, conceived in relation to other bodies (not invested with psychical fantasies as we see in psychoanalysis) is fluid and mutable, constituting itself through becomings. What these student artworks suggest is a body constituted through touch as openness, change, mutability, fluidity and complexity.

While touch was understood as physical contact of skin on matter, touch also played an important role in understanding affects, emotions and the body as becoming. In her journal Heather writes that skin tells us a lot about what a person has touched.

> For instance if someone's hands are rough or smooth it might tell us about some of the things that this person has been touching. In terms of touch, skin can be very sensitive, which I think is really interesting. Because even though it works as a protective shell, it is still extremely sensitive to stimulus.

In another passage she continues with this reflection.

> I think a big part of touch is emotion. Like if your hand brushes against someone else's hand who you are attracted to. It is a physical touch, but you would have a

> somewhat emotional response. I think for most people the best way to learn is through touch. It is through touch and experience that one begins to understand how things work. I think contact with any and everything constitutes touch, which basically means that I view touch as the affect that any person, object, or situation can have on a person.

Trinity's reflection expresses a similar sentiment.

> Touch is a difficult thing to describe because it's the sense of feeling. When someone tries to explain or describe to you what they have felt by touch, I usually cannot understand them until I myself have touched it. I think to fully understand the description of touch one must first experience what one is trying to describe or at least come in contact with it.

I wondered if Trinity was trying to say that she could only understand and make sense of things that were familiar. However, in one of our conversations she told me that it's not about things being familiar or not, but about being in a situation where touch helps us to understand. What she was describing then is the concept of proximity as knowledge production. Jamie concurs writing: "I find that I use touch to understand things because I am closer to it." Emma furthers this when she says that "touch implies more than one thing, it takes place between things." Instead of reading the surface of things (skins), or looking beyond the skin (penetration), touch accounts for the effects of surfaces, how knowledge is produced in the between, in and of the threshold. Skin is a border that feels. It is the threshold between bodies, the site of interactions and encounters. It is the space of exposure. Therefore, while it can separate and contain bodies, skin, as a threshold, is the opening of bodies to other bodies. Thus, touch calls for recognition that skin is formed and marked between beings; a site of inter-embodiment where difference is produced.

Locating the body at the threshold of meaning moves away from discursive analysis of the body's absence in education, towards an understanding of the body as fantastical, in excess, and as becoming. Previously, I had explored research that examined the dress as a marker for the absent body (see Springgay, 2001, 2002). Allowing for a particular feminist reading, dress stood in for the body, suggesting and imposing a boundary between presence and absence, inside and outside. Educational imperatives suggested rupturing the boundary, penetrating it and valuing both sides of the border. But the student's art and conversations shift away from a boundary of containment to the border, the site of contact itself, not as inside and outside, but as a threshold. Touch as a threshold in and of the body, is a body that is always already present—fantastical, vulnerable, and uncertain. Inter-embodiment opens up the space and time between

experiences and our responses to it. "It gives us time and space to come up with some other way of being in relation at that moment. It introduces a stutter, a hesitation" (Ellsworth, 2005, p. 64). Inter-embodiment is a space where the skin-to-skin face off between self and other "has been pried apart so that a reordering of self and other can be set in motion so that we might go on relating to each other at all" (p. 64).

Months into the semester Bronwyn abandons her nest project (see Introduction). Instead she too takes up the space of boundaries as the threshold of embodied experience. Retreating to her island home one weekend, she asks if she might be able to borrow one of my video cameras. The next week she returns with a short film. On the island she tells me are a number of public walk ways and paths that lead to various beaches and wander throughout the island. The island, however, she believes has become a closed community, one that does not like outsiders who come to explore the beauty of the island on weekends and holidays. Many of the residents put obstacles in the paths, large tree trunks and old metal appliances, anything large that impedes and blocks the paths. That weekend, Bronwyn and her daughter set out on a project of clearing the paths. They remove some of the detritus and then Bronwyn's daughter uses the lawn mower to clear the over grown grass along the paths. The film documents this process and meanders around the island on these now exposed boundaries. It is not a removal of boundaries, but rather contact with, an uncovering of borders, that opens them up to new knowledges, difference, and encounters between being(s)-in-relation.

Pedagogies of Excess

Instead of understanding body image as a splitting of self, an awareness of one's body marked by inside and outside, body image through comfort, the fantastical body, and a becoming body becomes a means to interrogate limits. As Braidotti (2006) suggests, the enactment of limits as thresholds refers to embodied subjects in interaction and relation to others. As thresholds, limits become points of encounter as opposed to closure—"living boundaries not fixed walls" (Braidotti, 2006, p. 268). According to the students at *Bower*, limits are recognizable precisely because they are unfamiliar, and it is in the uncertain terrain of unfamiliarity that body knowledges become unraveled, enabling us to imag(e)-ine educational possibilities that focus on the fantastical body, rather than simply a critique of body image as something needing repair. Body image understood through

the fantastical body offers insights to student understandings of tactility, sensuality, and emotions—rupturing a place for embodied knowing in teaching and learning.

The girls' conversations, the installation and the sculptural dresses illustrate the tensions at work in adolescent understandings of body image. On one level there is a split between a visible, observable, and therefore knowable outside, and a hidden, private and thus more authentic inside. The girls are clearly drawing on modernist discourses of the self that suggest there is something deep inside us, an ideal or authentic self about which knowledge is possible (Gonick, 2003). Ming's articulation of self suggests a theory of subjectivity that links discourses of recognition with those of identity. Identity is not simply a matter of self-identification but, rather, is also shaped by the recognition or its absence by others. And yet, comfort so clearly defined as neither interior nor exterior and as something vulnerable and un/attainable complicates such understandings of bodied subjectivity. The ability to fantasize about changing clothes and thereby changing image, and the embodied inter-relations of touching fabric pose alternative questions about the ways students might understand inter-embodiment. What are the experiences that are mediated as an effect of a fantastical body? How is the fantastical body implicated in the relations of schooling? How is the fantastical body implicated in the production of "becoming somebody"? As they attempt to grapple with these questions the girls' use of art making seems a particularly provocative choice and poses certain possibilities for thinking further about how *pedagogies of excess* might work with and against these contradictions. The fantastical body allows students "to explore fantasies and fears, enact relations that would otherwise be restricted if not taboo, or temporarily dissolve boundaries, facilitating a loss of distinctiveness of the border between self and other" (Gonick, 2003, p. 182). Moreover, this type of work may open up the possibility of pedagogical practices that attempt to work across the contradictions between self and other, private and public, body and image, bearing witness to these contradictions, inviting students to bring them together, to examine them, to experiment with engaging them differently in the world. Shifting the terms of representation, the artworks and all of their tensions and contradictions may eventually produce transforming ideas—ideas that may work towards thinking about the world relationally, where "the goal is not to undo our ties to others but rather to disentangle them; to make them not shackles but circuits of recognition" (Gonick, 2003, p. 185). The artworks enabled the girls to perform a fantastical transformation and an active reworking of embodied experience.

In thinking about the body as excess, I conceived of an installation incorporating felted human hair. The exhibition, "Excess," exhibited at the Nanaimo Art Gallery, Nanaimo, British Columbia, and the Palmer Museum of Art, State College, Pennsylvania, was a way for me to think through this bodied curriculum and pedagogy. Methodically felting the hairballs not only provided me with time to reflect on the students' art and conversations, it was a way for me to materialize the excessive and becoming body. The passage below is taken from the exhibition text:

* * *

On entering the space one encounters an unexpected relationship with the work. The familiar becomes grotesque, and the grotesque reveals itself as familiar—human hair trapped and entangled, soft tendrils that cling to a host. Hair, a seemingly stable substance is un/done becoming something else entirely. Thus, the piece is experienced twice; first as something familiar and reliable, then as a more intricately contrived world of interacting materials and elaborate visual patterns. Curiosity gives way to further curiosity, examination gives way to further examination: the piece breathes like a living thing.

The body is revealed rather than represented; is delivered as fragment, effluence, or field, rather than as form or picture. The materiality is literally that which falls from the body, an excess through which to enact touch; and with its associative chain of cobwebs, dust, and mourning, it is a haunted touch, the space's atmosphere of loss memorialized in the fetishistic ritual of gathering and weaving locks of hair. But the loss is troubled by the in/temperance of hair crawling, growing, and feeding on the walls. It wants to take over. In this instance the space reverberates between an excess of loss and an excess of fecundity, where in tension and uncertainty, the doubling questions the bodies boundaries relocating the body as relational and intercorporeal.

* * *

Reconstituting body image as fantastical and becoming involves *pedagogies of excess* where knowing is constantly interrupted and deferred "by the knowledge of the failure-to-know, the failure to understand, fully, once and for all" (Miller, 2005, p. 130). It is the unthought which is felt as intensity, as becoming, and as inexplicable that reverberates between self and

other, teacher and student, viewer and image, compelling a complex interstitial meaning making process. Writing about pedagogical relations, Ellsworth (2005) states:

> In excessive moments of learning in the making , when bodies and pedagogies reach over and into each other, the pedagogical address and the learning self interfuse to become "more" than either intended or anticipated. In some cases, they becomes more than they ever hoped for. The instability and fluidity of pedagogy hold the potential for an unknowable and unforeseeable "more," and the actualization of that potential is what springs the experience of the learning self. (p. 55).

This "more" or "other than" shifts teaching and learning away from representation of something with a meaning to an aesthetic assemblage, which moves, modulates and resonates through processes of becoming.

In proposing *pedagogies of excess* I draw on poststructuralist feminist pedagogies (Villaverde, 2008). In her critique of critical pedagogy, Ellsworth (1989) reminds educators that pedagogies need to move away from "reason" and recognize that thought, knowledge, and experience are always partial— "partial in the sense that they are unfinished, imperfect, limited; and partial in the sense that they project the interests of "one side" over others" (p. 305). Shifting emphasis from "empowerment," "voice," "dialogue," "visibility" and notions of "criticality," poststructuralist pedagogies problematize partiality "making it impossible for any single voice in the classroom...to assume the position of center or origin of knowledge or authority, of having privileged access to authentic experience or appropriate language" (p. 310). Rather, as Leila Villaverde (2008) suggests, it is important that pedagog(y)ies engage with "dangerous dialogues" in "order to expose the complexity of inequity and our complicity in it" (p. 125). Deborah Britzman (1998) asks similar questions about the production of "normalcy" in the pedagogical encounter, creating the myth of the stable and unitary body/subject as the centre from which all else deviates. Unhinging the body from such normalizing practices, how might *pedagogies of excess* "think the unthought of normalcy" (Britzman, 1998, p. 80)? Unsettling and rupturing the limits of normalcy and representation *pedagogies of excess* help us "get underneath the skin of critique ...to see what grounds have been assumed, what space and time have remained unexamined" (Roy, 2005, p. 29). Furthermore, *pedagogies of excess* stress the need for an ethics of embodiment where transformations are connected to body and flesh and to a perception of the subject as becoming, incomplete, and always in relation. Thus, ethical action becomes unpredictable and adaptive (as opposed to enduring and universal) and what happens when we venture into the complexities of the unthought.

Pedagogies of excess compel us into a place of knowing that is aware of how much it does not know, leading us to an elsewhere that is replete with what Barbara Kennedy (2004) calls an "aesthetic of sensation." An aesthetic of sensation "is not dependent on recognition or common sense" (p. 110), but operates as force and intensity, and as difference. This, argues Kennedy, has significance for the way we approach perception. Visual culture—images—then shift from being "representation" to a material embodied encounter as sensation. Images do not exist as static forms, but are experienced as processes and as movement. An aesthetics of sensation is not an aesthetic based on "normalcy" or structuralist semiotics, but an aesthetics that vibrates and reverberates in modulation with, in, and through bodied encounters, shifting such concepts as "beauty" from form to a process—an assemblage. Thus, in *pedagogies of excess* movement becomes an essential element. For instance, in the installation "Excess," the tendrils of hair that litter the gallery floor begin to attach themselves to other hosts—creeping up the gallery walls, clinging to visitors' shoes—slithering around only to be set in motion once more; the gasping gagging reflex of hair caught in one's mouth spit out until devoured again. The movement and sensation of the hair are not perceived outside of the body, but "rather affections localized within the body" (Kennedy, 2004, p. 118), thus materializing a pedagogical encounter imbued with forces, oscillations, intensities and energies. At the heart of *pedagogies of excess* normalcy, the common, and representation become un/done, entangled again and again as difference, as "hair balls" that grow, and feast, and exceed the limits of knowing, being, and creating.

Corporeal Cartographies: Materializing Space as a Textual Narrative Process

I love the idea of maps. As a nomad of sorts, a dreamer, traveler, and mover (I have lived in a dozen cities in four continents with a considerable amount of time spent dwelling in-between), I find maps an important means of orienting myself to new spaces. Maps facilitate new knowledge of the world. They enable discovery, exploration, and unending possibilities.

However, the maps I find most compelling are narratives, sometimes found in guidebooks, others posted on websites, and then there are those that are novels, short stories of places and travel adventure. I love to read these narrative cartographies, imag(e)ining places and encounters, searching, disclosing, and inventing the world in which I live. These types of maps are experienced and offer possibilities of what is yet to come, rather than simply reproducing what is known. These maps are less about orienting myself on the grid, and more to do with losing myself in discovery and the unknown.

Contemporary mapping theories argue that mapping is a creative activity that focuses on the *process of mapping* rather than on the object of maps (Cosgrove, 1999). As opposed to traditional views of maps as stable and complete, contemporary cartographies recognize mapping's partial and provisional nature. Thus, mapping is not just an archive of projected points and lines onto a surface, often referred to as a trace; it is a dynamic and complex actualization of un/foldings. While traditional maps chart and graph the lay of the land, codifying, naturalizing, and institutionalizing conventions, contemporary mapping that finds its place in visual art and culture, views maps for *what they can do*, the potential and possibilities of the unnamed. This mode of thinking finds the agency of mapping in its ability to uncover or to un/fold (Corner, 1999). The mappings that I find so

compelling are ones that inaugurate new worlds, opening bodies to other bodies and encounters. Furthermore, mapping as process argues that the "experience of space cannot be separated from the events that happen within it; space is situated, contingent, and differentiated. It is remade continuously every time it is encountered by different people, every time it is represented through another medium, every time its surroundings change, every time new affiliations are forged" (Corner, 1999, p. 227). Rather than a view of space as an empty vessel that objects are placed within, my arguments are located in theories of space that link space with corporeality and subjectivity. Therefore, what we need to examine is how spaces and bodies are simultaneously created in the process of mapping as intertextual narratives. Instead of mapping as iconographic deductions or representations, I want to think of mapping as engagements that are enfleshed intercorporeal becomings. By challenging the idea of a map as an orientation that relies on points, I explore the possibilities of narrative cartographies as textual interconnections between body and space.

In this chapter I examine short segments of student-created videos, investigating how these works of art question subjectivity, representation, and meaning making in relation to bodied space. I draw on contemporary mapping theories that conceptualize the process of mapping as disruptive and differential, and which enable alternative ways of imag(e)ining space. My guiding question is: How do youth construct and negotiate the body with, in and through space as visual narrative text? Examining student videos that transform "boxes" or relocate "shopping carts," I use a cartographic approach in order to provide new figurations and alternative representations of bodily space—a kind of living map. According to Braidotti (2006), cartography engenders a nomadic subject rendering knowledge in a permanent process of transition, hybridization, and in-betweenness.

Rather than posing curricular questions "about" the body, or how "the body" should be taught in education, my analysis discloses the ways that students creatively engage with nomadic subjectivities. The significance of curriculum envisaged as enfleshed and intercorporeal space lies in the possibilities for reconstructing teaching and learning as variable, heterogeneous, and discontinuous, where enfleshment increases the capacity of teachers and learners to engage in the complexities and difficulties of life's unknowingness.

Un/folding Boxes: The Agency of Mapping as Un/folding

It's a clear blue, crisp day. Inside the classroom I move between students, helping one thread a sewing machine, another add a music soundtrack to an i-movie, and stop to talk to two others as they search the Web as part of their artistic inquiry. Sounds of laughter add to the already noisy room, and I glance up and out the window. Cameron has boxes on his feet and is comically attempting to walk up the sidewalk toward the front doors of the school. In front of him, Tyler and Andrew direct his movements, a video camera cradled in their hands. I smile as I watch Cameron stumble, the enormous boxes disrupting his movements as he propels his now overlarge "feet" up the stairs.

Later, Bronwyn the art teacher beckons me into the hallway. There, the students have arranged the boxes and are filming different students getting into and out of the boxes. Weeks later in a class discussion Bronwyn suggests that schools put people in boxes, a comment that embodies the pedagogical directive "to think outside the box." But the students disagree with this statement, not objecting to the notion that education occasionally encloses students, surrounding them with stable objectives and fixed results. Their disagreement has more to do with what they imagine the re-configurations and assemblages of the boxes *can do*. Thus, instead of reading the meaning of the boxes as static, empty, identifiable markers, the students were interested in the activity and process of the box as embodied space.

Andrew responds to the class discussion: "But these boxes are too small, the students' bodies—much larger. The boxes are also open. The boxes are about mobility and change. We can get in and out whenever we want, wear more than one at once, discard them at random." Over the coming year as I returned to view the video "Monkey Puzzle," I paid close attention to the activity of the boxes and their transition throughout the school. These boxes did not contain bodies, they were not vessels into which information was placed, but rather the boxes moved in-between; in the threshold of bodies and space.

At some point in the semester I discovered an artist who un/folds boxes virtually. John F. Simon Jr.'s virtual art installation is a computer-designed artwork that un/folds a cube (box) at the "click of the mouse."[10] When you enter the site you find a blank cube. The viewers' activated response from the mouse causes the cube to un/fold in infinite patterns. Each folding produces lines or traces of past un/foldings that previous participants created. On the Guggenhiem website the unauthored curatorial statement reads: "For example each leaf of this 'book' that has been turned four times in the past is

marked with four vertical lines; a horizontal line, meanwhile, stands for ten such un/foldings; and left and right diagonals denote hundreds or thousands of previous clicks. The pattern of lines thus changes over the course of the project."[11]

In contrast to representing a single image, "un/folding object" presents every possible permutation including those that are "other than," ones that are yet to be conceived and articulated—infinite possibilities and materializations of space. Any change to the pattern of folding results in an entirely different set of possible images. What does it mean to encounter images, bodies, and/or spaces that continually change towards infinity?

On the site, Simon describes his work as "an endless book that rewrites itself and whose use dictates its content" (n.p). Similarly, Simon's work is performative; its mutations allow for the latency of the body to un/fold and map in space and time. The infinite creation maps the something else, moving beyond representation towards the infinite possibilities of experience. Rather than simply mathematical, "un/folding object" is tactile; participants touching and connecting within a cyberfold.

Likewise the students' boxes continue to map space as intercorporeality. Boxes appear again in a subsequent film entitled "Monkey Puzzle II," and are taken up in a number of classroom narratives throughout the school year. Instead of transforming the boxes through a "click" of a mouse, the boxes are moved, worn, cut into, disassembled and circulated suggesting the potential for new possibilities and fresh discoveries. In fact in one video episode "the box" dies, a memorial service is performed, and a number of students and teachers are interviewed in the school asking them to say a few words about "the box."

Opening either bodies or boxes, we rupture the links that we assume automatically exist between things, words, spaces and bodies. Tyler informs me that the boxes are entangled, they are threads between all of the various videos, but they are not boxes that contain or hold things in the ways that we traditionally think of boxes. Boxes are more than empty space that needs to be filled. Rather, the box embraces intercorporeality mapping narrative text as process and transformation.

Pedagogically, in place of "thinking outside the box" a more apt metaphor might be to un/fold boxes and spaces, to materialize knowledge, to touch it in such a way that endless, infinite, and unfathomed processes can be explored. "Outside the box" imposes order and containment to the inside, separating it from what lies external to it. In contrast, un/folding does not separate inside and outside; rather it opens each onto the other, rendering the "map" as a fluid, anamorphous space. Un/folding invites the corporeal body

into the threshold, a dehiscence of difference that is inside the outside, rupturing the visible, the map, and discovering new sensory becomings.

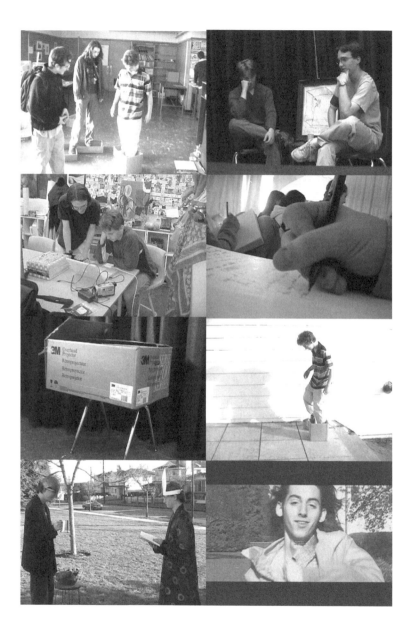

Shifting our focus to another segment in the "Monkey Puzzle" film, we spend time analyzing a section where Tyler is writing in his journal. The students have discovered the possibilities of the reverse function in i-movie so that the act of writing moves backwards. They find this exciting and as we sit and explore this section together they begin to ask questions and think through this gesture. Andrew tells me they are "un/writing." Initially their responses position this act of un/writing as a move backwards. Andrew states: "Clearly," he says, "it's like the un/writing takes away the writing and leaves just this pristine page," and Tyler interjects "it's cleansing." However, as we move through our discussion I ask them if they see this movement as a negative affect. Andrew is quick to respond: "It's not an act of destruction like if you took a part a Leggo house. It is not being deconstructed, it is more like different knowledge." He continues, "It's not really positive or negative—it's in-between." At this point in our conversation Tyler interrupts "It's not just about our bodies, but how things affect our bodies and how our bodies affect things."

Following Tyler's statement Andrew continues with the idea of un/writing, relating it to the concept of un/doing:

> Another thing I like about this un/writing is that when you reverse it, and you are witnessing this action take place at some point along that point in reverse, you realize that it is something that has been reversed; then by the time the un/writing is finished you've figured out it's in reverse so in fact he is actually about to start writing, so it is almost that what you just saw didn't actually happen. Because you are actually at the start now. At the end you realize it's the beginning and what you have witnessed has never actually occurred.

As they continue to discuss the un/writing, Tyler says: "there was one other thing that I noticed here. I'm going to play part of this clip. At one point I erase something and that's putting something back in." Andrew responds: "Now that would be a different angle." I'm not so quick and I have to ask: "What do you mean putting something back in." Tyler explains: "Because when you are using an eraser [remember they are using the reverse tool] it's doing the exact opposite the tools are reversed. Its like a double reverse of writing."

The idea of peeling away successive layers of meaning, of looking beyond or beneath the surface takes the notion of trace as a starting point. The palimpsest is a perfect metaphor for this process of layering. A palimpsest, according to one source, is a medieval manuscript where text is erased in order to make room for subsequent writings (Gerber, 2003). Viewed in this way, the act of erasure is a "making room" for new information. In this act of erasure removal is never complete.

Traces are left, in some cases literally, but also metaphorically, embodying the memory and history of the trace. Other configurations of contemporary palimpsests include torn posters on billboards, signs with missing letters, stamps and envelopes with traces of travel and even a chalkboard. These suggest yet another, but similar meaning to the word palimpsest, where the object becomes a vessel or container recording the history and memory of its experiences. A number of artists have explored the idea of the palimpsest, where in the instant of erasure something else is created. In this sense the erased becomes more than just a negative or a non-attribute. In "Monkey Puzzle" the un/writing scene and the doubling of erasure did not simply remove text and return the piece of paper to its previous stage, in the process of erasure the remnants of pencil becomes a deliberate making of new possibilities.

The metaphor of the palimpsest lends to Derrida's (1997) concept of "sous rature" or writing under erasure, where in meaning there is an always already absent present. Gyatri Spivak, in the preface to Derrida's *On Grammatology*, translates Derrida's text: "This is to write a word, cross it out, and then print both word and deletion. (Since the word is inaccurate, it is crossed out, since it is necessary, it remains legible" (in Derrida, 1997, p. xiv). In other words, the trace of the word remains present. It is the idea of "trace" that Derrida puts under erasure, a word, writes Spivak "that cannot be a master-word, that presents itself as the mark of an anterior presence" (in Derrida, 1997, p. xv). Accordingly one could transcribe the word "difference" here as well. The trace of a word is its absent "something else." Extending this reading we might consider the active form of Derrida's term. Derrida's use of the French phrase "sous rapture" implies that his focus could be turned away from settling on fixed meanings of terms, towards the *activity of crossing* something out that thereby leaves a trace. This trace is no longer a static point of meaning but instead has been transformed in the process of erasure. So while in *On Grammatology*, trace is translated as track, a meaning more inclined with traditional maps, and points of origin, I'd like to consider the *trace as a process*.[12] Thus, I'd be disposed to rethink the metaphor of the palimpsest from vessel or archive of past meaning, which would imply a container of closed boundaries, to a more rhizomatic configuration, where the *act of crossing out* turns from a remainder or an absence, towards a reconfiguration of mark making as not only new knowledge, but knowledge that points to possibilities that are yet to come, further tracings. In "Monkey Puzzle" the act of erasure is not a making room for something else, but alternatively a process of foraging new connections

and understandings. Erasure shifts from the removal of something to the act of creation, a being in the midst of space as intercorporeality.

We often think of space as a void or a kind of emptiness in which events or phenomena occur. Metaphorically, we use the term space as in "literary space" or "public space" to describe what had been added to it or arranged in it (Roy, 2005). However, space in a Deleuzian sense is fragmented, rhizomatic, fluid, ambiguous, vulnerable and open to constant change. Space is linked with how one encounters, constructs, and performs the body, thereby mapping the relationship of space to subjectivity and ways of knowing. In other words the body is not simply in space (an object placed in a particular location), but rather the body is spatial itself. Feminist scholar Elizabeth Grosz (1994, 1995) contends that an understanding of the ways in which subjects occupy, materialize, and disrupt space is predicated on an exploration of how bodies and spaces define and shape one another. Space becomes both the production of culture, and the making and circulation of intersubjective experiences. This notion of space is what Rosi Braidotti (2006) calls "enfleshed materialism" (p. 5). Materiality in this sense does not refer to the body's natural or biological structure, but to "the complex interplay of highly constructed social and symbolic forces" (p. 21). Moving away from psychoanalytic ideas of the body as a map of semiotic inscriptions, enfleshed materialism envisages the body through intensities, flows, and affects. Thus, the embodied subject becomes a process of intersecting forces and spatial connections—a becoming body. Louie's use of a shopping cart in her video "Stuck" embraces this notion of enfleshed materiality—rendered on film in sound, rhythm, and a sensation of physical discomfort.

Cartographical "Other Thans"

A shopping cart takes a trip to the beach. The scene is dusk, blue light casting moonscape-like shadows along the shore. The tide is out making the sand soft and rippled. A young man steers the cart, pushing it awkwardly in the sand. It gets wedged in the sand, inciting the title of Louie's film: "Stuck." The pushing movements appear directionless, the young man is neither going towards the sea nor further inland, he is simply struggling with the wheels of the cart that sink further and further into the soft darkness. The struggle un/folds in split time as shots move between the cart at the beach and an underground parking lot, where a young woman, face solemn, pushes the cart between rows of parked cars. Again spliced camera angles create a

sense of movement that is adrift, wandering. The dimly lit beach scene and the dark concrete space of the parking garage evoke a sensation of physical discomfort—of pushing endlessly and in exasperation while simultaneously avoiding the perils that might lurk in the dark.

While there is a direct confrontation with urban space and outward surroundings, the film creates an inward awareness and almost a detached sense from the urban scene. We see the characters but imagine and feel their invisibleness, as if the people are part of the backdrop of beach and garage and we are watching a solitary shopping cart on a voyage. Voices and sounds have been removed, replaced with a soundtrack of a popular song. Only the opening segment where the cart speeds away from the camera and the final segments in the parking garage do the sounds of the outside world, the urban core, filter in, creating a sense of tension between the physical space of the city, and the materialized corporeal space of the film. Although "the city" is limited to scenes of a beach, with sprawling urban growth visible in the distance, and a parking garage, the shopping cart is an emblem of urban life, consumerism, and a marker of habitual time—shopping. Yet, the cart is empty, accentuating the coldness of its metal structure, allowing it to become a cage or border between the viewer and the person attempting to move the cart. In her journal notes she's written: "It's staining us this excess of stainless steel."

Unlike the "Monkey Puzzle" films, where actors and cameramen change places, "Stuck" is filmed and directed by Louie, bringing the surface of the film even closer to the viewer, as if we are inside interfacing with the "skin of the film" (Marks, 1999, p. 127). The differentiated and shifting perspectives between beach and garage become a means of moving between stories while exploring multiple selves that haunt space. Questions about representation are applicable, as the film shifts between spaces and locations. There is an awareness of interconnected views that examine the relationship between bodies and spaces, the expansiveness of the beach and the concrete mass of a parking garage. The shopping cart as its moves between scenes precludes any simple linear narrative, as memories jostle amid a shifting present. It opens up a prospect of a passage through which we discover spaces that exist within space, and the body's relationship and weaving with, in, and through space. Writing about film, Barbara Kennedy (2004) suggests that when knowing is perceived of as an encounter an aesthetic emerges which is not dependent upon recognition or common sense. Rather, the aesthetic operates "as a 'force' and as an 'intensity' in a differential relationship" (p. 110). This Kennedy contends has significance for how we encounter the cinema: "What we see on the screen may not operate merely as

'representation' but as signs of material encounter, as sensation" (p. 110). "Stuck" becomes an event in which the images on the screen are not read as literal "shopping carts" for instance, but as "transitions, pulses, elements that allow variations …to thus allow endlessly changing 'locomotions'" (p. 111). This impacts how we might understand or interpret student narratives. The images function, not as representations of youth bodied thought, but as force and intensity. The encountering subject is included in the film/images/ encounter, not as a fully integrated body (see Sobchack, 1992) but as a body that is still becoming.

In class discussions, students related to the video through walking metaphors. Walking suggests paths that others have walked before, a collective walking; a walking that is not solitary but joined with all of the past and future walkers and places. These multiple walkers break down the idea of an individual autonomous self through interconnection; an invasion of sorts between bodies and spaces.

Cartographical scholar James Corner (1999) proposes three thematic ways in which new practices of mapping emerge, and each of them produce certain understandings of space as embodied, relational, and intertwined: *drift, layering,* and *rhizome.* I want to focus on the interconnections between these themes and the videos.

Walking as drifting creates a condition of lived experience that produces unexpected encounters between bodies. Corner (1999) contends that drifting allows for a process of "mapping alternative itineraries and subverting dominant readings and auth-

oritarian regimes" (p. 231). More a form of embodied mapping where the body becomes part of the space and social surroundings, drifting is ephemeral, vague, and explores the un/familiar terrain of meaning making. Drifting turns knowledge from distant and objective towards an understanding of proximity—an intimate distance.

Canadian artist Kirsten Forkert's walking project entitled "Public Time" examines the places one moves through everyday, but where one never stops, because you have no reason to spend time there.[13] Her project gathered a group of people together and walked through a section of an urban city in Canada, examining the spaces between destinations—the gaps and moments that one does not readily pay attention to. Her intervention also required participants to actively engage in the process of walking as opposed to being distant observers. Instead of claiming space, the movement or drifting engages questions such as what it means to define a public, a group or a collective experience as an interconnectedness between bodies and space in-the-everyday. In an urban environment that privileges efficiency and the directedness of destinations, Forkert's walking interrupts bodied encounters of walking and space.

Walking becomes a corporeal cartography where distance is measured through uncertain means. The walk interconnects body and space enabling a particular set of events to create meaning through alternative gestures. Traditional mapping is contingent on making something visible, tangible, and concrete. Forkert's work is temporal, relational, and sometimes invisible. Invisible in this sense does not mean, that which cannot be seen, but rather it is visible through other perceptions than sight alone.

Similarly, "Stuck" depicts a cartography of enfleshed materialism, where space is not simply a backdrop to events but "a living participant in the enactive moment" (Roy, 2005, p. 30). Space as enfleshed is a process of connective relations where flows, intensities, and forces between these relations produce generative possibilities. In "Stuck" the beach and garage are no longer fixed or inert backgrounds against which things occur but rather they become contingent and participative, complex bodies creating new ways of organizing thoughts, events, and meaning. Deleuze and Guattari (1987) refer to this as haptic space, which induces new becomings through connections, deterritorializations, intensities, and an infinite succession of linkages. Haptic space is also tactile (Marks, 2002) and attends to particularlity rather than distance. Curriculum envisaged as enfleshed or as haptic space would mean paying closer attention to the things we normally ignore, but would also preference a sensibility of disorientation, propelling us along a different path. Space, as a network of proximities, brings bodies

together as being(s)-in-relations that lead to new assemblages, meanings, and outcomes. Enfleshed space moves away from issues of representation and recognition to processes and endless becomings. The significance of a curriculum envisaged as enfleshed space lies in the possibilities re-constructing teaching and learning as variable, heterogeneous, and discontinuous. Like the shopping cart, curriculum would have no constant directionality and would undergo continuous change in orientation.

The student videos map and reveal space, not as representation but as intertextual narratives that call attention to the body's relation to text. Meaning is not "in" the text, but in the relations between texts, bodies and the acts of reading, writing, and meaning making. In place of narrative threads that are meant to bring points together through common connections, the obscurity of intertextual narratives in these videos is a circling through words/images/sounds where meanings never find a final resting place. As opposed to text as a discrete unit or an object with a linear traceable history, intertextual narratives are becomings that connect in unpredictable ways. In place of points or an iconographic representation of mapping, becomings are created through a series of conceptual rather than physical lines. One extracts concepts by mapping the lines, providing a cartography that can be pursued in any number of ways. "The map is open and connectable in all of its dimensions; it is detachable, reversible, susceptible to constant modification. It can be torn, reversed, adapted to any kind of mounting" (Deleuze and Guattari, 1987, p. 12). Such mappings are intertextual interstitial spaces that indicate "other thans" and point towards emergent stories, complicating things instead of reducing them to universal points or markers.

The videos investigate the construction of subjectivity as narrative. They are testaments to the students' urge to construct scenarios and narratives around everyday encounters that fringe on the bizarre and yet are strikingly real. Watching the films as characters move in and out of boxes, or pushing shopping carts, there is an underlying presence beneath the narrative that we are not simply watching, but participating in a world that dramatizes life, to make it real by making it filmic.

The "Monkey Puzzle" videos demonstrate a concern not only with exploring spaces that are dynamic and undetermined, but also with memory. However, it is not the excavation of memory, a palimpsest as vessel, but a narrative intertextual cartography of the body that is patterned on new assemblages and meanings.

In "Monkey Puzzle II" the students adopt different characters throughout the film. There is no feedback loop though, as, say, Andrew appears in a variety of roles, and sometimes the same role surfaces with a different

student playing that role, so that it too shifts and slides. Without these points in the film to ground the narrative (he plays this character, this character does this, and assumes these characteristics) self-identifications become ever more complex. Devoid of the need or desire for identification, the subject is free to travel, to map, with the intensity of each new moment, but without building these moments into stable structures. Subjectivity becomes part of a flux of forces with no stable pattern. Andrew can exchange himself within himself, just as he may exchange himself with others. Without points of origin in the films, there is no repeating formation of the same. Similarly, memory is no longer structured on the trace as the successive layers that link back to an original surface. Un/writing writes the body with, in, and through space, engaging its ambiguities, activating and interrogating inbetweens, and unlayering the trace as a process of erasure. Un/writing refigures the body as a site from which and for which youth can create multiple spaces of agency, subjectivity, and representation.

There are references to a past, but even these references are elliptical rather than successive. For example, in the opening scene of "Monkey Puzzle II," Andrew as director describes how and why "Monkey Puzzle" [the first film] was created. Scenes later, James is the director, and his narrative references previous films/scenes, but takes on its own interpretations and mutations. It's memory within memory not as a fixed trace but as intercorporeal mapping. Traces filter into the present tense, reminders of previous steps that may not have existed, intertwining memory with the present, not through linear tellings, but as evocative new constructions and stories.

The theme of disappearance runs through "Monkey Puzzle II" and "Stuck," but not in the same way that one traditionally views the disappearance of history, memory and artifacts fading from the presence, leaving only ghostly traces. Instead, disappearance happens suddenly as scenes abruptly shift, only to perhaps appear again in another form. There is a disruption to space, like in a dream where the fixity of space and the linearity of time give way. In the gap between the scenes, as they are seen by the viewer, described by the sometimes narrator, and experienced by the actors of which you are apart, questions arise about the (in)stability of what is transformed before you.

What I'd like to consider is how these cinematic encounters are palimpsests understood as acts of erasure that forage new meanings and materialize intercorporeal textual and spatial relations. Again, Corner (1999) offers layering as a thematic development in contemporary mapping discourse. Layering, he argues, is a thickening process, where each layer is

considered independent of the other. Layers are not "mappings of an existing site or context, but of the complexity of the intended programme for the site" (p. 235). The layering of layers produces a stratified spatial arrangement, stratified being another rhizomatic-based term. The resulting structure is not simply a "track-trace" of original layers, like ghosts, but "a complex fabric, without centre, hierarchy or single organizing principle" (Corner, 1999, p. 235). This process of layering functions to establish the indeterminancy of meaning making, while remaining open to new and multiple configurations and inter-textualities.

Layering thus becomes un/folding where the addition and movement between layers creates further combinations and assemblages. In this way the palimpsest moves from vessel of historical topography, towards a intertwining that suggests something else altogether. Instead of the palimpsest containing traces that are absent, the palimpsest becomes a spatial surface, a threshold that in excess and the fullest of presence points towards an "other than", meaning that is unfamiliar.

Interrupting Curriculum Cartographies

As a countermove to current initiatives in education that are based on standardized, disembodied, and dehumanized models, an approach to curriculum as enfleshed offers possibilities for teaching and learning as something complex and discordant. As Alyson Huntly (2005) maintains, "the aim of teaching and learning should be to restore life to its original complexity" (p. 100) denouncing the tendencies to "create out of disordered chaos an order based on rigidity, uniformity, and sameness" (p. 100). Deterritorialized space interrupts the drive towards sameness by uncovering complexity and exposing difference. Because knowing is always incomplete and partial it recognizes the difficulties inherent in bodied encounters where otherness cannot be reduced to the same. "Knowing the partiality of our own horizons, knowing that where we stand is not where everyone stands nor where we will remain, enables us to form alliances for action in which differences thrive, enabling us to live more fully in life's original complexity" (Huntly, 2005, p. 112). Similarly, bell hooks (1994) argues that an engaged educational act seeks to transform both student and teacher. This transformation cannot happen, she writes, unless we embrace the vulnerability of inquiry. Vulnerability recognizes that knowledge is felt, that it is sentient, embodied, and deep. Rather than a view that understands interior knowledge as inferior, intercorporeality un/folds inside and outside

disrupting patterns in an attempt to create meaning through entanglements and spatial realignments—a mapping as trace and as process.

Curricular encounters through touch enhance moments in knowing and understanding that are unfamiliar. Touch becomes a commitment to knowing that is engaged, emphasizing bodied encounters that are interrogative and unsettling. I am reminded of David Smith's (1999) hermeneutical writings on ambiguity and uncertainty in curriculum inquiry. Western thought, he argues, emphasizes structural order and universalism. Instead he contemplates a space premised on disorder: "Disorder also reveals the limits of language, that is, the resistance of things to be fully named, yet also to the pull of freedom which lies beyond names but is itself the silent generosity out of which things find their voice" (p. 127). What lies beyond is not an absence, but unknowingness and the unfamiliar. It is this space that ruptures the expected, the same, and the stable. To pose questions about the not yet known is to open up possibilities, to examine the border, the limit, and to map "what we do not understand and for which we may not at present have words" (Smith, 1999, p. 128).

This chapter, and the book in general, responds to Lisa Cary's (2006) call for new curriculum theories that move beyond lived experience as *Currere*. Enfleshed cartographies open up a space for other ways of understanding a living curriculum based on sensation and flows of interconnecting spaces endowing curriculum with contradictions and complicated knowledge. Moreover, intercorporeality connects curriculum theory and educational research, centering "knowing and spaces of knowing as a discursive production that shapes the educational experience on all levels" (Cary, 2006, p. 134). It is an ethical turn toward responsibility in research and in teaching. It takes us out of ourselves, out of our customary routines and assumptions. Intercorporeal cartographies as visual narrative text refuse to be grasped, to become pinned down and held. Rather these bodied encounters flicker and slip, affecting a release, and bringing us into the world itself. All at once new maps occur, a touching that glides across, colliding with other maps, pulling apart the space between.

Cookies for Peace and a Pedagogy of Corporeal Generosity

C ontemporary artist Sophie Calle has a fascination with the strange(r), revealing and embracing the uncanny of-the-everyday. For example she: hired a detective to follow her and document her movements; found a lost address book and then wrote to everyone listed in the book asking them to describe the person the book belonged to; worked as a chamber maid in order to document the personal belongings of guests in each room; inhabited the life of a character from a novel; and hosted a birthday party for herself each year where guests were required to bring gifts that would be documented and preserved in curiosity cabinets. Her methods include meticulous documentation, observation, and surveillance—mundane gestures that explore the moments of sociability and art of the everyday.[14]

Sophie Calle's interventions create possible moments of interaction, whether inviting people to attend a birthday celebration, or by inhabiting a phone booth in a large city. They are rituals of the instant, the moment, and the mundane. By altering the moment, making the encounter susceptible to modification, and putting things to strange new uses, Calle gestures at meanings that are not named, but that are present.

Since the 1960s, visual artists have engaged in what has commonly come to be understood as site-specific work. Miwon Kwon (2002) identifies various permutations of this form including site-determined, site-oriented, site-referenced, site-responsive, and site-related. All of these various terms are concerned with the relationship between the art work and its site; how the production, presentation, and reception of the work incorporated the physical

conditions of a particular location (Kwon, 2002). However, as Kwon argues, the term "site" itself needs to be redefined not through physical or local terms, but as a complex figure in the unstable relationship between location and identity. In other words, "sites" are not geographically bound, but informed by context, where "context [is] an impetus, hindrance, inspiration and research subject for the process of making art" (Doherty, 2004, p. 8). Site is not a fixed category but constituted through social, economic, cultural and political processes, which Nicholas Bourriaud (2004, 2001, 2002) calls *relational aesthetics*. Like Kwon, Bourriaud contends that in "site-specific" art or "situations" (see Doherty, 2004) both process and outcome is marked by social engagements. These encounters break down the conventional relationships between artist, art work, and audience. The artists and art works that are the subjects of Kwon and Bourriaud's investigations create art as a socially useful activity: "The forms that [the artist] presents to the public [do] not constitute an artwork until they are actually used and occupied by people" (Bourriaud, 2004, p. 46). In this instance the audience moves from beholder of art (interpretation) to interlocutor (analyser). In many instances audiences are actually called to a specific time and place where they become active participants in the art work and, thus argues Bourriaud (2004), alternative modes of sociality are created.

This chapter examines three student artworks—an email-generated artwork, a mail art piece, and an intervention-based performance work—through the perspective of relational aesthetics. In the first section, I focus on student understandings of body knowledge that unravel in an email-generated art project entertaining the question: How is touch encountered through digital environments (see Springgay, 2005a)? From here I analyze a mail art[15] piece and attend to the practice of giving, examining the ways in which bodies and knowledges are produced through such encounters. The final section in the chapter considers a public intervention as a pedagogy of corporeal generosity. Pedagogical implications will reconsider what it means to give and create meaning that is relational and corporeal.

Cyber Touching

Marshall McLuhan (1994) asserted that the era of information communication technologies was moving "out of the age of the visual into the age of the aural and tactile" (p. x). Likewise Cathryn Vasseleu (1999) contends that in naming "touch—as well as hearing—as a privileged sense of the electronic age, McLuhan recognized the emergence of an era of

communication characterized by the disappearance of all sense of distance in a proliferation of contacts involving multiple senses" (p. 153). Sadie Plant (2000) reiterates these thoughts, asserting that hypermedia allows the senses to collapse and connect. "Touch is the sense of multimedia, the immersive simulations of cyberspace, and the connections, switches and links of all nets. Communication cannot be caught by the gaze, but is always a matter of getting in touch, a question of contact, contagion, transmission, reception and connectivity" (p. 332). Touch constitutes an embodied experience that is not detached from the world, nor reducible to the body itself. Touch poses an alternative theory of vision, where vision is not structured as distant, separate, or in advance of an encounter, but formed in relations between subjects. Vision thus becomes an embodied interaction with the world. Charles Garoian and Yvonne Gaudelius (2001) further such claims arguing that the physical/virtual is not signified "as a disembodied ontology, but embodiment that is in a continual state of liminality, contingency, and ephemerality" (p. 338).

Returning to the two modalities of touch introduced in Chapter One, the first, skin on matter, is often likened to the physical aspect of typing on the keyboard or moving the computer mouse. The second mode—proximity— implicates bodied encounters in the process of meaning making in an online environment. The question that un/folds is this: What student understandings of body knowledge unravel in an email-generated art project?

Uncovering the Unexpected in an Email Exchange

In the thematic exploration *body encounters* students engaged in critical discussions on globalization, communication, and consumption, and the ways contemporary artists have taken up these themes. Students contextualized this through their own interests in graffiti and subvertizing, in particular, the journal *Adbusters*. I introduced students to the concept of mail art. Discussions included the concept of a work of art *as* circulation.

Andrew generated an email that he randomly sent to over 200 addresses. I supplied him with addresses from my address book including a number of list serves at the University. The list serves provided him with mass mailings instead of specific individual email addresses. Andrew spent a considerable amount of time creating the initial email so that it would not appear like a virus, and thus immediately deleted from an individual's inbox. Originally, the impetus for the piece was to focus on the transmission of email, which occasionally malfunctions, sending emails to the wrong people. Emails are often misdirected; individuals receive mass mailings of junk mails, and

viruses fill up our inboxes with random messages. Misdirections are often said to be "lost in cyber space," as if it is an "out there" physical reality. Andrew writes of his intent: "Strangely when we receive a piece of mail through the post office that is intended for someone else we tend to blame the actual person involved, while when we receive an erroneous piece of email we assume that something electronic is to blame." To send his first email, Andrew set up a Hotmail account under the pseudonym Marty Holsten, a name he felt sounded plausible. The email he signed MH, inscribing his identity as ambiguous. The email is a rather vague attempt at forgiveness, asking the receiver to move beyond the unsaid act that necessitated this forgiveness. The actual act of wrong-doing is left unclear.

I guess we all have things we'd rather have forgiven. I think in this case we all agree that it'd be best to just drop this here and now, and move on. Personally, I'm willing to forgive anyone if they'll forgive me. It seems like we've all just kind of fallen into something none of us want, and it also doesn't look like we're ever gonna figure it out. My vote's for just moving on. Things can only go up from here. Anyway, keep up the correspondence. –MH[16]

Andrew immediately received 32 responses. Some of the emails were simply one-line informing him that the email had been misdirected. However, a few emails were more specific and wanted to know what had instigated this forgiveness, and requested Andrew/Marty, to clarify his relationship to the receiver.

Marty,

Why are you writing me, re: forgiveness, which is of course the doorway to all inner spaciousness and freedom. I don't know you.
C

Andrew began to discuss his email project with the class. What had initially transpired as an act of forgiveness Andrew was now interpreting through an understanding of guilt. Andrew and a few of the other students believed that people had responded because they felt guilty.

> I think if you prompt them they will [respond]. People can always come up with something to feel guilty about even if they haven't thought about whatever for a really long time. If I just walk up and forgive them, then eventually they try and rationalize it by finding something that they feel guilty about.

Andrew continues: "But if you look at it totally objectively there is no reason why anyone would respond to the email. But yeah people seem to feel that being forgiven for something is plausible. It could certainly happen to them." Either the sender had done something wrong to someone and they needed clarification that this was in fact an email coming from the individual wronged, or individuals seemed to feel some sense of guilt in receiving a personal email that they believed was intended for someone else. By responding to Andrew, letting him know his email had been "misdirected," they might have been alleviating some of their assumed guilt.

I have received this email by mistake.
Please check your addresses and update to ensure your privacy.
J

From : L██████████████████>
To : "Marty Holsten" <martyholsten@hotmail.com>
Subject : Re: Apologies/Forgivness
Date : Mon, 14 Apr 2003 12:33:00 -0800

```
Hi Marty - thank you for your apology/forgiveness
but I'm drawing a blank about what this is about? I
just wanted to tell you that I'm not sidestepping
your words - my computer system crashed and I'm
only now getting it back into gear and back on
line. Movin' on is what life is about - but of
course, we carry what we've learned and experienced
always within the molecules of our bodies - best to
make peace always!
L███
```

Through interviews and in-class discussions Andrew mused that he had discovered a "cheap renewable source of guilt," but was also startled by the unexpected responses his project generated. Andrew's own guilt surfaced because he believed he had invaded people's personal space. What originated as a random act of forgiveness was returned to the sender as guilt.

> I think I've been developing some kind of guilt over this. Ironically I feel I need to genuinely apologize for this—because I'm tricking these people. The longer it goes

on the more complex it gets. I can't keep this going without giving any details whatsoever, and if I give any then it's not going to work. But there is a certain point that I can't just keep having this vague conversation. I want to actually tell them what I'm forgiving them for, but if I do I'll have to make something up and they'll know it's not real. (Andrew)

While email and the web constitute public domains, an individual email address is connected with a private or personal identity. Andrew's "invasion" caused anguish on the part of the receiver—who are you?—and similarly for Andrew, as he felt somehow he had deceived these individuals. The tensions and uncertainty between the private and public space, convinced Andrew to take the project in a different direction than he had originally intended. For his second email, responding to the responses, Andrew decided that the boundaries between inside and outside had shifted, necessitating that he disclose his identity and the nature of the email as an art project. Andrew decided that what had begun as a "random message sent to thousands of email addresses" had collapsed the distance between bodies producing knowledge of self and other simultaneously. As Andrew began to make connections between bodies, he created a second email in which *he* asks for forgiveness for his act of forgiveness.

All right, I have to come clean here; it was, in fact, a somewhat unorthodox art project under the guidance of [researcher's name inserted here]. The original premise mutated, for those of you interested, from my attempt to provoke an honest apologetic response, into something much, much stranger. My original message actually wound up generating feelings of guilt in me, for intruding, however minutely, upon your lives, and deceiving you. I'd be interested to know your responses to this info, and to my now-sincere apology. - Andrew 'Marty'

All but one of the original respondents wrote back a second time. Some were fascinated by the art idea and wanted more information about the project, while others continued to think through the nature of guilt and forgiveness.

From : ███████████████████ >
To : "Marty Holsten" <martyholsten@hotmail.com>
Subject : Re: Apologies/Forgivness
Date : Wed, 30 Apr 2003 10:33:00 -0700

well that's a relief!!:) - all those sleepless
nights trying to figure out who? what? why? when?
how? - !!

your email was a stop- a pause. Not knowing the
context of the apology - it was so beautifully
worded, that one could not, not respond, not, not
forgive - even without knowing what it was about:)
- which is interesting - to me it speaks to the
power of apology, of literally lying on your back,
neck exposed (as dogs do in surrender and admission
of the "cards are in your hands now" - terrible
mixed metaphors - but hopefully you understand the
gist of what I'm saying:)) Perhaps it suggests that
apology as an opening move within the negotiation
of difficult events is a good strategic move in
terms of conflict resolution. For it opens up to
the next step: what happened? why?(from your
perspective) - this is why I responded the way I
did?

thanks for coming clean - now you really do have to
apologize!! :)
--
L███

Andrew writes in his weekly reflections: "What interests me about guilt
is that it can be viewed as an external blame or as an internal weight. We can
all feel guilty for something that we have done that clashes with our own
personal value system, but we can also assign guilt to external sources." If
we think of guilt as an interior signification where moral consciousness
judges and condemns (Ricoeur, 1974), then forgiveness or freedom from
guilt is an exterior condition. This definition separates and makes distinct
interior feelings, which can be controlled and abated from the outside,
rendering affect as deeply personal and individualistic.

Megan Boler (1999) points out that this perspective designates emotions as natural and private conditions that individuals are taught to internalize and monitor through self-control. Through self-policing, individuals internalize social norms of emotions and their external expressions, "eras[ing] gendered and cultural differences through the discourse of universal biological circuitry of emotions" (p. 60). The ideal body is thus one who controls his or her emotions through rational choice. However, as Boler's critical project so aptly demands, how might we define emotions as a mediating space between bodies? In exploring this question Boler sets out a project of critical empathy and witnessing in which pedagogical practices and educational contexts need to attend to the emotional lives of students and to re-cognize the inherent power structures and struggles in the public articulation of emotions. Her arguments for emotional epistemologies bear significant weight in re-evaluating what counts as knowledge and the ways in which difficult knowledges need to be and can be addressed in educational contexts. Through a critical praxis of emotions, individuals will be able to publicly articulate different emotions, to listen with attention to all views and perspectives, and to learn to inhabit positions of ambiguity (Boler, 1999). While these outcomes are significant in the context of educational institutions that generally neglect the emotional and sentient lives of students, unfortunately her position continues to render the body as static. Boler asserts that communities (e.g., classes) are constructed from multiple identities, each of which embodies different emotions, and that critical emotional pedagogy needs to create spaces where these multiple identities can give voice to these feelings. This instance links emotion with identity and assumes that an individual's position is determined prior to a given situation. While we do carry with us bodied memories of emotions from past encounters, it is not the past that shapes lived emotional experience, but rather the act of remembering in the present. To remember a particular emotion from the past implies that in the instant of remembering in the present emotions are created (Ahmed, 2000). The act of remembering is an encounter in the present, an event that is unexpected. These encounters become part of the social interstice of lived experience. In constructing pedagogical contexts that attend to students' emotional lived experiences, we must turn to the threshold of experience, where body knowledge is created as an encounter between bodies.

In doing so, non-dualistic understandings of emotions entail a rethinking of the terms *reveal* and *conceal*. Instead of labeling emotions that are hidden through institutionalized, socialized, and politicized control as concealed, and the act of making public these emotions as revelation, an understanding

that continues to divide the two terms, we need to investigate how emotions are *created* in the act of an encounter.

In the email exchange Andrew initially believed he had caused people's emotions to simply surface. However, as he and I later discussed, these emotions, including his own, were not already given, but created in the instant of circulation and exchange. Emotions are not static. They mutate and change with each encounter, attesting to their fluidity. We should not view encounters from the perspective of revelation. Encounters do not reveal; they create. Bodied encounters produce revealed *and* concealed emotions, but not as binary opposites.

In responding a second time, Andrew chose to ask for forgiveness himself. This doubling of forgiveness Ricouer (1974) describes as an extreme form of interiority, where guilt anticipates punishment. Doubling occurs when we recognize that we have the potential and power to act against this guilt. It is this relationship of interior to exterior that dislodges the containment of guilt and shifts it towards the possibility of hope and forgiveness. Through the unexpected, Andrew's email correspondences between bodies altered the perception of guilt to the idea of forgiveness—to possibility and agency.

During the second phase of the project Andrew began to fold back on his acts of forgiveness, reassessing the ways in which emotions are constructed. "Guilt" he writes, "can be determined by us. Guilt forms cycles, in the sense that it causes and is caused by actions and feelings. It seems that the only way to break out of this circle is to move sideways, to understand that within guilt is forgiveness."

Andrew began to understand this act of forgiveness as an exchange, an economy of sorts, something people need and want, but are unable to purchase freely at the local supermarket. People felt compelled to respond to his email for a variety of reasons, reaching out and giving back, shifting and interrogating emotions through encounters. Andrew says: "The interesting thing about forgiveness is it is a kind of virus. When someone forgives you, you forgive back. It transmits between people. I infected all those people."

Intercorporeality recognizes that emotions are negotiated and produced between bodies, as being(s)-in-relation. Empowerment shifts from learning to listen to different emotions, towards an encounter where the multiplicities of interactions shape subjectivities and emotions in the process of circulation. Articulating, experiencing, and exchanging emotions "depends not on detachment from others, but can only arise in and through our relations with others" (Weiss, 1999, p. 158). Emotional and bodied knowing becomes a complex, dynamic fold of being(s)-in-relation. Thus, the question shifts to:

How might digital environments contribute to an understanding of emotions as bodied encounters?

From : ▮▮▮▮▮▮▮▮▮▮▮▮▮▮▮▮▮▮▮▮
To : "Marty Holsten" <martyholsten@hotmail.com>
Subject : Re: Apology/Forgiving
Date : Tue, 6 May 2003 18:34:09 -0700

```
Well, Interesting project. Forgiveness is a
topic that I have always found intriguing as
it seems so hard to do. We prefer to hang on
to our positions and being 'right' instead of
being accepting, understanding and forgiving
which would bring all of us a little closer.

I would have felt guilty too, as you never
know what buttons you are pressing when this
topic gets mentioned. I am personally having a
crisis of forgiveness where I am the person
needing it from a loved one. One thing is for
sure - you can't make anyone do anything they
don't want to do ever.

I forgive you - your guilt may be lifted. Al-
though I am curious about the art project.
B▮▮▮▮▮
```

Like many individuals today, Andrew initially believed the Internet to be a space of unbounded possibilities, an open, endless space. Although he and the other students articulated these thoughts, his email project demonstrates the tensions he faced in grappling with the complex nature of information technology and his relationship to it. Andrew's original idea was to examine the ways in which email is misdirected and how people blame cyber space for this loss. He laughed and joked at the common misgiving that people have over a lost email. Andrew remarked, that individuals construe cyber loss (experienced for instance when an email does not arrive at a particular destination) "as an email that floats around in some vast open space called cyberspace. As if cyberspace is a real place and no place in particular." In addition, Andrew was interested in the relationship contemporary society has

with machines, most notably in this case—computers, adding that when things fail to work on a computer, individuals often blame technology. In his journal he writes: "Depressingly, any forcing of this issue reveals the somewhat disturbing idea that our blaming of machines is just another step in a long sequence of finding external scapegoats when in actuality there's only ever been humans." These articulations are understood through a sense of divided presence that is occurring here and elsewhere at the same time. Virtual space is understood as disembodied, disconnected, and distant. It is something we can't see or grasp. This sentiment places the body as separate from digital connections. Instead how might we begin to consider digital technologies as material, immanent, and inter-embodied?

Vasseleu (1999) claims that virtual touching develops a unique sense of intercorporeality by creating an opening through which we become sentient beings. Touch is important because it is a knowing through doing and sensation rather than through conscious acts. Thinking through *ticklishness* as a metaphor for the tactility of digital communication, Vasseleu (1999) writes,

> Regarded in this way, digitally manipulated currents flowing through contact points in electronic circuits become transmissions of excitement that can be taken to various extremes of intensity. This measure would act as a perpetual reminder of the uncontrollable tactility of a sentient body. (p. 159)

She continues:

> With its dual emphasis on maintaining contact and infinite communicability, digital technology is producing new ways of being moved, of being transported from context to context without reference to a formal body, or self-defined in relation to any overarching schema. (p. 159)

It is not that technology discards the body, but that it replaces any formal schema of the body with a materiality that is multiple, unstable, and instantaneous. It is an embodied materiality that is uncontrollable and undetermined. Borrowing Katherine Hayles' characterization of the body in virtual space as a "flickering signifier," Garoian and Gaudelius (2001) are compelled to argue that it is the unexpected that constitutes an embodied critical pedagogy. They write:

> Flickering between the randomness of digital information and its patterning, the body's identity is continually negotiated and re-negotiated, a play of resistance between the disjunctive attributes of cyberspace and the conjunctions that occur as the subject coalesces meaning and interpretation. (p. 338)

Considering that our bodies are socially and historically constructed, our bodies according to Hayles (1999) are as much machines as machines are flesh. This intertwining between technology and the body represents an "interconnective relationship that ruptures binary logic, passes through the dialectical, and opens to the multiple possibilities of the rhizome for interaction and interconnectivity" (Garoian & Gaudelius, 2007, p. 19). Exposing, examining, and materializing bodied relations, mail art, either electronic or in paper form, disrupts normative discourses of bodied exchanges. In the next section I turn to a mail art piece that circulated through the Canadian Postal system.

Cupcake Crumbs and Seeds: The "Thingness" of Things

James decided that he would like to approach the idea of circulation through a mail project that he would send via the post. The initial impetus was to subvert Canada Post and to circulate mail without stamps. To do so, he discovered that if he put the "To" address in the space for the "Return" address and did not affix a stamp to the envelope, Canada Post would return the mail to the "Return" address which is really the "To" address. While an interesting concept, beyond subverting the postal system, the small gesture terminates once the mail has reached the intended recipient. I asked James if he could think of something to include in these letters that might in fact provoke a response, to start a conversation of sorts. I thought he might actually write about his theories of the Canadian postal system as an institution of power and control, and his "no stamp" scheme. Instead he described in a letter his preference for cupcakes based on their superiority over muffins.

When I asked him why he had chosen this topic, his response was: "I was thinking about cupcakes. I just needed some sort of content in the letter to provoke a reaction and I thought cupcakes would do as well as anything. I wanted to express an opinion." I was curious to know if he received the letter in the mail how he might, or if he would, respond. "I'm not really sure. I'd find it amusing. I'd be happy to get it. If I did respond I'd write something, counter the argument. Or, I don't know if I'd respond just out of laziness but I would have thought about it for sure."

In addition to the envelopes sent without stamps I provided him with stamps for an additional twenty-five envelopes and suggested he include

A little of This, a little of That. A Canadian Living little bit. Everything in Moderation Moderation Moderat Mod MODERATION

CMA CANADIAN MARKETING ASSOCIATION

Visit us at www.canadianliving.com

MODURATION

1000012792-L6B1A4-BR01

ART / LIFE / EAT IT! MUFFIN, MUFFIN MA MUFFIN CAKES CANADIAN LIVING PO BOX 30004 STN BRM B TORONTO ON M7Y 7A6 Mm Mm Mm Baby just eat it.

CANADIAN ART/LIFE/EAT

You can have your cake and eat it too! You can have your cake and eat it too! You can have you cake and, eat it too!

0083698299-L6B1A7-BR01

You can have your cake and eat it too. You can have your cake and eat it too. EAT CAKE! SUBSCRIPTION DEPARTMENT EAT CAKE! CANADIAN ART CUD CUP PO BOX 30000 STN BRM B CUPPA KOO! TORONTO ON M7Y 7A2 EAT YOUR CAKE, CAKE, eat eat CA

A Always **B** et **C** **d** emons **e** at Mm Mm Mm Good for you. EAT IT EAT IT!

self-addressed stamped envelopes in order to facilitate ease of response. He used his own home address as the return address, commenting that if he used the school address people would assume it was a school project, which he didn't want. He chose to mail the piece to fifty addresses[17] around the lower mainland, noting that he targeted what he considered to be communities where "alternative thinking individuals lived."

A month passed and no letters had been returned. Somewhat disappointed, James thought that perhaps his letters had not in fact reached anyone, having been lost in the mail. James and Andrew, another student, discussed the fact that James had randomly pulled the addresses out of the phone book; the recipients of his letters were unknown to him and he was unknown to them. Many of the mail art projects use the web to sign-up to receive mail art, thereby bringing the unfamiliar into an already established proximinal relationship. They wondered if James's project perhaps failed to generate a response because the piece of mail was so random and distant it was simply discarded as another piece of junk mail. In fact they realized that because the "To" address was really just an arbitrary address, and the

receiver's address was in the "Return" space, many people might read the incorrect "To" address, assume the piece of mail was not for them and had been delivered to the wrong address, and thus forward on the envelope. The possibility of this continued exchange had the two boys quite excited as they dreamt up possible destinations, and encounters. You see, James had not used the phone book for the "To" address, so the potential for the "un-real" addresses to become identified as "real" was an unsettling and yet pleasurable concept for Andrew and James.

James added yet another perspective, suggesting that regardless of whether or not people had responded, he was sure his letter had caused people to at least think. As a thinker himself, this was sufficient. However, a few days later James came racing into class, wearing the hugest smile, and exclaimed with delight: "I got Mail!" In his hand was a small gesture of attention; a gift of communication and exchange. Inside the envelope there was a cupcake wrapper and some crumbs.

Mail art transforms known objects into slightly different configurations or situations. This displacement stimulates thought about how such objects are normally used and our usual forms of behaviour. Dislodging the familiar becomes a means of altering the ways participants become aware of their responsibility in formulating the meaning of events. Mail art sets up situations where artist and audience interrogate the means of social exchange, asking questions about how we interact and the gestures we use. Similarly there is an idea in making work that changes or disappears, whose limits are difficult to identify, complicating patterns of exchange in the process.

On the one hand, James's mail art created a situation where recipients of his letters were asked for a brief moment to pay attention to everyday objects—cupcakes and muffins. By extolling the virtue of the cupcake through humorous and poetical means James was not interested in people's opinions of cupcakes and muffins, rather it was intended as an examination of the "*thingness*" of things. Thing "thingness" is not the object itself per se, but its excess, it's temporality, and sensuousness. Bill Brown (2001) in theorizing things writes that "thingness amounts to a latency (the not yet formed or the not yet formable) and to an excess (what remains physically or metaphysically irreducible to objects)" (p. 5). Thingness, he suggests, points towards the objects/things' materiality, while simultaneously naming something else. James's mail art was a reexamination of mundane objects as signifiers for sensory information, knowledge, and memory while highlighting the interwoven nature of our perception and the interplay between art and life. Thingness asks questions not about what things are, but

about their "subject-object relation in particular temporal and spatial contexts" (Brown, 2001, p. 7). Creating artwork that is relational invites thingness to interconnect and intertwine subjects through various bodied encounters.

A number of weeks later, James arrives in class with another response. He has been sent two collage type text-images and a few "cupcake seeds."[18] James has some interesting ideas about the manner in which people have chosen to respond to his work.

The two image-text collages have been created on the inserts for two different Canadian magazines, *Canadian Art* and *Canadian Living*. Both magazines are publications that extol the virtues of gentrification and legitimization of what are exemplary art and/or life-style practices. These magazines are part of the corporate economy of exchanges that mark some bodies and objects as being of greater or lesser value, and dictate the commodification of visual culture in Canada. However, it is the text on the cards that James is most interested in: "You can have your cake and eat it too," Art/Life/Eat. While one respondent sent back the devoured remnants, the other offered textual interpretations of sensory experiences and provided him with "seeds"—gestations and future possibilities. James says: "It's almost like I sent them an intangible product and they intangibly consumed it, and then they compensated me for it by sending a thing or a notion back. It's like a phantom economy of eating."

Devouring art is a sensual, tactile response—digesting and consuming, not as mastery or control, but in and through the senses, attesting to the body's participation in knowing and meaning making. In their essay on popular culture and pedagogy, Henry Giroux and Roger Simon (see Giroux, 2005) suggest that experiences of popular culture are active, communal, and participatory, rendering the body meaningful in the production of knowledge. Similarly, the "devouring" that was experienced through James's mail art piece reaffirms the place of pleasure and sensuousness in pedagogical actions while simultaneously "opening up the material and discursive basis of particular ways of producing meaning and representing ourselves, our relations to others, and our relation to our environment so as to consider possibilities not yet realized" (Giroux, 2005, p. 180). Eating is connective; it does not render something meaningless. Eating does not absorb the object of consumption so that it no longer exists; it transforms it, reconstituting materiality in and through the body. Thus, eating takes place in and through time.

The coming of time, "advenire," has as its Latin roots the verb "enenire," from which "event" is derived. An event is something that is unexpected, a

surprise, or an accident. The event, or what Derrida (1992) calls "the gift," dislocates time and ruptures it with an unanticipated future. Such openness allows for embodied experience to be "in the making," to be constituted as unfamiliar, rather than programmed as sequences of events (Ellsworth, 2005). It is this event—this giving—that constitutes being in the making, that is part of relational aesthetic encounters and embodied in the students' art explorations. Before turning to the student artwork, I will briefly examine some theoretical considerations of "the gift" and of "giving"—underlying the unexpected and destabilizing nature of giving and generosity.

The Gift and Giving

The enterprise and economy of the gift has been widely theorized by a number of scholars throughout history and in a variety of disciplines. Mauss's classic theory illuminates the nature of circulation and obligation inherent in any concept of the gift. Mauss defines a gift as any object or service, including social pleasantries that are given within a web of social interrelationships. According to Mauss a gift involves obligation. A person gives to another person because one is required to act in this way based on imposed systems of exchange that are socially driven. Prestige is bestowed on the recipient with the moral obligation to return. The gift as obligation keeps it in perpetual circulation.

Furthermore, Mauss believes that a gift always embodies traces of the person who gave the gift, suggesting that the gift is always connected to the giver. "One must give back to another person what is really part and parcel of his nature and substance, because to accept something from somebody is to accept some part of his spiritual essence, of his soul" (Mauss, 1990, p. 12). Thus, the gift possesses an animate characteristic of the individual giver and creates a lasting bond between persons. Mauss stresses three aspects of obligation, which are essential to the theory of the gift: to give, to receive, and to reciprocate.

This cycle of giving forms a structure of obligation that constrains both the giver and the recipient. The gift would always be both voluntary and obligatory. Within this bind are two more features of the gift—ownership and certainty. When a gift is given the receiver takes on the ownership of the object in exchange, thus possessing something of the giver. The very nature of obligation and reciprocity underlies a certainty that another gift will be given back in return.

In contrast, Bataille (1985) troubles the excessiveness of the gift, arguing that unlike Mauss's theory of a homogeneous gift exchange of static obligation, the very nature of the gift itself implies power, violence, and sacrifice. Bataille arrives at this conclusion through an interpretation of the American Native Potlach. Bataille understands a Chief's giving as intricately linked to postures of greatness, wealth, and power. This act of giving, Bataille believes was premised on the act of humiliation, where the receiver, then faced with the challenge of a counter-gift, must return something of greater value. In this gift exchange, the giver sacrifices goods that would have increased his wealth, or been used by himself or the community. In the cycle of exchange, items given are removed from their participation in the daily lives of those who initially possessed this wealth. For instance, Bataille offers that a Chief in trying to outdo another Chief would gift food, clothing and other valuables thereby rendering them useless to his own community. Thus, gifting is premised on surplus and waste.

Obligation that is intertwined with power and excess places the gift within an act of difference, where the surplus of the gift accounts for the giver's prestige. Not only is excess collected and given away, this very act simultaneously destroys and creates surplus. The giver "must waste the excess, but he remains eager to acquire even when he does the opposite, and so he makes waste itself an object of acquisition" (Bataille, 1985, p. 72). A contemporary equivalent might be re-gifting. For instance, we acquire a number of gifts that we simply do not need or want, creating a surplus, which then circulate as an economy in itself.

Excess is what is gained and lost. It reveals something of the sublime, the horror and terror that inhabits the seemingly innocuous things we do. What is enfolded in the ostensibly mundane activities of the everyday? What meanings are created when we attend to small gestures? What manifests in the interconnections that are immanent in the everyday actions of humans and in our environment? Yet, James's mail art exchange, understood through relational aesthetics, reconstitutes excess not as waste or as surplus, but as a fold, wherein new possibilities and complexities lie. Our participation in relational events (such as the mail art piece) "offers potential ways out of the subject/object and inside/outside binaries by facilitating flows of movement, use, and inhabitation in the spaces between subject and object, inside and outside" (Ellsworth, 2005, p. 124). It is the potential of the event, of giving as movement that enables different corporealities to be expressed.

Derrida (1992) offers yet another interpretation on the nature of the gift, which according to him is an impossibility. Challenging Mauss, Derrida insists that a gift should not create debt. Obligation marks the gift as not

neutral. From this he argues that a pure gift is one that must not come back, must not circulate, and must not be exchanged. There need not be an exchange, no communication, no reciprocal gesture in order for a "gift" to exist. A gift, he argues, is only possible at the instant that it interrupts the circle of exchange. The only way for a gift to become plausible is if the receiver does not recognize it as a gift. Thus, identification and familiarization destroy the gift. According to Derrida, not only can the gift not be recognized as a gift it must necessitate forgetting. Forgetting he argues is not repression of the event, but is an absolute forgetting that absolves. Thus, forgetting and the gift are conditions of each other. This forgetting, argues Derrida is unknowing. Unknowing is not not-knowing—rather it creates and constitutes the unfamiliar, the peculiar, the uncertain—as "things in the making." Gifts understood in this way are unexpected relational encounters where reciprocity is not informed by obligation but made meaningful because it determines new connections, interstices, and un/foldings. Unexpected gifts cause us to dwell, to pay attention to the thingness of things. However, this attention is not a monumental structure; it is fleeting, flickering, moving on and passing through.

When we are presented with unknowing and the conditions of being in the making, we are faced with response-ability—or in Levinas's (1969) terms generosity—that is a shift in how we perceive self and other in relation to one another "learning to live together in our differences rather than in spite of them" (Luke, 2003, p. 21). Generosity then shifts from acts of giving constituted in obligation, surplus, or waste, towards an understanding of interaction, a communicative gesture "that does not have as its end anything except its own communicativeness, its own response" (Todd, 2003, p. 48).

As with Derrida's notion of the gift, where there is no expectation of return, no exchange, or circulation of objects, Levinas (1969) insists that the gesture of giving needs to be full. This fullness is not *what* one gives (my hand is full of something), but the very *act* of giving and of generosity. It is the fullness of the gesture—its unfamiliarity and unexpected nature that enables bodies to come together, to have a pedagogical encounter, and to produce meaning.

James was initially searching for a returned gift. He was expecting individuals to re-send him a response to his letter. Without this reciprocal gesture he felt his project had failed. However, when that first envelope arrived full of cupcake crumbs and a wrapper—the obligatory gesture, itself peculiar and unexpected—caused him to think about bodily encounters, the nature of exchange between self and other, in which new meanings are made. Giving in this instance moves from a gesture full of "what," to a gesture that

is an opening to the other; an opening that suggests a capacity for relationality not premised on control. This opening is rooted in a response, a receptivity to attend to ambiguity, to admit that we cannot "know" beforehand what it is the Other wants, to be vulnerable to the consequences and effects that our response has on both ourselves and others (Todd, 2003). In this sense then, generosity—giving—involves our ability to be altered, to "be in the making," to become someone/thing different than we were before. Encounters, argues Todd (2003) between self and other are a profoundly ethical event premised on unpredictability and nonintentionality. It is ethical when we recognize how the "encounter itself is implicated in the broader relations and circuits of production and exchange" (Ahmed, 2000, p. 152) and thus, how different encounters produce different corporealities. It is this understanding of generosity, of being in the making that I want to further explore in the following section, through an intervention-based artwork, titled "Cookies for Peace."

Cookies for Peace and a Pedagogy of Corporeal Generosity

After one particular class discussion Rohan began to formulate an intervention-based artwork that would allow him to participate in public peace demonstrations that were a part of the public landscape in the winter of 2003. Rohan decided that he would get some of the other students to help him bake peace cookies, which he could hand out downtown where most of the peace demonstrations were taking place. I offered to loan him a digital video camera in case he wanted to document his "intervention." It seemed interesting enough. I hoped that by giving him the camera, the gift of a cookie might be extended into something else. I was curious to see what might erupt. In this section I discuss Rohan's art intervention not in terms of its success as a means of protest, but to examine this artwork as a bodily exchange, an act of corporeal generosity. To that extent, I also take up, Ellsworth's (2005) call for a thinking about the "materiality of pedagogy"—a challenge for educators to shift how we make bodies matter in pedagogy.

Rohan returned to school with the camera and a host of stories about his day participating in the peace demonstrations. Trusting him with the camera off-school property for four days had unexpectedly shifted the intervention. Rohan and his co-conspirator, Quin, who was not a student at the school, decided that handing the cookies out on the downtown streets needed to be pushed a bit further. Armed with their innocent looking brown wicker basket

and frosted pink peace cookies, and fueled with excitement, Rohan and Quin approached the American Consulate where they were turned away, gave cookies to two police officers parked outside the Consulate, and then entered an office building where a number of large gas corporations have regional offices. They brazenly walked into offices handing out their peace cookies to secretaries, office staff, and company Vice Presidents, video recording their encounters, and in some instances "words of peace."

Watching the tape in class was pivotal for Rohan. He narrated his experiences from the day's events, but the video footage provided him with space to reflect on aspects that he had not noticed before. In the video we notice that Rohan and Quin did not ask people questions about the war, which immediately establishes a context of "for" or "against," a conversational move that is closed rather than open. "Seeing as we were handing out peace cookies we thought we'd just get people to comment on peace. We were really interested in people's understandings of peace. Everyone has different ideas of what peace is, for some peace is the war. We also just thought it would be funny to be in a corporate gas company talking about peace. The irony itself provides a nice critique." Weeks later, Rohan writes in his journal: "What originally began as a project about corporate and public hypocrisy was replaced by a focus on peace. Peace became the replacement message. Ironically, no one disputes the concept of peace."

In class we began to talk about different points in the video. When Rohan and Quin first approached an individual and offered them a cookie most people shook their heads and said no. Watching the video, Rohan noticed something he had not been aware of during the "intervention." Although most people were pleasant when refusing the cookies, many of them appeared suspicious of the cookies. Rohan and a few other students began to talk about a "culture of fear" that was permeating the city and the country. Yet, Rohan went even further in his reflections, moving beyond a critique of the climate of fear tied to terrorism and the un/known (this was also a time in Canada when there was the initial outbreak of SARS,[19] airports had increased security, and fear of contamination from the unknown "other" was on the rise). Rohan thought that on one level he could understand how people might be wary of a stranger handing out food, given the national media coverage on SARS, but on another level he started to think about how his random acts of kindness were in fact producing the unsettling and uneasy tensions. "People look like they are just uncertain about what I am doing. They can't figure out why someone would want to give peace away. They don't seem to understand that I'm not selling things or asking for money. I

guess it's also a bit weird that I have a video camera. But mostly I think it's because they are being asked about their opinions and given a peace cookie."

Images, texts, media reports and the like, circulate in the public imagination as a series of pathos-ridden or corrupt power struggles, all in the name of goodness and "peace giving" efforts. These artifacts, which I will simply call images, normalize the concept of peace and cannot be taken up outside of history, politics, or ideology. As Giroux (2005) contends, images

do not record reality as much as to insist that what they capture can only be understood as part of a broader engagement over cultural politics and its intersection with various dynamics of power, all of which inform the conditions for reading

[images] as both a pedagogical intervention and a form of cultural production. (p. 230)

Peace becomes a static symbol that should mean the same to nations and peoples globally. Images of peace necessitate an oppositional understanding where war and terror are countered, erased, and commodified by peace. Peace becomes something those in the Western First World "give," an abstract concept that avoids the conditions that produce it or that it in turn creates. Rohan's cookies are unsettling because they point to the ridiculousness of giving peace, confronting the impossibility of peace as something that can be given. The uneasiness of the frosty pink cookies lies not only in the horrific sweetness of their form, and any repulsion people might have to unwrapped food offered by a stranger, but to the unbelonging of Rohan's gesture in the circulation of images on peace. He calls attention to the very thing both peace activists and nation states involved in the war promised: *A gift of peace.* Yet, his gesture is unexpected, challenging us to examine the impossibility and the unknowingness of a gift of peace.

The gesture of giving away peace cookies destabilizes the romanticism and nostalgia for peace, a longing for an unnamed possibility that is so often imaged in the public imagination. His gift forces us to think about peace as belonging to actual existence, its relationality rather than its abstract universal qualities. As a gift that inferred no obligation of return, it ruptures the circulation and economy of goodness and peace, with peace itself, provoking us to think about our own actions and participation in the exchange. As Rohan so candidly states: "To be able to bake, consume [Rohan and Quin apparently ate their fair share of the cookies] and to give the cookies to unsolicited people including the police, represented the ultimate freedom." Romanticized gestures that reduce the idea of peace to expected conditions and an established set of practices refuse to acknowledge the necessity of unexpected possibilities. When we make peace certain and sure, universalizing it in its own tautology, we close ourselves to the chance of a surprise. If we lack the capacity to openness, to welcome the unfamiliar, we refuse the opportunity to examine and question encounters and the nature of being itself.

Another section in the video shows Rohan and Quin in an elevator. They offer a cookie to a woman who joins them there. She does not respond at all, but immediately starts digging in her purse for something. The camera focuses on her activity until it becomes apparent that what she is looking for is money, loose change, an offering and obligatory gesture in return for a cookie. While Mauss's theory of obligation and exchange could be fitting in this instance, Rohan describes a slightly different understanding of this

gesture. Rohan says: "I don't think she was paying us for the cookie. I think she was just doing what she thought was necessary. It had nothing to do with the cookies. She didn't take a cookie. She didn't want one. She was giving money, like you do with the Salvation Army people on the street. People often give without any thought to it at all." Re-watching this scene un/fold in the classroom Rohan and a few other students sharing in the conversation, made connections between this gesture and foreign aid, and even linked the cookie project to another student's email project on forgiveness and guilt. Andrew offers: "Do you think part of it may be that people have this vision of life and how you should do things for others and in fact life is maybe not that selfless and hard? People in fact do give you things but you're not supposed to get things. Selflessness is really a good thing, pride isn't."

Perhaps education needs to rethink the nature of "the gift" and what it means to give in meaningful ways. Schools often ask students to give. Whether it is to contribute to local food banks, to give time through voluntary/mandatory hours of public service, or to donate time, money, and skills in fundraising efforts for the school, teachers and students rarely think through the nature of giving itself. What we need are curricular and pedagogical interventions that inquire into the exchanges and encounters that produce generosity, and the conditions of this bodied production. Education needs to interrogate giving from the perspective of "things in the making"—events that rupture, challenging us to remain open to new possibilities. The possibilities of generosity, the fullness of the gesture of giving, then, resides not in the "what" is given, but in the corporeal exchanges that take place and the bodies/meanings produced through those actions.

While Derrida's concept of "forgetting" enables giving to generate new possibilities and new assemblages, feminist scholars Sara Ahmed (2000) and Rosalyn Diprose (2002) argue that an understanding of generosity needs to move beyond forgetting, arguing that if the gift only functions if it goes unrecognized then it fails to account for intentionality, materiality, and the corporeality of those involved in an encounter. As such, it is important that when we think of giving—of generosity—within teaching and learning, we not do so devoid of embodied experience.

Embodied experience suggests that we do not have experiences—as in experiences are not separate from our bodied selves—rather we *are* experiences (see Merleau-Ponty, 1968). Similarly, bodies are not "things" that we "give" meaning to, but that bodies *are* meaning (Grosz, 1994; Nancy, 2000). Understanding the body *as* meaning, as opposed to a container in which we store or put meaning, resists an understanding of pedagogy as something that is enacted by bodies onto bodies. Rather "teaching becomes

the activity of participating in the 'becoming pedagogical' of 'expressive materials' distributed across many teachers, sites, events, and interactions" (Ellsworth, 2005, p. 28). In other words, neither teachers, students, nor the sites of learning preexist pedagogy—they are invented in the process. Thus, we might shift from trying to "know" and then "teach" [generosity] to engaging with it as an event that has not yet ended and to contemporaneously respond to it" (Ellsworth, 2005, p. 19).

Thinking about pedagogy relationally, according to Ellsworth (2005), requires a "withdrawl from oneself" (p. 31). Unlike Derrida's forgetting, this withdrawl is not an alienation or an inauthenticity of the self, but a "condition that frees difference from the determinations of habit, memory, routine and the practices of recognition or identification within which we are caught, opening up other vital possibilities" (Ellsworth, 2005, p. 31). Visual culture theorist, Irit Rogoff (2005) explains this "withdrawl" in other terms, insisting on the potential for emergent collectivities in shared and performed cultural activities. For Rogoff, collectivity is something that takes place when we "look away" from normative power relations (static art object viewed by passive audience) and instead engage in a meaning making process that views audience members as co-participants in the creation of an event (versus and object). Collectivity, according to Michael Smith (2000), is the foundation upon which the transglobal is based, and proposes, that in order to understand the future of urban change we must focus our attention upon communication circuits, no matter how complex, by which people are connected to each other, make sense of their lives, and act upon the worlds that they see, in which they dwell, and through which they travel. This collectivity occurs as we arbitrarily gather to take part in different forms of cultural activity. However, the performed collectivity that is produced in the very act of being together in the same space and compelled by similar activities, produces a form of mutuality that is not always based on normative modes of shared beliefs, interests, or affiliation. In other words, collectivity alters a hegemonic perception of community, where community is understood solely through roots of origin, and replaces it with a process of becoming community—a mobilizing force that has no end (Nancy, 2000). In a pedagogical sense, collectivity does not depend on dialogue where each person engages equitably in sharing their experiences and thoughts, rather it acknowledges that collectivity is fragmented, unstable, and not given.

Collectivity in this sense is engaged with what Hanah Arendt calls the "space of appearance" characterized by speech and action or a coming together for a momentary expression and then coming apart again. Arendt's "space of appearance" is not a physical space demarcated by buildings,

environments or tasks, but one which comes into being through relational understanding of actions and of the bodies/subjectivities created through these actions. Rather than an understanding of self and other as oppositional, community becomes imbricated and reciprocal, offering a reconceptualization of self and other in which these previously distinct parts constantly inform each other and their relationship. The potentiality of this "space of appearance" says Arendt,

> ... is that unlike the spaces which are the work of our hands, it does not survive the actuality of the movement which brought it into being, but disappears not only with the dispersal of men... but with the disappearance or the arrest of the activities themselves. Wherever people gather together, it is potentially there but only potentially, not necessarily and not forever. (cited in Rogoff, 2004, p. 117)

A pedagogy of corporeal generosity resembles Arendt's notion of collectivity, which engenders a form of power—not power in terms of strength, violence, or the law, but a power created through the ephemeral coming together in momentary gestures of speech and action. The "space of appearance" in which these momentary actions take place are sites of protests, refusals, affirmations, or celebrations—frosted pink cookies and a video camera. These sites do not bear the markings of traditional political spaces but rather animate the spaces of everyday life by temporarily transforming them through reciprocity and relationality. In other words, a pedagogy of generosity conceptualized through a "withdrawl" and by "looking away" invokes interconnectivity, embodiment, and becomings. Examining the students' artworks beyond the visual, beyond their being simply "objects to look at," a pedagogy of corporeal generosity encourages collectivity through interpersonal, affective relations.

What might become of pedagogy if we were to consider it from the perspectives of relationality, generosity, and corporeality? In order to establish ways in which we might rethink pedagogy, I argue that we need to investigate the body's participation in learning and knowing. "A body in the process of learning is a body blurred by its own indeterminacy and by its openness to an elsewhere and to an otherwise. This implicates pedagogy in the promise of an indeterminate, unspecifiable future and an unlimited open-endedness" (Ellsworth, 2005, p. 122).

Likewise, there needs to be a shift in the "what" that creates a pedagogical encounter. This means recognizing that the practices that constitute pedagogy are ever changing and evolving, irregular, peculiar, and unexpected. In the context of this research study, pedagogical practices were not limited to the "what" that existed and happened between the students and myself as an artist/researcher/teacher. Rather pedagogy existed in the in-

between—by withdrawing and looking away from the normalizing discourses and habits that mark experiences. Similarly, pedagogy did not exist prior to these sites (the teachers, students, the artworks) rather pedagogy was created, materialized, and mobilized through participation "in the making." Pedagogy seeps into the cracks in-between the bodies of the students, in-between their artistic interventions, and in-between the spaces of learning and knowing. This thinking of the in-between of pedagogy presents us with strange and unfamiliar constructs, staging encounters with the unthought, the unknown, and the ambiguous.

It is the event of the unexpected, the being in the making of something different, that Todd (2003) contends makes learning and knowing as a mode of relationality across difference possible. It is the giving over of the self, the affective openness to the other, and the indeterminableness of becoming that is at the heart of corporeal generosity.

Teaching and Learning through Touch

The day is gray and miserable. Rain pours down my windshield as I drive to the high school. It's eight a.m. and I am physically and emotionally exhausted. It has been a long few months of teaching and researching. Last week every possible thing seemed to go wrong. Computers crashed, a tape got caught in the camera and tore, a couple of students weren't working and I'd had to find ways to motivate them, and on top of that I felt I had so much "data" and nothing was making sense any more. My questions were so tangled they seemed confusing, and everything seemed fragmented and messy. Ironically these are the very spaces I encourage my student teachers and the students at *Bower* to embrace. Yet, here I was mindful of just how difficult and painful this can be. A note in my journal reads: But what does this all mean? Where do I go from here? The page has been added to—line drawings in red pen, notes creased along the margins, and cup rings stained coffee brown; marks of my interrogations—my relational body knowledge.

I stop in front of the school and begin the ritual of unloading my car, laptop computers, digital cameras, and other materials, and trudge up the steps to the school. At the door Louie greets me with a smile. "Need help?" she asks, and I succumb graciously to her offer. More students join her and my car is soon unloaded. Louie is still hanging around as I talk with Bronwyn about the day's plan and fill her in on other matters. Louie must need some help, I think, and I ask her if she wants assistance with her video. "No" she says, "but I have something for you." A few minutes later when the room has settled, Louie hands me a box wrapped with paper. She disappears before I can open it.

Louie was anxious in an interview setting, often preferring not to participate in any form of discussion. She was always present, listening and active in her position in the classroom, but she rarely spoke. She and I had agreed that she could create artistic renderings as opposed to participating in the group and individual interview sessions. These renderings usually came in the way of poems and the occasional collage. That day the box got set aside as I busied myself with a day of living inquiry, and it wasn't until the last student filed out the door that I sat down to open it. Inside I discover seven recycled envelopes, each embossed with text and stuffed with photographs and other personal memorabilia. I take one out and hold it in my hands, press it up against my face, breathe in to smell ink and paper.

Just when I think the fragments are slipping so far apart that I can't find my way through them, something un/does me. Louie's words are mindful gestures that speak of the students' involvement in the world and of their bodied interrogations. I feel my red threads begin to gather, to move in and out, finding connections, asking questions—a living inquiry. How do we negotiate fragmented and messy spaces in art, research, and teaching? What are the implications of teaching and learning through touch?

On my way home I detour past my studio where I cut discarded fabric into strips, knotting them together. I place the tangled knotted construction in Louie's box, along with photos, and other debris, and return it to her at school the next day. Touch me—it continues to breathe. The next week I arrive to another such gift. A large old-fashioned suitcase sits in the middle of the room filled with earth. Sprouting from the earth are rows and rows of glass test tubes each one holding forth a small seed or a single bud of a flower. Over the weeks as the plants grow and open, their vinelike stems twist around each other, creating flexible, fluid lines as a visible act. These lines are multi-directional, suggesting movement and change. They are haptic, tactile, material—bodied elements. The threaded, entangled space is intensive, active, and aware. Slowly the lines un/do, they shrivel and decay; dried and brittle they return, folding back, not to their original state, but towards new becomings. Louie continues to exchange image and word. I encourage her to do this with other students, to use it as an opening towards conversation; a bodied encounter as "other than" where meanings become something else altogether, and bodies touch creating knowledge in their folds.

The rains disappear, replaced by the startling intensity of early spring sun. Emma gathers my long skein of red felt from a chair and heads outside. I watch through the window as bodies dance against a backdrop of cherry blossoms. She begins to weave and wind the wool between and around the

students. Some of them won't stand still and the wool lines bend and sway, moving with the rhythms of their bodies; a game of cat's cradle.

In the year following the research study Bronwyn shows me the new high school graduation requirements pointing out that students must include in their personal portfolio aspects devoted to health. She tells me that while this has been left open for school boards, schools, and teachers to interpret, at a recent school meeting it was translated for the staff at *Bower* as the documentation of eating habits, physical activity, and life style habits (such as drugs, cigarettes, alcohol and sexuality). Heather, who has joined us in the conversation, adds that this requirement normalizes students' bodied experiences while also suggesting that schools have the power to judge and control the adolescent body. Trinity interjects, "who decides what healthy is?" I'm reminded of the literature that speaks of mending and repairing adolescent bodies, and I wonder when education will understand that it is more generative to unfurl the edges, to slit open seams, to dis/repair.

I spend the day at the school talking to students in different classes. Heather and her friends decide to artfully think through the experiences of their bodies. In doing so, Heather argues, they will not only fulfill the portfolio requirement, but their inquiries will also attest to the different ways that bodies are lived, touched, and encountered, challenging structured, objective, and coded assumptions that continue to normalize the body. Not only have the students in the senior grades continued to interrogate the meanings of their bodies, this living inquiry has seeped throughout the school, asking and responding in a diversity of ways to the questions: How do youth understand body knowledge through touch? How do students make meaning and interrogate body knowledge as visual art and culture?

Bronwyn is angry. She wants to know how, after six months devoted to a curriculum through bodily inquiry, something like this can infiltrate her school. "Education," she says, "is moving backwards." At the school meeting she was so angry she took out her knitting in protest. "I just sat there casting this big ball of yarn, on and off the needles." As an a/r/tographer she too continues to un/knit the bodies and lives of her students, not to mend, or to make whole, but as a process of becoming open and un/done. In response to these curricular objectives, the students at *Bower* installed their artworks at the Vancouver school board offices. The exhibition ruptured the stasis of institutional change, unhinging the very concept of the body in education— an educational model aimed at the mastery of codes reinforcing fixed interpretations, calculations, and objectives. Instead what was present in the concrete corridors was a relational, interstitial body that opened for youth a sense of possibility of their own involvement in the task of meaning making.

The portfolio, understood in a structural sense, configures the body as a discrete object that can be codified and documented, where knowledge is "fact" that can be assembled and accumulated. In contrast, teaching and learning through touch puts the complex, lived realities of contemporary youth front-and-centre challenging educators and researchers to meet youth in the threshold of meaning making. Moreover, it suggests that we focus on investigating youth's roles as active participants in knowledge production.

Writing about globalization and youth culture, Greg Dimitriadis (2008) argues that while various global "flows"—flows of people, ideas, images, technologies, and monies—are characteristic of the current global space, a set of binaries continue to structure bodies, subjectivities, and knowledge—"us" versus "them"; those "with us" versus "against us." All of this then, makes *Body Knowledge and Curriculum* important for the ways it highlights how young people materialize their own bodied subjectivities, imaginations, and communities, and produce the new conditions for how they live their lives.

Imag(e)ining Embodied Resistance:
Youth, Art, and Activism

Contemporary feminist scholars, like Anita Harris (2008) argue that young people's resistance, politics, and activism—once easily recognizable—now seem obscure, transitory, and disorganized. While the artworks, interventions, and conversations that the students at *Bower* created were not conceptualized as forms of formal activism, "they are examples of youth citizenship, in that they represent ways young people can get together and debate social issues, enact alternative social arrangements, and create spaces for alternative transitions and alternative political forums" (Harris, 2008, p. 4). Recognizing the excessiveness of body knowledge in teaching and learning offers new ways for thinking about young people's cultural and political action, and the complexities of bodied subjectivities and identities.

Third wave feminisms rupture and expand notions of resistance, arguing that youth activism is forging new paths and theoretical spaces, "broadening the sense of what action is" (Mitchell, Rundle, & Karaian, 2001, p. 22). This is arguably due to the complex relationships youth have with popular and visual culture that requires "them to negotiate, infiltrate, play with, and undermine cultural forms rather than simply reject them" (Harris, 2008, p. 7). Therefore, as Harris (2008) argues, it is paramount that in examining youth resistance, culture is understood as a "mutable, creative, and negotiated

space" (p. 8). This creative resistance can either offer a path to political activity or it can be the political activity in itself.

I turn to these arguments about a third-wave or post reconceptualization of resistance in my concluding arguments, to offer what I believe was the core of the students' art making activities. Although produced in the context of a classroom, the students discovered their own power as creators, or as Carly Stasko (2008) suggests, "turning their media-saturated childhoods into media literate action" (p. 199). Immersed in visual culture, both inside and outside of the school, the students at *Bower* explored new ways to coopt, subvert, and repackage dominant visual codes in order to express alternative ways for living in the world. Activism in this sense, shifts the boundaries between activism, media, and art—infusing them with a sense of play, creativity, and imagination. Imag(e)ination, writes Leila Villaverde (2008) is "a moment of deep reflexivity and creativity where one can slow things down for deeper engagements" (p. 92). Likewise, imag(e)ination allows for active theorizing and acts as a "site for organizing and understanding what [youth] know and what they have experienced" (p. 95).

In the intervening years since working alongside the students at *Bower* and the writing of *Body Knowledge and Curriculum* I have continued to provide curricular and pedagogical spaces for students to inquire through artistic means into the lived experiences of their bodily encounters. Yearly, on the Penn State campus, various classes of mine have performed a variety of different art activist projects. Inspired by Bronwyn's un/knitting and global knitting art projects such as "The Revolutionary Knitting Circle" (http://knitting.activist.ca/); "Microrevolt" (http://www.microrevolt.org/); "Wombs on Washington" (http://jscms.jrn.columbia.edu/cns/2007-03-13/gohil-knittinginprotest); and "The Knitted River" (http://www.iknit.-org.uk/knitariver.html) in addition to work by artists like Janet Morton, Sylvia Kind, and Sabrina Gschwandtner, this semester I arrived on campus one day with a bag full of knitting needles, balls of yarn, and some old wool sweaters found at the local thrift shop. While discussing the weeks' assigned readings with my undergraduate women's studies class we collectively learn to knit. Each week we spend time working on our knitted forms. Our theoretical discussions about feminist research and teaching are punctured by this collective and embodied action. In contemplating how we will eventually use our knitted forms (see Betty Christiansen, 2006), we step into the threshold of teaching and learning through touch, our desires, forces, and intensities always already moving into new assemblages.

It is in through the actions of the students at *Bower* and at Penn State University that a/r/tography shifts the emphasis from "being researched" to

"being in the process of living inquiry" where art making, researching, and teaching de-centres what it means to know and to learn. Leif Gustavson (2007) suggests "that in order for classrooms to truly honor the way youth work on their own terms, we need to move beyond thinking of their work as products and instead understand them as habits of mind and body that youth develop and employ in order to create personally meaningful learning experiences" (p. 132). This orientation of teaching and learning contends that meaning making is performative and inter-embodied. Moreover, it positions youth in the in-between space of teaching and research—neither on the periphery, nor the centre—but as active agents in the research process. Like Harris, I believe that "to take seriously the possibility of young people as reflective and knowledgeable sociopolitical actors means regarding them as more than data" (Bulbeck & Harris, 2008, p. 233). Vital to the a/r/tographic process and an ethics of embodiment is the unknowability of experience—the partiality and undecidability of bodied encounters. As Ellsworth (1989) contends, this unknowability is not a failure, or something to overcome. Rather the uncertainty of bodied encounters recognizes difference as difference, as "different strengths" and as "forces for change" (p. 319). This reverberates with David Smith's (2003) words that "between the formal texts of life is another kind of life, the life that mediates, that announces, repudiates, or cajoles curriculum formalities" (p. 46). What seeps between, touches bodies, and creates moments of exposure, is a sense of dwelling, living, and being-with—an un/knitting of sorts.

At the heart of such transformations is the body as threshold, a passage between, an un/folding that brings understanding together as a tangled, messy, and uncertain space. In Grosz's (1994) words, "The body is an open ended, pliable set of significations, capable of being rewritten, reconstituted, in quite other terms than those which mark it, and consequently capable of reinscribing the forms of identity and subjectivity at work today (p. 60). In *Body Knowledge and Curriculum* the body becomes an incalculable limit of a being that is constantly taking form, turning to living experience and inquiry as a gesture of responsibility and generosity. If our desires, aspirations, and educational concerns are to discover the fullness of the body, its fecundity and excess, it is necessary to intervene in the history of binary thought and in turn to shift the invisibility or absence of the body towards a body that is situated as sensation, touching, and relational. *Body Knowledge and Curriculum* exposes the body in the construction of difference through touch, while challenging any attempt to view the world through distant, objective reason. *Body Knowledge and Curriculum* intertwines the material

and sensual; understanding and knowledge become tactile, textured, and "other than."

Notes

[1] When layers of wool are dampened and pressed together through rubbing, the microscopic scales on the wool fibers mesh together to form felt.

[2] All names have been changed to ensure anonymity. Some students selected their own pseudonyms while other names I selected and were later approved by the students.

[3] Some students were not taking art during all class periods. The concept of self-directed learning embraced by the school allowed students to enroll in classes that had timetable conflicts. Students attended art class one period a week and worked on independent projects towards the art credit.

[4] Parts of this chapter emerged from researching, writing, and teaching in collaboration with Debra Freedman (see Springgay and Freedman, forthcoming, 2008).

[5] For essays on of a/r/tography see de Cosson, 2003, 2002, 2001; Irwin, 2003; Irwin & de Cosson, 2004; Springgay, 2004; Springgay, 2005a, 2005b; Irwin & Springgay, 2008; Springgay, Irwin, & Kind, 2005; Springgay, Irwin, Gouzouasis, & Leggo, 2008.

[6] Cited from Marlatt, D. (1988). *Ana Historic*, p. 126 and p. 47.

[7] The impetus for theorizing the fantastical body originated during a research project that I was involved in with Dr. Linda Peterat at the University of British Columbia. This research project investigated implications and student understandings of a secondary school fashion show (see Springgay & Peterat, 2002-2003). While I have expanded on this understanding of the fantastical body it is imperative to note that its conception grew out of conversations with adolescents in addition to a visual experience with their textile creations.

[8] The BwO is not empty. Like zero, which is a number, it is a place of potentiality. Anything undivided by zeros is undefined, not absent, but cannot be articulated by any other system or number. Zero is intensive.

[9] Ironically there is no staff lounge, but staff and students move fluidly through the halls, the lounge, and classroom spaces together, disrupting schooled notions of segregated student space and teacher space.

[10] http://un/foldingobject.guggenheim.org/, retrieved February 2004.

[11] As cited at http://www.guggenheim.org/internetart/welcome.html.

[12] Deleuze and Guattari (1987) argue that a trace is a traditional type of map, where fixed points affirm objective and stable representations of visual facts. Mapping, they argue, is the process of creating new assemblages and opening traces.

[13] http://www.expectdelays.com/, retrieved February 2004.

[14] Many Contemporary International and Canadian artists create art as a means of social exchange and as circulation. Their works are in part informed by the *Situationists International*, which emerged as a group in 1957 in France and Germany. Among those most influential in the group was Guy Debord whose book *Society of the Spectacle* was published in 1967; English translation in 1994. For further readings on contemporary art see

Nicolas Bourriaud *Relational Aesthetics*, 2002; *Postproduction* 2001, and Kim Pruesse *Accidental Audience*, 1999.

[15] Mail art is art which uses the postal system as a medium. Mail art artists typically exchange ephemera in the form of illustrated letters, zines, rubberstamped, decorated, or illustrated envelopes, artist trading cards, postcards, artist stamps, faux postage, mail-interviews, naked mail, friendship books, decos, and three-dimensional objects. An amorphous international mail art network, involving thousands of participants in over fifty countries, evolved between the 1950s and the 1990s. It was influenced by other movements, including Dada and Fluxus. One theme in mail art is that of *commerce-free exchange*; early mail art was, in part, a snub of gallery art, juried shows, and exclusivity in art. A saying in the mail art movement is "senders receive," meaning that one must not expect mail art to be sent to them unless they are also actively participating in the movement (see http://en.wikipedia.org/wiki/Mail_art).

[16] The emails have been inserted into the text using the exact font and form that existed in the original email. Personal names and addresses have been blanked out to maintain confidentiality. As an art project the email texts circulate as visual culture and as image.

[17] Fifty envelopes were sent. Twenty-five without a stamp. Twenty-five with a stamp. All contained a self-addressed stamped envelope.

[18] The letter accompanying the items explains that the seeds (which appear to be sunflower seeds) are cupcake seeds.

[19] SARS (Sever Acute Respiratory Syndrome) was first publicly detected in Canada in the winter of 2003, primarily in the city of Toronto, but Vancouver had a few cases. However, the media surrounding this disease contorted it to the level of epidemic and a number of people, fearing contamination chose to mask themselves in public spaces, refused to fly, and many restaurants and other public spaces were closed or empty.

REFERENCES

Agamben, G. (1993). *The Coming community*. Minneapolis, MN: University of Minnesota Press.

Ahmed, S. (2000). *Strange encounters: Embodied others in post-coloniality*. London, UK: Routledge.

Ahmed, S. & Stacey, J. (2001). *Thinking through skin*. London, UK: Routledge.

Baert, R. (2001). The Dress: Bodies and boundaries. *Reinventing Textiles*, 2, 11–22.

———. (1998). Three dresses, tailored to the times. In I. Bachmann & R. Scheuing (Eds.) *Material matters* (pp. 75–91). Toronto, ON: YYZ Books.

Bagley, C., & Cancienne, M. B. (2001). Educational research and intertextual forms of (re)presentation: The case for dancing the data. *Qualitative Inquiry, 7* (2), pp. 221–237.

Bataille, G. (1985). *Visions of excess: Selected writings 1927–1939*. Translated by Allan Stoekl. Minnesota, MN: The University of Minnesota Press.

Bauman, Z. (1993). *Postmodern ethics*. London: Blackwell.

Bordo, S. (1998). Bringing body to theory. In D. Welton (Ed.). *Body and flesh: A Philosophical reader* (pp. 84–97). Malden, MA: Blackwell Publishers.

———. (1997). The Body and the reproduction of femininity. In K. Conboy, N. Medina, & S. Stanbury (Eds.). *Writing on the body: Female embodiment and feminist theory* (pp. 90–110). New York: Columbia University Press.

Borsato, D. (2001). Sleeping with cake and other affairs of the heart. *The Drama Review, 45* (1), 59–67.

Boler, M. (1999). *Feeling power: Emotions and education*. New York: Routledge.

———. (Ed.) (2004). *Democratic dialogue in education: Troubling speech, disturbing silence*. New York: Peter Lang.

Bourriaud, N. (2004). Berlin letter about relational aesthetics. In C. Doherty (Ed). *From studio to situation* (pp. 43–49). London: Black Dog Publishing.

———. (2002). *Relational aesthetics*. Paris: Les presses du réel.

———. (2001). *Post production*. Paris: Les presses du réel.

Braidotti, R. (2006). *Transpositions*. Cambridge, UK: Polity Press.

———. (2002). *Metamorphoses: Towards a materialist theory of becoming*. Cambridge, UK: Polity Press.

Britzman, D. (2003). *Practice makes practice: A critical study of learning to teach*. Albany, NY: Suny Press.

Britzman, D. (1998). *Lost subjects, contested objects: Toward a psychoanalytic inquiry of learning*. Albany, NY: Suny Press.

Bresler, L. (2004). *Knowing bodies, moving minds: Towards embodied teaching and learning*. Boston, MA: Kluwer Academic Publisher.

Brown, B. (2001). Thing theory. *Critical Inquiry, 28* (1), 1–22.

Bulbeck, C. & Harris, A. (2008). Feminism, youth politics, and generational change. In A. Harris (Ed.). *Next wave cultures: Feminism, subcultures, activism* (pp. 221–242). New York: Routledge.

Butler, J. (2006). Sexual difference as a question of ethics: Alterities of the Flesh in Irigaray and Merleau-Ponty. In D. Olkowski & G. Weiss (Eds.). *Feminist interpretations of Maurice Merleau-Ponty* (pp. 107–125). University Park, PA: The Pennsylvania State University Press.

Butler, J. (1993). Bodies that matter: On the discursive limits of "sex". New York: Routledge.

Carson, T. & Sunara, D. (1997). Action research as a living practice. New York: Peter Lang.

Cary, L. (2006). *Curriculum spaces: Discourse, postmodern theory, and educational research.* New York: Peter Lang.

Classen, C. (1993). *Worlds of sense: Exploring the senses in history and across cultures.* New York: Routledge.

Chalmers, G. (2002). Celebrating pluralism six years later: Visual transculture/s, education, and critical multiculturalism. *Studies in Art Education, 43* (2), 293–306.

Christiansen, B. (2006). *Knitting for peace: Make the world a better place one stitch at a time.* New York: Harry Abrams, Inc.

Corner, J. (1999). The Agency of mapping: Speculation, critique, and invention. In D. Cosgrove (Ed.). *Mappings* (pp. 213–252). London, UK: Reaction Books.

Cosgrove, D. (1999). Introduction: Mapping meaning. In D. Cosgrove (Ed.). *Mappings* (pp. 1–23). London, UK: Reaction Books.

Davis, B. & Sumara, D. (2006). *Complexity and education: Inquiries into learning, teaching and research.* Mahwah, NJ: Lawrence Erlbaum Associates.

Debord, G. (1994). *The society of the spectacle.* New York: Zone Books.

de Cosson, A. F. (2003). *(Re)searching sculpted a/r/tography: (Re)learning subverted-knowing through aporetic praxis.* Unpublished Doctoral Dissertation. Vancouver, BC: University of British Columbia.

———. (2002). The hermeneutic dialogic: Finding patterns amid the aporia of the artist/researcher/teacher. *The Alberta Journal of Educational Research,* xlviii (3), article on CD-ROM insert.

———. (2001). Anecdotal sculpting: learning to learn, one from another. *jct: Journal of Curriculum Theorizing, 17*(4), 173–183.

Deleuze, G. (1993). *The Fold: Leibniz and the baroque.* Minneapolis, MN: University of Minnesota Press.

Deleuze, G. & Guattari, F. (1994). *What is philosophy?* New York: Columbia University Press.

———. (1987). *A Thousand plateaus: Capitalism and schizophrenia.* Minneapolis, MN: University of Minnesota Press.

———. (1983). *Anti-Oedipus: Capitalism and schizophrenia.* Minneapolis, MN: University of Minnesota Press.

Derrida, J. (1997). *Of Grammatology.* Baltimore, MD: John Hopkins University Press.

———. (1992). *Given time counterfeit money.* Chicago, IL: University of Chicago Press.

———. (1978). *Writing and difference.* Chicago, IL: University of Chicago Press.

Dimitriadis, G. (2008). Series editor introduction. In N. Dolby and F. Rizvi (Eds.). *Youth*

moves: Identities and education in global perspective (pp. ix–x). New York: Routledge.

Disprose, R. (2002). *Corporeal generosity: On giving with Nietzsche, Merleau-Ponty, and Levinas.* Albany, NY: State University of New York Press.

Doherty, C. (2004). *From studio to situation.* London: Black Dog Publishing.

Driscoll, C. (2002). *Girls: Feminine adolescence in popular culture and cultural theory.* New York: Columbia University Press.

Duncum, P. (2001). Visual culture: Developments, definitions, and directions for art education. *Studies in Art Education, 42* (2), 101–112.

Duncum, P. & Springgay, S. (2007). Extreme bodies: The body as represented and experienced through critical and popular visual culture, In L. Bresler (Ed.). *Handbook of Research in the Arts* (pp. 1143–1158). Boston, MA: Kluewer Academic Publications.

Durham, A. & Baez, J. (2007). A Tail of two women: Exploring the contours of difference in popular culture. In S. Springgay & D. Freedman (Eds.). *Curriculum and the cultural body (pp. 131–145).* New York: Peter Lang.

Ellsworth, E. (2005). *Places of learning: Media, Architecture, Pedagogy.* New York: Routledge.

———. (1989). Why doesn't this feel empowering? Working through the repressive myths of critical pedagogy. *Harvard Educational Review, 59* (3), 297–324.

Fidyk, A. (2003). Attunement to landscape: Dis/composure of self. *Educational Insights, 6* (2). http://www.ccfi.educ.ubc.ca/publication/insights/v08n02/contextualexplorations/curriculum/fidyk.html

Fidyk, A. & Wallin, J. (2005). The Daimon, the Scarebird, and Haiku: Repeated narrations. *Journal of Curriculum and Pedagogy, 2* (2), 215–243.

Foucault, (1977). *Discipline and punish: The birth of the prison.* New York: Pantheon Books.

Freedman, K. (2003). Teaching visual culture: Curriculum, aesthetics, and the social life of art. New York: Teachers College Press.

Gerber, A. (2003). What lies beneath. *Print, 57* (4), 50–57.

Garoian, C. (1999). *Performing pedagogy: Toward an art of politics.* Albany, NY: State University of New York Press.

Garoian, C. & Gaudelius, Y. (2001). Cyborg Pedagogy: Performing resistance in the digital age. *Studies in Art Education, 42* (4), 333–347.

———. (2007). Performing embodiment: Pedagogical intersections of art, technology, and the body. In S. Springgay & D. Freedman (Eds.). *Curriculum and the cultural body* (pp. 3–19). New York: Peter Lang.

Gatens, M. (1996). *Imaginary bodies: Ethics, power and corporeality.* New York: Routledge.

Giroux, H. (2005). *Border crossings: Cultural workers and the politics of education.* Second Edition. NY: Routledge.

Gonick, M. (2003). *Between femininities: Ambivalence, identity, and the education of girls.* Albany, NY: State University of New York Press.

Greene, M. (1973). *Teacher as stranger: Educational philosophy for the modern age.* Belmont, CA: Wadsworth.

Grosz, E. (2001). *Architecture from the outside: Essays on virtual and real space.* Cambridge, MA: MIT Press.

———. (1999). Merleau-Ponty and Irigaray in the flesh. In D. Olkowski & James Morley

(Eds.). *Merleau-Ponty, interiority and exteriority, psychic life and the world* (pp. 145–166). Albany, NY: State University of New York Press.

———. (1995). *Space, time and perversion: Essays on the politics of bodies.* New York: Routledge.

———. (1994). *Volatile bodies.* Bloomington, IN: Indiana University Press.

Grumet, M. (1988). *Bitter milk: Women and teaching.* Amherst: The University of Massachusetts Press.

Gustavson, L. (2007). *Youth learning on their own terms: Creative practices and classroom teaching.* New York: Routledge.

Harris, A. (Ed.). *Next wave cultures: Feminism, subcultures, activism.* New York: Routledge.

hooks, bell. (1994). *Teaching to transgress.* New York: Routledge.

Hayles, K. (1999). *How we became posthuman: Virtual bodies in cybernetics, literature, and informatics.* Chicago, IL: University of Chicago Press.

Hunter, L. (2005). Who gets to play? Kids, bodies, and schooled subjectivities. In J. Vandeboncoeur & L. P. Stevens (Eds.). *Re/constructing the adolescent: Sign, symbol, and body* (pp. 181–210). New York: Peter Lang.

Huntly, A. (2005). Returning teaching and learning to its original complexity. *Journal of Curriculum Theorizing, 21* (4), 97–116.

Irigaray, L. (2001). *To be two.* New York: Routledge.

———. (1993). *An ethics of sexual difference.* Ithaca, NY: Cornell University Press.

———. (1985). *This sex which is not one.* Ithaca, NY: Cornell University Press.

Irwin, R. L. (2004). A/r/tography: A metonymic métissage. In Irwin, R. L. & de Cosson, A. (Eds.). *A/r/tography: Rendering self through arts-based living inquiry* (pp. 27–38). Vancouver, BC: Pacific Educational Press.

———. (2003). Towards an aesthetic of un/folding in/sights through curriculum. *Journal of the Canadian Association for Curriculum Studies, 1* (2), 1–17.

Irwin, Rita L. & deCosson, Alex. (Eds.). (2004). *A/r/tography: Rendering self through arts-based living inquiry.* Vancouver, BC: Pacific Educational Press.

Irwin, R. L. & Springgay, S. (2008). A/r/tography as practice-based research. In S. Springgay, R. L. Irwin, C. Leggo & P. Gouzouasis (Eds) *Being with a/r/tography* (pp. xix–xxxiii). Rotterdam, The Netherlands: Sense Publishers.

Irwin, R. L., Beer, R., Springgay, S., Grauer, K., Gu, X., & Bickel, B. The Rhizomatic relations of a/r/tography. *Studies in Art Education. 48* (1), 70–88.

Jaggar, A. (1994). *Living with contradictions: Controversies in feminist social ethics.* San Francisco, CA: Westview Press.

James, I. (2006). *An Introduction to the philosophy of Jean-Luc Nancy.* Stanford, CA: Stanford University Press.

Kristeva, J. (1982). *Powers of horror: Essays on abjection.* New York: Columbia University Press.

Kennedy, B. (2004). *Deleuze and cinema: The aesthetics of sensation.* Edinburgh, UK: Edinburgh University Press.

Kwon, M. (2002). *One place after another: Site-specific art and locational identity.* Cambridge, MA: MIT press.

La Jevic, L. & Springgay, S. (in press). A/r/tography as an ethics of embodiment: Visual

Journals in pre-service education. *Qualitative Inquiry.*

Leggo, C. (2008). Autobiography: Research our lives and living our research. In S. Springgay, R. L. Irwin, C. Leggo & P. Gouzouasis (Eds). *Being with a/r/tography* (pp. 3–23). Rotterdam, The Netherlands: Sense Publishers.

Levinas, E. (1969). *Totality and infinity: An essay on exteriority.* Pittsburgh, PA: Duquesne University Press.

Lingis, A. (1994). *The community of those who have nothing in common.* Blommington, IN: Indiana University Press.

Lorraine, T. (1999). *Irigaray and Deleuze: Experiments in visceral philosophy.* Ithaca, NY: Cornell University Press.

Luke, A. (2003). Literacy education for a new ethics of global community. *Language Arts, 81* (1), 20–24.

Marlatt, D. (1988). *Ana Historic.* Concord, ON: Coach House Press.

Marks, L. (2002). *Touch: Sensuous theory and multisensory media.* Minneapolis, MN: University of Minnesota Press.

———. (1999). *The Skin of the film: Intercultural cinema, embodiment, and the senses.* Durham, NC: Duke University Press.

Mauss, M. (1990). *The Gift.* New York: Routledge.

Mayo, C. (2007). Teaching against homophobia without teaching the subject. In S. Springgay & D. Freedman (Eds.). *Curriculum and the cultural body* (pp. 163–173). New York: Peter Lang.

McLuhan, M. (1994). *Understanding media: The Extensions of Man.* Cambridge, MA: MIT Press.

McWilliam, E. & Taylor, P. (1996). *Pedagogy, technology, and the body.* New York: Peter Lang.

Merleau-Ponty, M. (1962). *Phenomenology of perception.* New York: Routledge.

———. (1964). *Signs.* Evanston, IL: Northwestern University Press.

———. (1968). *The Visible and the invisible.* Evanston, IL: Northwestern University Press.

Meskimmon, M. (2003). *Women making art: History, subjectivity, aesthetics.* New York: Routledge.

Miller, J. (2005). *Sounds of silence breaking: Women, autobiography, curriculum.* New York: Peter Lang.

Mitchell, A., Rundle, L. B., & Karaina, L. (2001). *Turbo chicks.* Toronto, ON: Sumach Press.

Mohanty, S. P. (1986). Radical teaching, radical theory: The ambiguous politics of meaning. In C. Nelson (Ed.). *Theory in the classroom* (pp. 149–176). Urbana, IL: University of Illinois Press.

Mullen, C. (2003). Guest editor's introduction: A Self-fashioned gallery of aesthetic practice. *Qualitative Inquiry, 9* (2), 165–181.

Nancy, J. L. (2000). *Of being singular plural.* Stanford, CA: Stanford University Press.

Oliver, K. & Lalik, R. (2000). *Bodily knowledge: Learning about equity and justice with adolescent girls.* New York: Peter Lang.

Perpich, D. (2005). Corpus meum: Disintegrating bodies and the ideal of integrity. *Hypatia, 20* (30), 75–91.

Phelan, P. (1993). Unmarked: The politics of performance. New York: Routledge.

Pink, S. (2001). *Doing visual ethnography*. London, UK: Sage Publications.

Plant, S. (2000). On the matrix: Cyberfeminist simulations. In David Bell & Barabara Kennedy (Eds.). *The cybercultures reader* (pp. 325–336). New York: Routledge.

Pollock, G. (1988). *Vision and difference: Femininity, feminism and the histories of art.* London: Routledge.

Pollock, D. (1998). Performative writing. In Peggy Phelan (Ed). *The ends of performance,* pp. 73–103). New York: New York University Press.

Porter, N. (2004). Exploring the making of wonder: The a/r/tography model in a secondary art classroom. In R. L. Irwin & A. F. de Cosson (Eds.). *A/r/tography: Rendering self through arts-based living inquiry* (pp. 103–115). Vancouver, BC: Pacific Educational Press.

Price, J. & Shildrick, M. (1999). *Feminist theory and the body: A Reader.* New York: Routledge.

Prosser, J. (2001). Skin memories. In S. Ahmed and J. Stacey (Eds.). *Thinking through skin* (pp. 52–68). London, UK: Routledge.

Pruesse, K. (Ed.). (1999). *Accidental audience: Urban interventions by artists.* Toronto, ON: Offsite collective.

Ricoeur, P. (1974). *The conflict of interpretation: Essays in hermeneutics.* Evanston, IL: Northwestern University Press.

Rogoff, I. (2005). Looking away: Participations in visual culture. In G. Butt (Ed.) *After criticism: New responses to art and performance* (pp. 117–134). Oxford: Blackwell Publishers.

———. (2004). http://theater.kein.org/node/95

———. (2000). *Terra infirma: Geography's visual culture.* London, UK: Routledge.

Rose, G. (2001). *Visual methodologies.* London, UK: Sage.

Roy, K. (2005). Power and resistance: insurgent spaces, Deleuze, and curriculum. *Journal of Curriculum Theorizing, 21* (1), 27–38.

Shapiro, S. & Shapiro, H. S. (Eds.). (2002) *Body movements: Pedagogy, politics, and social change.* Cresskill, NJ: Hampton Press.

Shildrick, M. (2002). *Embodying the monster: Encounters with the vulnerable self.* London, UK: Sage.

———. (2001). Some speculations on matters of touch. *Journal of Medicine and Philosophy,* 26 (4), 387–404.

Smith, D. G. (2003). Some thoughts on living in-between. In E. Habe-Ludt and W. Hurren (Eds.), *Curriculum intertext: Place/language/pedagogy* (pp. xv–xvii). New York: Peter Lang.

———. (1999). *Interdisciplinary essays in the pedagon: Human sciences, pedagogy and culture.* New York: Peter Lang.

Smith, M. P. (2000). *Transcultural urbanisms: Locating globalization.* New York: Blackwell Publishing.

Smith, S. (2002). Bodies of evidence: Jenny Saville, Faith Ringgold, and Janine Antoni weigh in. In S. Smith and J. Watson (Eds.), *Interfaces: Women, autobiography, image, performance* (pp. 132–159). Ann Arbor: University of Michigan Press.

Sobchack, V. (1992). *The address of the eye: A phenomenology of film experience.* Princeton,

NJ: Princeton University Press.

Sorial, S. (2004). Heidegger, Jean-Luc Nancy, and the question of Dasein's embodiment. *Philosophy Today, 48* (2), 216–218.

Springgay, S. (2008). An ethics of embodiment. In S. Springgay, R. Irwin, C. Leggo and P. Gouzouasis (Eds.). *Being with a/r/tography* (pp. 153–165). Rotterdam, Netherlands: Sense Publishers.

———. (2005a). Thinking through bodies: Bodied encounters and the process of meaning making in an email generated art project. *Studies in Art Education, 47* (1), *34–50.*

———. (2005b). An intimate distance: Youth interrogations of intercorporeal cartography as visual narrative text, *Journal of the Canadian Association of Curriculum Studies.* http://www.csse.ca/CACS/JCACS/index.html

———. (2004). *Inside the visible: Youth understandings of body knowledge through touch.* Unpublished Doctoral Dissertation, The University of British Columbia.

———. (2003). Cloth as intercorporeality: Touch, fantasy, and performance and the construction of body knowledge. *International Journal of Education and the Arts, 4* (5). http://ijea.asu.edu/v4n5/.

———. (2002). Arts-based educational research as an unknowable text. *Alberta Journal of Educational Research*, (3). CD Rom.

———. (2001). *The body knowing: A Visual art installation as educational research.* Master of Arts Thesis. Vancounver, BC: The University of British Columbia.

Springgay, S. & Freedman, D. (forthcoming, 2008). Sleeping with cake and other touchable Encounters: Performing a bodied curriculum. In E. Malewski (Ed.) *Curriculum studies—the next moment: Exploring post-reconceptualization.* New York: Routledge.

Springgay, S. & Freedman, D. (Eds.). (2007). *Curriculum and the cultural body.* New York: Peter Lang.

Springgay, S., Irwin, R., & de Cosson, A. (in press). The liminal (s)p(l)aces of a/r/tographical research. In Four Arrows, aka Don Trent Jacobs (Ed.). *The Authentic Dissertation: Alternative ways of knowing, research and representation.* New York: Routledge.

Springgay, S., Irwin, R., Leggo, C., & Gouzouasis, P. (Eds.) (2008). *Being with a/r/tography.* Rotterdam, Netherlands: Sense Publishers.

Springgay, S., Irwin, R. L., and Kind, S. (2005). A/r/tography as living inquiry through art and text. *Qualitative Inquiry, 11*(6), 892–912.

Springgay, S. & Peterat, L. (2002–2003). Representing bodies in a high school fashion show through touch, fantasy, and performance. *The Journal of Gender Issues in Art and Education, 3,* 52–68.

Stasko, C. (2008). (r)Evolutionary healing: Jamming with culture and shifting the power. In A. Harris (Ed.). *Next wave cultures: Feminism, subcultures, activism* (pp. 193–220). New York: Routledge.

Stawarska, B. (2006). From the body proper to flesh: Merleau-Ponty on intersubjectivity. In D. Olkowski & G. Weiss (Eds.). *Feminist interpretations of Maurice Merleau-Ponty* (pp. 91–106). University Park, PA: Penn State University Press.

Stewart, S. (1999). From the museum of touch. In Marius Kwint, Christopher Breward, & Jeremy Aynsley (Eds). *Material Memories: Design and evocation* (pp. 17–36). Oxford, UK: Berg.

Stevens, P. L. (2005). ReNaming "Adolescence": Subjectivities in complex settings. In J. Vadeboncoeur & L. P. Stevens (Eds.). *Re/Constructing "the adolescent": Sign, symbol and body* (pp. 271–282). New York: Peter Lang.

Stewart, Susan. (1993). *On longing: Narrative of the miniature, the gigantic, the souvenir, the collection.* Durham, NC: Duke University Press.

Tavin, K. (2003). Wrestling with angels, searching for ghosts: Toward a critical pedagogy of visual culture. *Studies in Art Education, 44* (3), 197–213.

Todd, S. (2003). *Levinas, psychoanalysis, and ethical possibilities in education.* Albany, NY: State University of New York Press.

Triggs, V. (2007). Contextual Fabric: Dialogue, Silence, and Gesture in Making Local Meaning of Educational Reform *Educational Insights, 11*(3). http://www.ccfi.educ.ubc.-ca/publication/insights/v11n03/articles/triggs/triggs.html

Turner, B. (1996). *The body and society: Explorations in social theory.* New York: Sage.

Vadeboncoeur, J. (2005). Naturalised, restricted, packaged, and sold: Reifying the fictions of "adolescent" and "adolescence." In J. Vadeboncoeur & L. P. Stevens (Eds.). *Re/Constructing "the adolescent": Sign, symbol and body* (pp. 1–24). New York: Peter Lang.

Vasseleu, C. (1999). Touch, digital communication and the ticklish. *Angelaki: Joural of the theoretical humanities, 4* (2), 153–162.

Vasseleu, C. (1998). *Textures of light: Vision and touch in Irigaray, Levinas and Merleau-Ponty.* New York: Routledge.

Villaverde, L. (2008). *Feminist theories and education.* New York: Peter Lang.

Watt, D. (2007). Disrupting mass media as curriculum: Opening to stories of veiling. In S. Springgay & D. Freedman (Eds.). *Curriculum and the cultural body* (pp. 147–161). New York: Peter Lang.

Weber, S. & Mitchell, C. (2004). *Not just any dress: Narratives of dress, body and identity.* New York: Peter Lang.

Weiss, G. (1999). *Body image: Embodiment as intercoporeality.* New York: Routlege.

Wenger, E. (1998). *Communities of practice: Learning, meaning, identity.* New York: Cambridge University Press.

Young, Iris. (1990). *Throwing like a girl and other essays in feminist philosophy and social theory.* Bloomington, IN: Indiana University Press.

Index